MONSTROUS BEAUTY

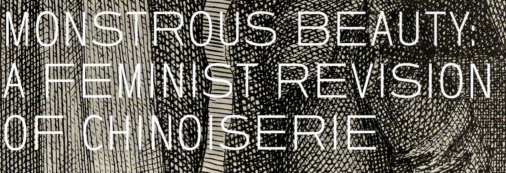

MONSTROUS BEAUTY: A FEMINIST REVISION OF CHINOISERIE

IRIS MOON

THE MET

THE METROPOLITAN MUSEUM OF ART, NEW YORK

DISTRIBUTED BY YALE UNIVERSITY PRESS, NEW HAVEN AND LONDON

CONTENTS

DIRECTOR'S FOREWORD

The holdings of European decorative arts at The Metropolitan Museum of Art contain some of the finest examples of eighteenth-century porcelain, which have formed a cornerstone of the Museum's collecting history. From rare pieces of Medici porcelain given to The Met by J. Pierpont Morgan Jr. in 1917 to the extraordinary export ware from the Helena Woolworth McCann Collection, and transformative gifts of Sèvres by Jayne Wrightsman, porcelain has been the subject of numerous exhibitions that have drawn attention to the history of this prized medium, first made in China, and widely admired and coveted in Europe upon its arrival in the early modern period. *Monstrous Beauty: A Feminist Revision of Chinoiserie* provides an opportunity to see these objects with a new perspective. Organized by Iris Moon, Associate Curator in the Department of European Sculpture and Decorative Arts, the exhibition and catalogue reimagine the history of Europe's preoccupation with porcelain through a feminist lens. Pairing historical works with contemporary pieces and commissions, *Monstrous Beauty* puts forward a new vision of, and vocabulary for, discussing porcelain "in the Chinese taste."

One of the most exciting aspects of *Monstrous Beauty*, a conceptual show that challenges the typical survey format that has been used in previous exhibitions of Chinoiserie, is how The Met's storied collection of porcelain takes center stage in a new narrative of significant relevance to our own time. The exhibition

and catalogue invite viewers to reenvision how something as seemingly decorative, beautiful, and harmless as a porcelain vase had the power to consume individuals in the past as they encountered this white, lustrous substance for the first time. In turn, the cultural power wielded by this type of inanimate object also constructed harmful racial and gender stereotypes toward Asian women, in ways that are not immediately obvious.

As *Monstrous Beauty* proposes, a dynamic combination of curiosity and critique is central to rethinking and expanding histories from new perspectives. The Met's mission of reaching diverse audiences through compelling narratives means not only bringing new voices and objects into the Museum. It also means developing new ways of looking at the permanent collection, opening up new discussions and posing questions that will encourage further conversations and interpretations. Museums play a crucial role in shaping active dialogue about different cultures, art traditions, and histories as well as provoking fruitful debate. At periods of momentous change, when conversations seem nearly impossible and attentions divided, looking closely at works of art can bring people together to engage with the past, present, and future as part of a shared story.

We thank the generous lenders of exceptional historical and contemporary works from American, Asian, and European institutions and private collections, and colleagues across The Met who have dedicated their time and expertise in bringing the exhibition and catalogue to fruition.

We are grateful to the William Randolph Hearst Foundation and the Mellon Foundation for making the exhibition possible. We also extend our thanks to Kohler Co., the E. Rhodes and Leona B. Carpenter Foundation, Karen and Samuel Choi, The International Council of The Metropolitan Museum of Art, the Edward John & Patricia Rosenwald Foundation, Mimi O. Kim, Minjung Kim, Gay-Young Cho and Christopher Chiu, Alexandra Cushing Howard, and Lorence Kim and Sherry Hsiung for their gifts to the exhibition. This beautiful publication is supported by the Diane W. and James E. Burke Fund, with additional gifts from Salle Yoo and Jeffrey Gray and the Doris Duke Fund for Publications, to whom we extend our deepest gratitude.

Max Hollein
Marina Kellen French Director and CEO
The Metropolitan Museum of Art, New York

ACKNOWLEDGMENTS

Bringing an exhibition to life, in all of its beauty and at times monstrous complexity, requires the collaboration of many individuals. Max Hollein, Marina Kellen French Director and Chief Executive Officer of The Metropolitan Museum of Art, believed in this project from the outset. Sarah E. Lawrence, Iris and B. Gerald Cantor Curator in Charge of the Department of European Sculpture and Decorative Arts, Andrea Bayer, Deputy Director for Collections and Administration, Inka Drögemüller, Deputy Director for Audience Engagement, Quincy Houghton, Deputy Director for Exhibitions and International Initiatives, and especially Lavita McMath Turner, Chief Diversity Officer, provided pivotal guidance.

Generous lenders made it possible to retell the complex stories of Chinoiserie: Martha Tedeschi and Lynette Roth at the Harvard Art Museums; Thomas Hyry and John Overholt at the Harvard Library; Timothy Potts, Anne-Lise Demas, and Jeffrey Weaver at the J. Paul Getty Museum; SeoHyun Lee, Sungwon Kim, June Kwak, and Jungjin Lee at Leeum Museum of Art; Nicole Bouché, Cynthia Roman, and Susan Walker at the Lewis Walpole Library; Matthew Teitelbaum, Courtney Harris, and Thomas Michie at the Museum of Fine Arts, Boston; Lynda Roscoe Hartigan and Karina Corrigan at the Peabody Essex Museum; Sasha Suda, Hyunsoo Woo, Jennifer Thompson, Jack Hinton, and Hiromi Kinoshita at the Philadelphia Museum of Art; Taco Dibbits,

Femke Diercks, and Jeroen ter Brugge at the Rijksmuseum; Tim Knox, Anna Reynolds, Cicely Robinson, Sally Goodsir, Lucy Peter, and David Wheeler at the Royal Collection Trust; William Gompertz, Helen Dorey, and Joanna Tinworth at Sir John Soane's Museum; Jonathan Boulware and Martina Caruso at the South Street Seaport Museum; Adam Levine, Diane Wright, Sophie Ong, and Robert Schindler at the Toledo Museum of Art; Tristram Hunt, Nick Humphrey, Rosalind McKever, and Simon Spier at the Victoria and Albert Museum; Julia Marciari-Alexander (now at the Samuel H. Kress Foundation) and Earl Martin at The Walters Art Museum; and Courtney Martin (now at the Robert Rauschenberg Foundation), Martina Droth, Edward Town, Laurel Peterson, and Jemma Field at the Yale Center for British Art. I am grateful to The Belvedere Collection, Lawrence and Marilyn Friedland, Stephan Loewentheil, and McKay Otto and Keith Coffee for generously lending works to the exhibition, and to artists Patty Chang, Jennifer Ling Datchuk, Heidi Lau, Candice Lin, Jen Liu, and Yeesookyung.

Departments across The Met contributed loans and expertise to the exhibition. We are grateful to Sylvia Yount, Lawrence A. Fleischman Curator in Charge of The American Wing, Nonnie Frelinghuysen, Anthony W. and Lulu C. Wang Curator of American Decorative Arts, Betsy Kornhauser, Curator Emerita, Amelia Peck, Marica F. Vilcek Curator, American Decorative Arts, and Consulting Curator of the Antonio Ratti Textile Center, and Adrienne Spinozzi; Mike Hearn, Douglas Dillon Chair of the Department of Asian Art, Monika Bincsik, Diane and Arthur Abbey Curator for Japanese Decorative Arts, Hwai-ling Yeh-Lewis, and Stephanie Kwai; Andrew Bolton, Curator in Charge of The Costume Institute, Bethany Gingrich, Mellissa Huber, and Marci Morimoto; Nadine Orenstein, Drue Heinz Curator in Charge of the Department of Drawings and Prints, Constance McPhee, Femke Speelberg, Perrin Stein, and Elizabeth Zanis; Stephan Wolohojian, John Pope-Hennessy Curator in Charge of the Department of European Paintings, and Adam Eaker; Navina Haidar, Nasser Sabah al-Ahmad al-Sabah Curator in Charge of the Department of Islamic Art, Deniz Beyazit, Maryam Ekhtiar, Patti Cadby Birch Curator, and Martina Rugiadi; David Breslin, Leonard A. Lauder Curator in Charge of the Department of Modern and Contemporary Art, Clare Davies, Akili Tommasino, and Katy Uravitch; Jayson Dobney, Frederick P. Rose Curator in Charge of the Department of Musical Instruments,

and Bradley Strauchen-Scherer; Jeff L. Rosenheim, Joyce Frank Menschel Curator in Charge of the Department of Photographs, Stephen Pinson, and Karan Rinaldo.

My colleagues in European Sculpture and Decorative Arts provide constant inspiration and support: Denise Allen, Wolf Burchard, Roger Arrazcaeta Delgado, Pilar Ferrer, Sarah Gregory, Kristen Hudson, Daniëlle Kisluk-Grosheide, Henry R. Kravis Curator, Wolfram Koeppe, Marina Kellen French Senior Curator, Elyse Nelson, Juan Stacey, Denny Stone, and William Winks.

The incredible design team of Fabiana Weinberg, Jourdan Ferguson, June Yoon, and Alexandre Viault shaped an early vision into a concrete plan, with the unstinting encouragement of Alicia Cheng, Head of Design. In the conservation departments, I thank Lisa Pilosi, Sherman Fairchild Conservator in Charge of the Department of Objects Conservation, Mecka Baumeister, Warren Bennett, Linda Borsch, Matthew Cumbie, Andrew Estep, Manu Frederickx, Jacob Goble, Anne Grady, Vicki Parry, Fred Sager, Karen Stamm, and Wendy Walker; Rebecca Capua in the Department of Paper Conservation; José Luis Lazarte Luna in the Department of Paintings Conservation; Katherine Sanderson in the Department of Photograph Conservation; and Janina Poskrobko, Conservator in Charge of the Department of Textile Conservation, Cristina Carr, and Giulia Chiostrini.

In Development, Young Bae, Evie Chabot, Jason Herrick, Kimberly McCarthy, and John L. Wielk played an instrumental role in shepherding an idea into reality. In Publications and Editorial, Mark Polizzotti, Publisher and Editor in Chief, ensured the creation of a meaningful catalogue and exhibition text, along with Peter Antony, Michael Sittenfeld, Elizabeth L. Block, Chris Zichello, Jenny Bantz, Josephine Rodriguez, catalogue designer Michelle Lee Nix, and bibliographic editor Julia Oswald. I extend my gratitude to Jessica Ranne-Cardona, Fredy Rivera, and Andrijana Sajic in the Thomas J. Watson Library. Many other colleagues throughout The Met aided in the exhibition: Christopher Alessandrini, Allison Barone, Melissa Bell, Quinn Corte, Kate Farrell, Isabella Garces, Heidi Holder, Frederick P. and Sandra P. Rose Chair of Education, Marci King, Christine McDermott, Bindi Patel, Marianna Siciliano, and Rachel Smith. I am grateful to Erica Getto, and to Sarah Hilty, who ably assisted as an intern on the project, and to Joy Kim for her singular work as research assistant.

I express my deepest appreciation to the writers for the catalogue, whose names are provided on the Contributors page. The undergraduate students of my class on Porcelain and the Politics of Chinoiserie at Cooper Union helped to establish the stakes of the exhibition. To the following friends and colleagues, thank you for advice, support, and constructive feedback over the years that this project developed: Andrea Achi, Mary and Michael Jaharis Associate Curator of Byzantine Art, Department of Medieval Art and The Cloisters at The Met, Niv Allon, Malcolm Baker, Sophia de la Barra, Tim Barringer, Marisa Bass, Caitlin Beach, Sam Bibby, Sarah Bochicchio, Caitlin Bowler, Max Bryant, Ann and Larry Burns, Adrienne Childs, Austin Chinn, Jane Debevoise, Caroline Fowler, Rainald Franz, Hou Hanru, Georgia Henkel, Brenna and Nate Hernandez, Melanie Holcomb, Agnes Hsu-Tang, Geertje Jacobs, Jaeho Jung, Jai-Ok Kim, Minjung Kim, Susan Kim, Suzanne Lambooy, Stacey Lambrow, Chungwoo Lee, Claudia Lehner-Jobst, Melissa Lo, Francesca Marzullo, Cordula Mauß, Michele Matteini, Alicia McGeachy, Sequoia Miller, Lynda Nead, Guillaume Nicoud, MeeNa Park, Jane Hardesty Poole, Kelly Presutti, Paulus Rainer, Victoria Restler, Linda Roth, Sasa, Aude Semat, Susan Siegfried, Vanessa Sigalas, Rachel Silberstein, Lisa Stern, Hans-Peter Ströbel, Richard Taws, Sarah Turner, Julia Weber, Susan Weber, Samuel Wittwer, and Salle Yoo. To my wonderful family: you are the reason to rewrite the story.

My thanks go to the William Randolph Hearst Foundation and the Mellon Foundation for making the exhibition possible. For their additional support, I also extend my appreciation to Kohler Co., the E. Rhodes and Leona B. Carpenter Foundation, Karen and Samuel Choi, The International Council of The Metropolitan Museum of Art, the Edward John & Patricia Rosenwald Foundation, Mimi O. Kim, Minjung Kim, Gay-Young Cho and Christopher Chiu, Alexandra Cushing Howard, and Lorence Kim and Sherry Hsiung. The Diane W. and James E. Burke Fund, Salle Yoo and Jeffrey Gray, and the Doris Duke Fund for Publications made this catalogue possible and have our sincere appreciation for bringing this publication to our readers.

Iris Moon
Associate Curator, Department of European Sculpture and Decorative Arts
The Metropolitan Museum of Art, New York

LENDERS TO THE EXHIBITION AND CONTRIBUTORS

LENDERS TO THE EXHIBITION

His Majesty King Charles III

The Belvedere Collection

Patty Chang

Lawrence and Marilyn Friedland

The J. Paul Getty Museum, Los Angeles

Harvard Art Museums, Cambridge, Massachusetts

Harvard Library, Cambridge, Massachusetts

Leeum Museum of Art, Seoul

Jen Liu

Stephan Loewentheil

The Metropolitan Museum of Art, New York

Museum of Fine Arts, Boston

National Museums Liverpool, Lady Lever Art Gallery

McKay Otto and Keith Coffee

Peabody Essex Museum, Salem, Massachusetts

Philadelphia Museum of Art

Rijksmuseum, Amsterdam

Sir John Soane's Museum, London

South Street Seaport Museum, New York

Toledo Museum of Art

Victoria and Albert Museum, London

Lewis Walpole Library, Farmington, Connecticut

The Walters Art Museum, Baltimore

Yale Center for British Art, New Haven

Yeesookyung

CONTRIBUTORS

Marlise Brown
Assistant Curator, Allen Memorial Art
Museum, Oberlin, Ohio

Patty Chang
Professor of Art, University of Southern
California, Los Angeles

Anne Anlin Cheng
Professor of English, Princeton University

Elizabeth Cleland
Curator, Department of European
Sculpture and Decorative Arts,
The Metropolitan Museum of Art, New York

Patricia F. Ferguson
Honorary Advisor on Ceramics to
The National Trust, London

Eleanor Soo-ah Hyun
Korea Foundation and Samsung
Foundation of Culture Curator,
Department of Asian Art,
The Metropolitan Museum of Art, New York

Cindy Kang
Curator, The Barnes Foundation,
Philadelphia

Ronda Kasl
Curator of Latin American Art,
The American Wing, The Metropolitan
Museum of Art, New York

Joan Kee
Judy and Michael Steinhardt Director,
The Institute of Fine Arts,
New York University

Pengliang Lu
Brooke Russell Astor Curator of Chinese
Art, Department of Asian Art,
The Metropolitan Museum of Art, New York

Lesley Ma
Ming Chu Hsu and Daniel Xu Curator of
Asian Art, Department of Modern and
Contemporary Art, The Metropolitan
Museum of Art, New York

Iris Moon
Associate Curator, Department of
European Sculpture and Decorative Arts,
The Metropolitan Museum of Art, New York

David Porter
Professor, Department of English and
Comparative Literature, University of
Michigan, Ann Arbor

Joseph Scheier-Dolberg
Oscar Tang and Agnes Hsu-Tang Curator
of Chinese Paintings, Department of
Asian Art, The Metropolitan Museum
of Art, New York

Elizabeth Kowaleski Wallace
Professor Emeritus, English Department,
Boston College

Chi-ming Yang
Professor, Department of English,
University of Pennsylvania, Philadelphia

Yao-Fen You
Acting Director, Smithsonian Asian Pacific
American Center, Washington, DC

THE WOMAN
IN THE
MIRROR

The story of Chinoiserie has been told countless times, to the point that it sounds like a fairy tale. In the Age of Discovery, European ships began returning from distant shores laden with precious blue-and-white porcelain from China. Soon enough, these arrivals prompted an obsession with the fragile, white substance, and spurred imitations in Europe and an entire industry devoted to creating what became known in the eighteenth century as the "Chinese taste." In homes across Europe, residences naturalized colorful floral wallpapers imported from China. German palaces, British country houses, and Swedish pavilions were covered with scenic backdrops populated with birds of paradise and land-scapes filled with beautiful Chinese women. Porcelain garnitures graced mantels, shelves, and cabinets, while porcelain plates, cups, saucers, and sauceboats on the surfaces of dining and tea tables completed the decor. Ubiquitous luxuries in the home, they were rarely tied to the human hands that labored to produce them in China. Instead, Chinoiserie was associated with superficial beauty made for consumption elsewhere. In the study at Saltram House, a country house in Devon, England, owned by Lady Catherine Parker and her husband John Parker, *meiren*, or Chinese beauties, became a stock feature of the Chinese prints and paintings of landscapes that functioned as the scenic imaginary backdrop for the couple's domestic pursuits (fig. 1). In Qing China (1644–1911), *meiren*, combined with an illusionistic sense of space that made reference to Western painting techniques, had also been seen as decorative. Among the most famous examples were the *Twelve Beauties* painted on screens for the Emperor Yongzheng when he was a prince (fig. 2).[1] At Saltram, the depiction of beauties is not meant as a stand-alone composition. Instead, combined with porcelains and fretwork furniture, as

well as reverse-painted mirrors that featured more beauties, the figures are meant to be glanced at rather than fully seen. They blend into a broader surface of repeating patterns, colors, and forms, rather than representations of a singular human figure.[2] At the Royal Pavilion, Brighton, the culmination of the Chinese taste, George IV used dragons, fretwork, and theatrical Chinese figures to transform a seaside retreat into a spectacle of his personal idiosyncratic tastes as royal figurehead (fig. 3). The decoration took place despite the embarrassing political disaster of the 1793 Macartney Embassy, when England sought to offer its riches to the Qianlong emperor in an attempt to establish formal trade relations with China, including examples of Chinoiserie decoration made by domestic producers, only to be met with the response, "We have never valued ingenious articles, neither do we have the slightest need for your country's manufactures."[3]

Fig. 1. Study at Saltram House, Devon, United Kingdom, National Trust

Chinoiserie is both a style and an ideology. It is at once the stuff of enchantment, unfurling a seemingly endless range of luxuries wrapped in layers of ornamentation, and at the same time a system of entrapment that holds you captive to a process of objectification. The word was supposedly invented by the French novelist Honoré de Balzac in the nineteenth century as a pejorative used to describe a delusional, ancien régime obsession with "wanton" luxuries, which created Europe's early fantasies of the East as a faraway world, composed of lacquers, silk, mirrors, and porcelain. Before the word was coined, the Chinese taste was not about precise points of origin or geographic specificities, since the vast array of objects were manufactured not only in China, but also in Japan, India, and Europe. Instead, the decorative skin of Chinoiserie seemingly effaced the racialized human labor used to produce these luxury goods. The ornate,

Fig. 2. One of the *Twelve Beauties* painted for Emperor Yongzheng while Prince Yinzhen. Beijing Palace Museum, Yuanmingyuan
Fig. 3. Banqueting room, Royal Pavilion, Brighton

superficial, and decorative nature of this ubiquitous style birthed a racial imaginary composed of dehumanizing projections, fantasies, and fetishizations about the foreign and the exotic that came to settle upon the figure of the Asian woman, a modern subject held captive to the same "exoticizing" narratives constructed by Chinoiserie. Rather than erasing the term altogether, *Monstrous Beauty* proposes expanding its parameters by introducing an alternative set of historical and contemporary protagonists to tell an unseen side of the story. How might this style have given voice to women in Europe, at the same time that it constructed the fetishized figure of the Asian woman, a pervasive myth and by-product of the racial and sexual fantasies that were projected upon so-called exotic objects that populated countless domestic interiors?

Historical surveys that have tackled the subject of Chinoiserie try to create distance between this past style and our current moment, picturing it as a neutral, harmless fantasy that is removed from the present. The collaboration between the Peabody Essex Museum, Salem, Massachusetts, and the Rijksmuseum, Amsterdam, in the 2016 exhibition *Asia in Amsterdam: The Culture of Luxury in the Golden Age* focused on the trade routes that brought the geographically distant cultures of

Batavia (in present-day Indonesia), Japan, and China into close contact with Amsterdam, whereas the exhibition at the Musée des Beaux-Arts et d'Archéologie, Besançon (2019–20) of the French artist François Boucher and his significant collection of Chinese objects renewed understanding of Chinese luxury in shaping the artistic language of the Rococo.[4] Seeded throughout much of these surveys is a nostalgia, already found in the art historical literature on the style. Today, Chinoiserie functions as a safe kind of beauty, wedded to comfort, tradition, and a certain type of shabbiness, even though it had historically functioned as a stylistic cipher for the strange. In the introduction to Hugh Honour's *Chinoiserie: The Vision of Cathay* (1961), a book dedicated to his mother, the author recalled early childhood memories of an English youth filled with blue willow plates, ginger jars and lacquer trays, and fancy dress costumes, where Honour dressed up as a "mandarin," "complete with embroidered silk suit, straw slippers, a pigtail dangling from the back of my head." For the young Honour, the vision of China was "a topsy-turvy land of brilliant flowers, weird monsters, and fragile buildings where most European values were reversed."[5]

A misty-eyed nostalgia also pervades many of the exhibition surveys of Chinoiserie, from the 2009 exhibition *Chinese Whispers* at the Brighton Pavilion in England to *China: Through the Looking Glass* at The Met (2015), which pictured Chinoiserie as a fantasy that is once removed from the present and unrelated to contemporary perspectives. Privileging Europe's fascination with exoticism, terms such as *whispers*, *dreams*, and *fantasies* envelop the past obsession with an Asia constructed by the West, while simultaneously ignoring the pervasive cultural stereotypes around the image of the Asian woman created in the wake of Chinoiserie. Tradition combined with nostalgia cast a powerful fog of enchantment upon the present that is difficult to escape. In a 2021 article written by Aileen Kwun in *Elle Décor* about the need to rethink Chinoiserie, an interviewee responded: "Yes, chinoiserie is nostalgic. But who and what is it nostalgic for?"[6] Within the specific context of the history of porcelain, this stylistic nostalgia is tied to a study of porcelain as a technology created in China, which European princes desperately wished to replicate in Europe, as a symbol of power. Often discussed as if the precursor to a nuclear arms race, the quest to discover the recipe for true porcelain drove Europe's princely patrons such as Augustus II the Strong to develop *Porzellankrankheit*, or porcelain sickness, where his whole world revolved around recreating the Chinese recipe for porcelain—and beating the Chinese at their own game.

The demons of the past can be confronted with clear-eyed curiosity and critique. This catalogue foregrounds individual stories that often get lost in sweeping surveys, which focus on systems of exchange and cross-cultural

encounters that account with difficulty for anything idiosyncratic that does not fit into larger systems that pit West and East against each other. The title of the exhibition and book pays homage to David Porter's 2002 article "Monstrous Beauty: Eighteenth-Century Fashion and the Aesthetics of the Chinese Taste," in which he introduced the idea that Chinoiserie was not merely superficial, decorative, and ornamental, but was an important touchstone for eighteenth-century British culture. The style provoked strong reactions, with one eighteenth-century periodical describing Chinoiserie objects as "monstrous offspring of wild imagination, undirected by nature and truth." A central reason why Chinoiserie attracted criticism was its associations with an effeminate taste for porcelain, which "presented a glittering, hollow shell of seductive charm."[7] Importantly, Porter revealed the ways in which this decorative language and the porcelain imaginary provided female collectors with a vehicle of expression, apart from the masculine, nationalist taste for classical antiquity.[8] The exhibition and book are equally indebted to the intellectual work of Anne Anlin Cheng, whose critical writings have probed the ways in which Chinoiserie, far from being a mechanism that disempowered Asian women through a process of fetishiziation and objectification, can be reframed as a theory of empowerment. Cheng's work directly inspired many of the critical framings in *Monstrous Beauty*. In the book *Ornamentalism*, her exploration of the problematic figure she calls the "yellow woman," a transitive being occupying a place between persons and things, she writes:

> If we are willing to confront the life of a subject who lives as an object, then we will arrive not at an easy politics, but rather at an alternative track within the making of modern Western personhood, one that is not traceable to the ideal of a biological, organized, and masculine body bequeathed from a long line of Enlightenment thinkers, but is instead peculiarly synthetic, aggregated, feminine, and non-European.[9]

On another level, *Monstrous Beauty* speaks to the complex desires that drove women to buy porcelain as if their lives depended upon it. Shopping is rarely perceived as heroic. It is only when the history of porcelain belongs to elite men that the stories of obsession, possession, and desire are legitimate and positively epic, particularly if it involves the quest to unlock a technological secret tethered to a language of perfection.[10] When the story is about women shopping, becoming obsessed with what they acquire, the story loses interest, is no longer heroic, and is dismissed. And yet, as Mary II's porcelain obsession reveals, her desire to acquire these artificial bodies was intimately tied to the pressures of being a queen and the acute, bodily felt demand to produce an heir to the throne. Even today, retail therapy is often dismissed as a materialistic way to buy your way out

of problems. And yet, I thought of a Museum patron who purchased one of her first pieces of Japanese porcelain after her husband could no longer travel. She bravely decided to embark on her own from New York to London. There, while wandering around Kensington Church Street, when it was filled with antique shops, she spied a *shishi*, or mythological spotted creature, rambunctiously leaping atop the lid of a Japanese porcelain vase (fig. 4). From that point on, she was hooked. The acquisition marked a turning point in her life, when she transformed from a wife into a collector.

What does it mean to look at Chinoiserie with a feminist lens? It is more than counting numbers of women, writing taxonomic lists of "forgotten" figures who bought porcelain, collected and treasured it, or enumerating the nameless

female laborers who likely painted Chinoiserie scenes on porcelain in cramped working conditions. Nor is it about counting how many Chinese women were actually painted on the surfaces of porcelain, lacquer, and mirror objects. *Monstrous Beauty* instead seeks to empower viewers by asking them to see the past differently, in an intimate relation to our own times, by adopting what the feminist theorist Donna Haraway describes as a "diffractive lens" that activates a "more subtle vision" instead of only passively reflecting on things we cannot change. She writes, "Diffraction does not produce 'the same' displaced, as reflection and refraction do. Diffraction is a mapping of interference, not of replication, reflection, or reproduction. A diffraction pattern does not map where differences appear, but rather maps where the effects of difference appear."[11] Haraway's use of the optical term *diffraction*, which originates from the Latin word *diffringere*, meaning "to break into pieces," provocatively suggests that feminist activism not only depends upon changing the world around us, but requires breaking apart and reorienting the ways that we see it. Protagonists with alternative desires and storylines, who we never thought were there, suddenly materialize through objects that are brought alive for the viewer.

To offer one example of how a diffractive lens can prompt different kinds of seeing, let us turn to a reverse-painted mirror of a *meiren*-type beauty (pl. 74, fig. 5). Dating around 1760 and painted in Canton on imported mercury glass for the European export market, the figure has been painted on the reverse side of the eighteenth-century mirror, after parts of the reflective mercury had been scraped off and filled in with paint. Such mirrors were often integrated into interiors, like the Chinese pavilion at Drottningholm Palace in Sweden, where reflective surfaces were used to create a range of pleasing and theatrical visual effects, from the lustrous darkness of imitation lacquer paneling and furniture to the white shine of porcelain garnitures. European merchants who were a part of the East India companies shaped the taste for reverse-painted mirrors, which combined European and Chinese painting techniques. Some of the most lavish examples include a vanity set made for Catherine the Great of Russia, with pheasants and flowers that would have framed her face while the empress was at her toilette (fig. 6). Unlike the regal toilet set, this mirror was probably a "middlebrow" example of export art, intended for a male viewer with commercial interests in mind and a desire for paintings of beautiful women. Scholars rarely

Fig. 4. Japanese, made for the European market. Baluster-shaped vase, ca. 1690–1720. Porcelain (Hizen ware, Imari type), overall 23 ½ × 12 ¼ × 13 in. (59.7 × 31.1 × 33 cm). The Metropolitan Museum of Art, New York, Gift of Jane Hardesty Poole, 2019 (2019.257.6a, b)

Fig. 5. Detail of pl. 74
Fig. 6. Chinese, made for the European market. Toilet set for Catherine the Great, consisting of 32 objects, ca. 1740–50. Mercury glass, paper, silver, filigree, parcel-gilt wood, velvet, peacock and kingfisher feathers, mother-of-pearl, crystals. State Hermitage Museum, Saint Petersburg, Russia (ЛС-472/ 1,2, ВВс-373)

dwell for long on objects like this mirror. In export art, ideal beauties are dismissed as a generic type, just one category of decoration among the many different and interchangeable subjects of birds, flowers, and landscapes made for commercial purposes in China and shipped to Europe beginning in the sixteenth century, in order to satisfy the growing appetite for luxury objects.

Chinoiserie was supposedly a world of surface rather than depth, decorative reflection rather than contemplation, skimming the surface rather than reading meanings. A mercantile aesthetics drove the taste for Chinoiserie, and reverse-painted mirrors embodied the association with the superficial. As Stacey Sloboda writes, the high gloss and reflective surfaces of decorative objects participated in the discursive formation of Chinoiserie, where "objects in the Chinese taste were prized for their ability to reflect light, which kept their visual interest firmly on the surface." She points to John Stalker and George Parker's 1688 *A Treatise of Japanning and Varnishing...*, which spurred a variety of similar publications (fig. 7). The designers celebrate the glossy finish of this technique of imitating Japanese

lacquer by pasting pictures onto furniture: "What can be more surprising, than to have our Chambers overlaid with Varnish mor [*sic*] glossy and reflecting than polisht Marble? No amorous Nymph need entertain a Dialogue with her Glass, or Narcissus retire to a Fountain, to survey his charming countenance, when the whole house is one entire Speculum."[12]

The woman in the mirror looks back at us. If we see the painting not as a category of merchandise but as an unusual reflective technology, the mirror brings into focus a more complex set of relations between painting genres, histories, and cultures, and women as subjects. She wears a courtesan's blue silk dress and sumptuous ermine cape, her tautly combed hair set within an elaborate Manchu hairstyle, from which strands of shimmering pearls and coral dangle past a triple-pierced ear. Behind her on a table, a blue-and-white porcelain vase in a carved stand lends the composition a sense of depth. The blooming peonies in the vase echo the flowers in the woman's headdress to create a visual correspondence between porcelain and her body. Multitasking in the semaphores of desire, she clutches in her right hand a red silk handkerchief that crumples into soft folds like the creases in her fur-trimmed horseshoe sleeves. She strokes the ermine cape with the edge of her left pinky nail, as her index finger hooks around a pipe from which she has just taken a long drag, the bowl still containing an orange ember. Everything in this composition is intended to evoke the desire for luxury and possession, including the woman, standing as a cipher for the world of sensuous surfaces that played a key role in the Chinese literati's connoisseurship of objects.[13]

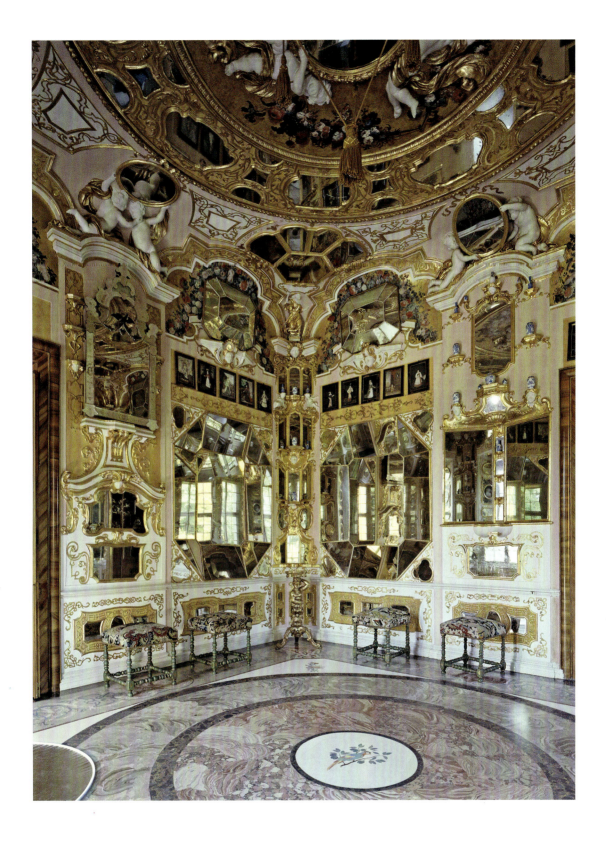

Fig. 7. Detail of Jean Pillement; published by Robert Sayer. *Ladies' Amusement: Or, The Whole Art of Japanning Made Easy*, 1760. Etching and engraving, hand-colored, 7 ⁷/₈ × 12 ⁵/₁₆ × 1 ³/₁₆ in. (20 × 31.2 × 3 cm). The Metropolitan Museum of Art, New York, Harris Brisbane Dick Fund, 1933 (33.24)
Fig. 8. Mirror cabinet. Schloss Favorite, Rastatt

Except women who gaze too long into the mirror are a threat. Asian American novelist Maxine Hong Kingston's *The Woman Warrior* begins with a story of the "No Name Woman," a nameless aunt in China who drowned herself in a well after giving birth to a child out of wedlock. This aunt, the narrator was told, haunted her immigrant family with shame. Imagining the scenarios of her aunt's life in the village, Kingston writes of the stolen glances and forbidden desires that may have led to the illicit affair, but also the dangers that befell a woman who "worked at herself in the mirror," and who needlessly drew attention to herself by combing her hair in an unusual way. A woman's individuality threatened to bring down an entire family: "She plied her secret comb. And sure enough she cursed the year, the family, the village, and herself."[14] What would it mean to restore to the "No Name Woman" the power to look back? To give to her the right to see the world from the position of the feminine, in all of its eccentricities? Might it entail not focusing on the woman in the mirror as the target, the object of desire, but a less disciplined wandering around the objects surrounding her in a sustained looking that is a longing for material objects and their surfaces, what art historian Jonathan Hay has described as a kind of sensuous taking pleasure in the act of looking itself? From the porcelain, to the flowers, to the fur, to the silks, pleasure is dispersed across an array of surfaces. And in between the objects and the woman on the other side of the mirror, you find yourself in the reflective gaps. The reverse-painted mirror, already occupied by another woman, which calls upon the viewer to actively reposition herself, calls to mind the very kind of diffractive lens about which Haraway speaks. Moreover, it might prompt a more generative interpretation of the many mirrored Chinoiserie cabinets commissioned by women for their use in the eighteenth century, including Sibylla Augusta's mirror cabinet at Schloss Favorite in Rastatt, which incorporated Asian and European porcelains into an interior, alongside portraits of the margravine of Baden-Baden wearing different costumes (fig. 8).

Before I looked into this mirror, I was not very interested in Chinoiserie. I thought it was superfluous and hardly intellectually meaningful. Still, there was something uncanny about this mirror when I looked at it in the storeroom of the Department of European Sculpture and Decorative Arts at The Met. The woman was disconcerting. Further, it struck me, while photographing the object, that this discomfort had less to do with her, and more to do with the other woman reflected in the mirror (fig. 9). Like a horror movie, it felt strange to find myself in a place I was not supposed to be. I felt thrown, forced into a position by the

Fig. 9. Detail of pl. 74

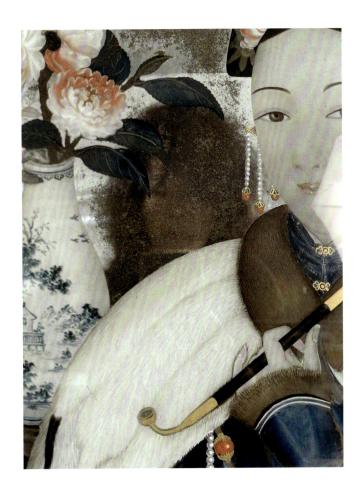

painted woman who occupied so much of a reflective surface that was supposed
to be used for seeing my own reflection. Finding myself in the mirror, I no
longer saw the image of Chinoiserie as simply about superficial appearances
and shattered ornament. I had the palpable realization of how the stories of the
past continually shape our present moment in deeply intimate and uncanny ways.
As Chi-ming Yang writes, "Surfaces have stories to tell, including the routes they
have traveled from afar, the bodies they conserve over time, and the mysterious
science of their construction."[15]

The contemporary Asian and Asian American women artists in *Monstrous
Beauty* anchor the conceptual framework of the exhibition and book, and the ways
in which critical engagements with history can help us reposition the present.
They critically interrogate Chinoiserie, more than representing a continuation
of the style. They reclaim the porcelain imaginary and use the material to empower
the voices of women. Most importantly, their works materialize the implicit
violence that has always lurked under the surface of Chinoiserie, and how the
history of objectification has shaped present-day understandings of race, gender,

and sexuality, even as the alluring surfaces of porcelain, lacquer, mirrors, and silk constructed a material world that enriched women's lives in countless ways. Few art historians have commented on the fact that the patterns and decorations found in books on japanning, such as the interestingly titled *Ladies' Amusement*, contained disturbing images of violence and torture, dismissing as mere absurdities their appearance in a manual for japanning that catered to women (fig. 10). Contemporary artists visualize the links between the discursive habits of Chinoiserie and the later racist fetishization of Asian women's bodies. Acts of horrific violence such as the 2021 Atlanta Massacre led to the deaths of eight people, including six women of Asian descent working in massage parlors, a form of labor rendered invisible because of its associations with sex work, and shamed by Americans, especially the Asian American community, because it does not align with so-called American values (fig. 11).[16] Diffractive looking means that when we look at the woman in the mirror, we see and remember these women. A self-possessed woman is the image that comes to mind in this active form of encounter. Perhaps a connecting thread can be traced from these Chinoiserie mirrors to artist Joan Jonas's 1960s experiments with mirrors, reflections moved to bisect and reposition spectators (fig. 12).

Fig. 10. Detail of Jean Pillement; published by Robert Sayer. *Ladies' Amusement: Or, The Whole Art of Japanning Made Easy*, 1760. Etching and engraving, hand-colored, 7 7/8 × 12 5/16 × 1 3/16 in. (20 × 31.2 × 3 cm). The Metropolitan Museum of Art, New York, Harris Brisbane Dick Fund, 1933 (33.24)
Fig. 11. Memorial outside Young's Asian Massage, Acworth, Georgia, March 2021. Photograph
Fig. 12. Joan Jonas (American, b. 1936). *Mirror Piece I*, 1969. Photograph of performance

Is it enough to rethink Chinoiserie? What is the life cycle of a style, and can we deliberately choose to end it?[17] Some scholars have seen Chinoiserie, following the expression of the Goncourt Brothers, as "a province of the Rococo," while others have argued that it emerged with the Baroque style, coming to an end in the nineteenth century when it merely functioned as a mood, or "sentimental projection on a landscape experience or as a picturesque set design."[18] Perhaps Chinoiserie's long afterlife allows us to see how a style not only comes alive as an unbroken line of continuity, but fractures and changes, accumulating different cultural, social, and political meanings within each historical moment that it reappears. Styles affect the ways objects look, or how they are perceived, and can color the ways in which individuals are perceived, at times against their will, demonstrating the hold that the past exerts over the present. It is easy to fall into the trap of enchantment. You have the power to look back differently, to find what you didn't see before.

SHIPWRECKS AND SIRENS: EARLY ARRIVALS OF PORCELAIN IN EUROPE

In 1613, the *Witte Leeuw* (*White Lion*) set off on its return trip from Bantam (in present-day Indonesia) to the Dutch Republic laden with spices, diamonds, and porcelain. A large, three-masted ship owned by the Dutch VOC (Verenigde Oostindische Compagnie, or Dutch East India Company), the 450-ton vessel had departed the Dutch island of Texel three years earlier, armed with a crew of nearly 100 men and 25–30 cannons, seeking exclusive rights to the spice trade and precious cargo to sell for profit.[1] As the *Witte Leeuw* rounded the Cape of Good Hope and stopped at the island of Saint Helena for provisions, the ship's captain spied a pair of rival Portuguese carracks, or merchant vessels, and spotted an opportunity to turn a profit.[2] Almost a decade earlier, in 1604, the Dutch had seized the *Catharina*, a Portuguese carrack, and sold off its contents, including nearly one hundred thousand pieces of Chinese porcelain at auction in Amsterdam, which sparked a frenzied "traffic in porcelain."[3] Greedy for spoils, the Dutch captain maneuvered to overtake the Portuguese ships when disaster struck: one of the *Witte Leeuw*'s own cannons exploded, sinking the vessel. Rediscovered centuries later in 1976 off the coast of Saint Helena, the sunken remains of the ship contained four hundred kilograms of porcelain, including Kraak plates, named after the Portuguese merchant vessels that first brought the Ming dynasty (1368–1644) wares to Europe (pl. 1).[4] The shipwreck also revealed more unusual artifacts. Marine invertebrates turned submerged porcelain vessels into new homes, creating monstrous bodies born from the greed for the artificial white substance that would feed European trade for centuries (pl. 2).

Shipwrecks are the messy counterparts to the early modern *Kunstkammer* collections that shaped Europe's early arrivals of porcelain into rarities for display. They are reminders of the voracious appetite, entrepreneurial risk, and colonial violence that accompanied porcelain on its voyages to Europe. Wave after wave of European boats arrived in Asia after the explorer Vasco da Gama discovered a sea route to India in 1497. The Portuguese launched expeditions in search of trade routes that would establish footholds in Cochin,

Calcutta, Colombo, and Goa in the early 1500s.[5] The Portuguese became renowned for a militarized form of trade, a combination of guns, gift diplomacy, and Catholic missionary efforts that eventually secured Macao as a permanent Portuguese settlement in 1557. A key port at the mouth of the Pearl River that connected trade between China, Japan, and Europe, Macao remained a Portuguese colony until 1999, when it became a special administrative region of China.[6] The Dutch launched their first trade voyage to Bantam, Java, in 1595, and forged the Dutch VOC, the world's first multinational joint-stock company, from companies based in six Dutch cities in 1602.[7] The English established a trade monopoly in 1600, with the Governor and Merchants of London trading into the East Indies, forming the basis of what would be known as the East India Company. Spoils and plunder continually drove the desire to create trading companies. The English East India Company had been set up in 1579, after the adventurer Sir Francis Drake captured a Spanish galleon heavily laden with sumptuous cargo, including porcelain, pieces of which he offered to Queen Elizabeth.[8] The last to join was the American republic, where venturing merchant vessels set off for China, beginning with the *Empress of China* in 1784 from New York to Canton. Though these monopolies promised riches, many rank-and-file employees were paid poorly. Meager salaries were supplemented by selling goods via the private trade.

At first, porcelain was a by-product of the seemingly inexorable race to establish monopolies on spices, the coveted commodity of early modern Europe. Porcelain functioned as ballast to balance ships, filling in the gaps of space that were originally reserved for the cloves, pepper, and more lucrative substances found on ships. Early explorers simply happened to stumble upon it during voyages to China. The Venetian merchant Marco Polo, who traveled to China during the Yuan dynasty (1271–1368) from 1271 to 1295, mentioned porcelain in his travel memoir, which was read hundreds of years later: Christopher Columbus ordered a copy, taking notes in the margins on "spices, gems, silks, ginger, pearls, and other merchandise."[9] The Venetian provided one of the earliest descriptions after traveling to Jingdezhen, in modern-day Jiangxi Province. He remarked that bowls could be bought cheaply, and were made in copious amounts, with vessels "stacked in huge mounds and then left for thirty or forty years exposed to wind, rain, and sun" so that "when a man makes a mound of this earth he does so for his children."[10] After the Portuguese had seized Goa in 1510, Malacca in 1511, and Hormuz in 1515, the Portuguese king Manuel I sent an embassy to the Chinese capital in Beijing, which initiated the earliest pieces of porcelain made for a European commission.[11] In an example dating to about 1520–40, a ewer bears the upside-down arms of Manuel I.[12] The remains of the handle possibly once formed a fish tail, now jutting out of the side of the bulbous ewer like a pair of puckering, veined lips.[13] While the wrongly positioned armorial may have indicated Chinese makers' early mistranslations of European designs, the Portuguese were no less confused about porcelain production. In 1569, the Dominican Gaspar da Cruz wrote, "There are many opinions . . . about where this porcelain is made, and touching the substance of which it is made, some saying of oyster-shells, others of dung rotten for a long time."[14] Joseph Justus Scaliger further conjectured their ties to cowries, or "umbilical shellfish": "Eggshells and the shell of umbilical shellfish (named porcelains, whence the name) are pounded into dust, which is then mingled with water and shaped into vases. These are then hidden

underground. A hundred years later they are dug up, being considered finished, and are put up for sale."[15]

In early modern Europe porcelain materialized the strange and the marvelous. The making of porcelain defied reason, and Europeans' understanding of the division between the natural and artificial worlds. By the late sixteenth century, Chinese porcelain could be found scattered across the globe, from the Manila galleons that brought Ming porcelain to Mexican monasteries, to the shards of blue and white that washed upon the shores of remote islands in Southeast Asia.[16] Travelers marveled at how it had ended up where it was. When Peter Floris arrived in the Andaman Islands in the Bay of Bengal in 1613, he was surprised to find on the shore "a greate percell of broken porseleyn of all manner of sortes. . . . From whence it was come wee coulde not knowe, for wee sawe no signe att all of any hunkces or shipps which might there have been caste awaye."[17] Seemingly evoking the later cargo cults of Melanesia, inhabitants of eastern Indonesia endowed the porcelain washing upon their shores with magical properties, as a "talismanic substance to be comprehended in exalted terms."[18] Early examples of porcelain entered European courts by way of Islamic rulers, with the Rasulid dynasty in Yemen and the Mamluk sultanate in Egypt sending diplomatic gifts of porcelain to courts in Venice and Florence.[19] By 1555, the Medici family inventories listed several hundred pieces of porcelain. Cosimo I de' Medici's obsession with the material led him to send an agent, Jacopo Capponi, in 1545 on a mission to Alexandria to acquire porcelain and carpets, and eventually to establish a porcelain-making workshop at his court in Florence, with the aid of the designer and architect Bernardo Buontalenti.[20] As Clare Le Corbeiller observed, the Medici workshop porcelains reveal the influence of Iznik floral designs alongside Chinese motifs, suggesting the key role that Islamic mediation played in the designs of export porcelain, seen in a dish with two dragons from around 1640 from Iran (pl. 3). Islamic motifs are discernible in a floral garden that encircles a dish made at the Medici workshop, with two travelers in hats traversing the distance between the sun and the moon (pl. 4). According to Medici court records, porcelain forms were often mounted in precious metals, suggesting that such objects were displayed in *Kunstkammers*, which incorporated natural specimens from around the globe with artificial forms of technology, art, and wonder as demonstrations of princely power and knowledge.[21]

Grotesques, hybrid creatures named after the discovery of Roman paintings in the Domus Aurea, which was mistakenly believed to be an underground grotto or cave, served as decorative motifs for many Medici porcelain vessels. Sculpted elements, such as the pair of harpies found on either side of a Medici porcelain ewer, or *brocca*, further animated the decorations (pl. 5). They reinforced porcelain's associations with hybrid monsters. Etymologically speaking, porcelain is a form of catachresis, a misused word, a corruption. The philosophical speculations on the origins of porcelain, and how it was made, often

Fig. 13. Detail of pl. 5

tend to veil its linguistic connections to a denigrating term for female anatomy. In Venetian slang, the word *porcellana* (little pig) was used to refer to cowrie shells, harvested by early European traders as forms of money, used to buy enslaved Africans, with slits that resembled the vulva.[22] Edmund de Waal writes: "The name of this grandest of commodities, this white gold, the cause of the bankruptcy of princes, of *Porzellankrankheit*—porcelain sickness—comes from eye-stretching Venetian slang, the vulgar wolf-whistle after a pretty girl. Porcellani, or little pigs, is the nickname for cowrie shells, which feel as smooth as porcelain. Cowrie shells lead, obviously, to Venetian lads, to a vulva."[23] The sexual violence encoded in this misogynistic street word, reducing a woman's body part to a piece of pork or money, could be found across porcelain objects made for the European market. Twisted examples of porcelain's ties to the sexualized language of conquest include the mermaid sweetmeat dishes made by the Doccia porcelain manufactory in the eighteenth century, long after the Medicis' own homemade recipe had been surpassed by Meissen's discovery of hard-paste porcelain in 1709 (pl. 6). Her head pulled back and mouth agape, the figure's clawed hands grasp at the shell base that would have served as a container for delicacies to be tasted. Doccia specialized in contorted mermaid figures, making an entire troupe of writhing maritime creatures for the table, perhaps intended to imaginatively evoke porcelain's ties to the "fruits" of the sea (pl. 7).

By contrast, the mermaids featured in Jen Liu's video *The Land at the Bottom of the Sea* function as perturbing afterimages of these eighteenth-century porcelain figures. They are aimless, hungry ghosts abandoned by a world seemingly interconnected through technology (pl. 8). Rather than serving as symbols of fortune, the mermaids swim through a dystopian world at the bottom of the sea, generated when the artist prompted AI chatbots to imagine the scenario after she typed in the words, "The day I was liquidated, . . . I"[24]

Mermaids, often interchangeable with sirens, also appear on the mounts that ensnare the blue-and-white Chinese porcelain vessels found at Burghley House, possibly once in the possession of William Cecil, Lord Burghley, who served as the Lord High Treasurer and closest adviser to Queen Elizabeth, or by his son Robert, an avid porcelain collector and privateer.[25] The blue-and-white "Burghley porcelains" date to the Wanli period of the Ming dynasty, typical of "folk ware" designs made for the domestic market, although the shape of the ewer shows the influence of the Islamic market on Chinese designs (pl. 9). Direct access to porcelain eluded England well into the 1580s; until then, much of it reached the island nation through "indirect and devious routes," primarily through the poaching operations that violently seized the ships of enemy nations. The spoils were divided among armed privateers and investors back in England. In 1582, Queen Elizabeth received a gift similar to the covered porcelain cup mounted in silver by the English silversmith Affabel Partridge (pl. 10). Known as a *kinrande* design, an ornate gold brocade pattern once ornamented the red ground cup originally intended for the Japanese market

and decorated with a blue-and-white motif on the interior.[26]

Access to rarities meant power. In England, exotic goods like porcelain had strategic significance for Queen Elizabeth, whose ability to rule the country as a woman was continually questioned, even as she was recognized as the Protestant heir to the Tudor throne of her father, Henry VIII, after the death of her Catholic sister, Mary.[27] In a country rife with civil unrest over religion, art helped to show England's power abroad, with each foreign diplomatic gift another notch in the symbolic global reach of the country's power beyond its island borders.[28] Silver mounts physically elevated vessels, with tooled feet and cast handles adding a material layer to their worth as status symbols. They also domesticated foreign motifs by containing them in more culturally legible forms, turning a simple bowl shape into a prestigious object with two handles. A notable example is the Burghley porcelain bowl decorated with an underglaze blue phoenix, a higher quality production made by an imperial workshop (pl. 11). The vessel is marked by the distinctive handles in the shape of a mermaid with entwined tails; the caryatids intimately hug the surface of blue-and-white porcelain, joining bands of silver on the lip and foot of the bowl with the phoenix decoration. Made by an English workshop about 1585, the silver gilt mounts demonstrate a keen awareness of the cosmopolitan tastes of European courts for grotesques. Inspired by Antwerp craftsmen, the silversmith probably relied upon the engraved patterns that circulated throughout workshops. The designs of Jacques Androuet du Cerceau, Johann Theodor de Bry, and other Continental printmakers worked in

Fig. 14. Johann Theodor De Bry (Netherlandish, 1561–1623). Title page from *Des Pendants de cleffs pour les femmes, 1580–1600*. Engraving and blackwork, sheet 3 ⅝ × 1 ⅛ in. (9.2 × 2.9 cm). The Metropolitan Museum of Art, New York, The Elisha Whittesley Collection, The Elisha Whittesley Fund, 1951 (51.501.5783 [1])

the idiom of grotesques, proposing hybrid, otherworldly figures inspired by classical antiquity as forms of decoration from knife handles to silver key rings (fig. 14).

European mounts turned porcelain vessels into display objects, the precious metals conferring the shine of prestige and the certainty of material value to an alien blue-and-white material with unstable cultural meanings. A silver-gilt mermaid mount encases the largest bowl in the group, not originally listed in the Burghley sale of 1886, but stylistically associated with the other pieces (pl. 12).[29] One of the caryatid straps features a female figure with exposed breasts and arms crossed tightly against her torso. Surrounded by fruit and hair aloft, she glances off to the side, an iconographic mélange of fecundity and chastity that mirrors Queen Elizabeth's image as an impregnable "virgin queen" who defended England's borders.[30] A carved and gilded mermaid can be found in one of the most famous portraits of the queen, known as the Armada portrait (1588), which commemorated Spain's thwarted attempt to invade England (fig. 15). The queen is seated between two windows with her

Fig. 15. Unknown artist. Armada portrait of Elizabeth I, 1588. Oil on oak panel. Woburn Abbey, England

hand on a globe, as English ships sail in calm, blessed waters in the left window, toward the Catholic Spanish ships buffeted by a Protestant wind.[31] Interpretations of the aquatic creature featured in the portrait are manifold. Some scholars have seen it as a symbol of unbridled female sexuality and a foil for Elizabeth's virginity. Others have seen the mermaid, pictured in profile with armor-like scales, as a representation of the queen's own sirenic qualities, since "she exercised power through alluring others and then eluding them."[32]

Beyond mermaids as mounts, sirens figure as subject matter on a porcelain teacup and saucer made around 1700 in Canton for export to the Dutch market (pl. 13). The design that is repeated on the saucer shows the ship of the Greek hero Odysseus sailing on the other side of a mermaid with loose hair and an enormous tail curling out of the water, who plays a musical instrument. Given the circular format of both cup and saucer, it is difficult to determine if the ship is pursuing the creature or evading it. In the *Odyssey*, the ancient Greek tale describes "two creatures that sit in an island-meadow and enchant men with their clear song."[33] Hovering over the head of the figure on the saucer is a banner that announces, in French, "beware of the siren." Writers in antiquity described sirens as creatures with wings that gained a fish tail in the Middle Ages.[34] In sixteenth-century England, poet Alexander Barclay warned of the sea's dangers, with "Mayrmaydes singing, abusing with their song," while John Lyly described a *Syren* "with a Glasse in her hand and a Combe."[35] These two symbols were associated with "narcissistic vanity, deceptive self-presentation, and a dangerous female sexuality."[36] Even as mermaids acquired long, often blond locks and irresistible beauty among their charms in the course of history, they retained their monstrous qualities. Despite the allure of sirens and mermaids, sailors recognized them as dangerous temptations, unnatural hybrids combining human and fish anatomies. Mythological creatures played an important role in the early modern European imagination for figuring collective fears and fantasies about race, gender, and colonization.[37] Recently, novelist Monique Roffey reimagined a Taino woman named Aycayia, cursed to roam the seas as a mermaid because of other women's jealousies, until a Boston whaler named *Dauntless* captured her after hours of struggle:

> Sea moss trailed from her shoulders like slithers of beard. Barnacles
> speckled the swell of her hips. Her torso was sturdy and muscular,
> finely scaled over, as if she wore a tunic of sharkskin. She was crawling
> with sea-lice. They saw that when her diaphragm heaved, it revealed
> wide slits which were gills and they looked sharp enough to slice a
> finger off.[38]

Despite the language of purity and whiteness that porcelain acquired in Europe, the material was ultimately bound to a world of mixtures. As figures of unnatural hybridity, mermaids and sirens suggested the process of colonial *métissage*, where European male

traders secured routes in Asia by establishing local ties through interracial relationships. The combination of colors found on "Batavia ware," a type of porcelain that consisted of a brown glaze on the outside with blue-and-white decorations on the inside, allegedly catered to the domestic market in the VOC's company town in modern-day Jakarta (pl. 14). Read across the grain, this decoration evokes the cultural mixtures produced in Batavia, which depended upon Dutch merchants marrying and having children with local women in order to establish a stable colonial population in a far outpost of the Dutch VOC. Eventually, it included an imposing fortified castle and bustling market, where merchants traded in goods and slaves (fig. 16).[39] Mixed-race merchant families had direct access to the market in foreign luxury goods, some of which were specifically made for the company and stamped with the monogram that proudly announced the VOC's rightful place in the visual language of blue and white, as if it had always belonged there. Even as the Dutch Republic remained geographically far removed from Batavia, imperial intimacies bound the two localities together, long after the company went bankrupt and dissolved in 1800. Ann Laura Stoler writes that "a relationship between the organization of the

Fig. 16. Andries Beeckman (Dutch, 1628–1664). *The Castle of Batavia*, ca. 1662. Oil on canvas, 42 ½ × 59 ⅝ in. (108 × 151.4 cm). Rijksmuseum, Amsterdam (SK-A-19)

domestic and that of the state together shaped colonial cultures that were at once home-spun and worldly, reformist and racist, and both self-identified as a singular nation—the Netherlands—and pan-European."[40] Indigenous women, who were not permitted to travel to the Dutch Republic, bound VOC trade to local populations made possible by mixed societies in Batavia, where porcelain, fans, leather, and lacquer formed part of the domestic material displays that brought colonial politics into the spaces of the everyday. Porcelain appears in one of the most extraordinary paintings of the period of a family in Batavia. Painted in 1665 by Jacob Coeman, *Pieter Cnoll, Cornelia van Nijenrode, Their Daughters and Two Enslaved Servants* portrays a VOC merchant and his wife, their children, and two enslaved servants, surrounded by the riches of the trade, including a porcelain vase (fig. 17). Cnoll is dressed in the black costume of a merchant, heightened with heeled shoes and gold buttons, tie, and fringe. His wife's ornate dress is decorated with lace and accessories including a brooch, pearl bracelet, necklace, hair ornament, and fan.[41] The portrait is a rare depiction of a mixed-race woman as the wife of a Dutch VOC merchant. Born in Japan to a Dutch father and Japanese mother, Cornelia was sent to Batavia according to her father's wishes

Fig. 17. Jacob Coeman (Dutch, 1632–1676). *Pieter Cnoll, Cornelia van Nijenrode, Their Daughters and Two Enslaved Servants*, 1665. Oil on canvas, 52 × 75 in. (132 × 190.5 cm). Rijksmuseum, Amsterdam (SK-A-4062)

before his death, where she would be brought up a Christian and recognized as part of the VOC community. Married in 1652, Cnoll and van Nijenroode had nine children before his death in 1672; one son survived into adulthood before dying on a ship en route to Holland in 1688, the year of the Glorious Revolution.[42] VOC law recognized that "official acknowledgement by a European father and Christian baptism conferred European status on illegitimate children whose mothers were Asian."[43] Whereas many of the children who resulted from mixed-race unions ended up in far less favorable circumstances, Cornelia is depicted as a racialized subject in the painting, surrounded by the attributes of refinement, in contrast to the two indigenous servants shown in the shadows to the far right of the composition.[44] Such complexities of race, class, and gender were scrubbed from the still life paintings of luxury objects that commemorated the great wealth brought on the ships of the VOC (pl. 15). No traces of the shipwrecks, losses, and violence of the China Trade are detectable in Willem Kalf's still life painting of a Kraak porcelain bowl and luxurious Turkish carpet, with freshly peeled lemon and orange, and glistening glasses filled with liquor (fig. 18).

Little remains of old Batavia, or the many trading cities and settlements that connected Europe to Asia in a complex entangled history of greed, violence, desire, and obsession.

Fig. 18. Detail of pl. 15

Artist Heidi Lau's ceramic pieces engage with these fraught traces of the colonial past, a history that inflects her chosen medium of clay. Lau's *From the Heart of the Mountain Anchored the Path of Unknowing* (2023) is a vertical structure made of glazed stoneware (pl. 16). Collective histories of colonialism are overlaid with the artist's personal memories of growing up in Macao at the moment when the port city, a territorial possession of the Portuguese, was transferred to China in 1999. While visiting her grandparents' home she discovered an ancient Taoist text possibly from the fourth century BCE, the *Classic of Mountains and Seas*, which provided the foundational stories for her totems and creatures made of clay. While reading the text, she encountered creatures and narratives that opened up to new queer and postcolonial readings. Lau conjures the strange, otherworldly forms of shipwrecked ceramics rediscovered centuries after their wreckage. At the same time, the totemic structure evokes the decaying Portuguese monuments in Macao such as the ruins of Saint Paul, a Catholic complex built by the Jesuits in the seventeenth century.[45] Lau remembers that schools taught very little of the colonial past, even as she saw the remaining buildings in a city dominated by the shiny new buildings made for the gambling industry that catered to Asian tourists. Access to high art came not through painting or sculpture, but via the ceramics and decorative arts found in museums, the objects deeply entwined with Macao's past as a center of the luxury trades. "Colonial history in Macao is not talked about. It gets eclipsed in a lot of ways. Sometimes people say, 'Well, there was no culture there to begin with, so what is there to talk about?' And all of that hidden history is buried."[46] Like the ruins, Lau's piece is, in fact, fragile, and needs the support of a wall to stand erect. Such contemporary works cut through the triumphalist histories of porcelain that focus on perfection in Europe's mastery of the arcanum, the secret recipe for porcelain. For at close glance, even a seemingly perfect blue-and-white vase made by Meissen, the first European manufactory to make true porcelain, wobbles unsteadily on its foot, due to a firing flaw (pl. 17).

Lau's totems also have a more personal dimension. Though architectural, *From the Heart of the Mountain Anchored the Path of Unknowing* also resembles a long, meandering spine, molded from the artist's fingers gripping and massaging the clay into organic shapes with holes, chasms, valleys, and malleable folds. The forms, Lau says, "are the remnants of a creature in between architecture, and it's a part of a body, and the creature is trapped by the totem." She began experimenting with these forms in 2009, after the death of her mother from leukemia. Intertwined with the rereading of an ancient Taoist text and collective memories of growing up in Macao as a decaying colonial city are Lau's moving personal memories of her mother, and the feeling of witnessing her spirit release at the moment of her death: "It's both about her and her captivity in the role of motherhood, and her freedom."[47]

1. China, Ming dynasty (1368–1644), Wanli period, before 1613. Kraak porcelain plate from the *Witte Leeuw*

3. Attributed to Iran. Dish with two intertwined dragons, ca. 1640. Stone paste
4. Medici porcelain workshop. Dish, ca. 1575–87. Soft-paste porcelain

6. Doccia porcelain manufactory. Sweetmeat dish, ca. 1750–60. Hard-paste porcelain
7. Doccia porcelain manufactory. Mermaid, ca. 1750–55. Hard-paste porcelain

10. Cup and cover, ca. 1507–66. Porcelain. Gilded silver mounts by Affabel Partridge, ca. 1570

11. Two-handled bowl from Burghley House, Lincolnshire. Chinese porcelain, 1573, British mounts, 1585
12. Two-handled bowl possibly from Burghley House, Lincolnshire. Chinese porcelain, ca. 1573, British mounts, ca. 1585

13. Teacup saucer. Chinese, made for the Dutch market, ca. 1700. Hard-paste porcelain

14. "Batavia ware" beaker and saucer. Chinese, made for the European market, 1700. Hard-paste porcelain

15. Willem Kalf. *Still Life with Fruit, Glassware, and a Wanli Bowl*, ca. 1659. Oil on canvas

16. Heidi Lau. *From the Heart of the Mountain Anchored the Path of Unknowing*, 2023. Glazed ceramic
17. Meissen porcelain manufactory. Vase with cover, ca. 1725. Hard-paste porcelain

SURROGATE BODIES: MARY II, SUCCESSION, AND PORCELAIN OBSESSIONS

Amid early modern England's dynastic crises, porcelain and Delftware emerged as obsessions for Mary II, queen of England and consort of William III, who ascended the throne as co-rulers after the Glorious Revolution of 1688. She devoted her energy to filling the royal palaces she renovated at Kensington and Hampton Court with cups, saucers, *rolwagen* vases, and ginger jars exported from China and Japan, and the latest earthenware imitations by Dutch makers. Soon after her unexpected death from smallpox on December 28, 1694, memories of the queen resuscitated her collection, thanks in large part to Daniel Defoe's *A Tour thro' the whole island of Great Britain, divided into circuits or journies* (1724–27). Upon encountering Mary's private retreat at the Water Gallery in Hampton Court, the writer marveled at "her majesty's fine collection of Delft ware, which indeed was very large and fine; and here was also a vast stock of fine China ware, the like whereof was not to be seen in England."[1] At the same time, Defoe also censured the queen's penchant for foreign goods, above all porcelain, and accused her of creating a fashion among women for "china-ware, which increased to a strange degree afterwards, piling their china upon the tops of cabinets, scrutores, and every chimney-piece, to the tops of ceilings, and even setting up shelves for their china-ware, where they wanted such places, till it became a grievance in the expense of it, and even injurious to their families and estates."[2] Defoe's concern was primarily commercial: he feared the trend for foreign goods would drive money away from local "Trade, and Ruining our Manufactures and the Poor." He wrote, "The Good Queen, far from designing any Injury to the Country where she was so entirely beloved, little thought she was in either of these laying a Foundation for such fatal excesses."[3]

Seen as the mother who "birthed" the taste for Chinoiserie, Mary's "fatal excesses" of collecting porcelain offers an entry point into rereading how this material was deeply entwined with the anxious discourses of succession and sovereignty in late Stuart England.[4] Mary's fame as a ruler rests primarily on her role as a cultural tastemaker who introduced Dutch fashions for luxury goods that inspired successive generations of English women.[5]

Stuart courtiers quickly used ceramics to signal their allegiance to William and Mary, with the courtier William Blathwayt acquiring blue-and-white Delftware from the Greek A factory for his residence at Dyrham Park, possibly as perquisites, or leftovers from the royal household (fig. 19).[6] Though there were English collectors of porcelain before her, Mary's reign coincided with the appearance of a remarkable range of new vessel shapes, colors, and forms of decoration, including examples of Kakiemon decoration from Japan and new motifs in Chinese ceramics. During the transitional period (1620–80) around the end of the Ming dynasty, women appeared in garden landscapes as decoration on porcelain vases, which replaced more stylized, nonfigurative designs for the court (pl. 18). In China, political uncertainty and the lack of royal patronage led potters in Jingdezhen to use popular genre prints as a way to lure wealthy nouveau-riche clients.[7] In England, Defoe's *A Tour. . . of Great Britain* established lasting connections between Queen Mary and the artificial bodies of china that appeared in the Water Gallery, where she constructed a system of displaying Chinoiserie that reclaimed the decorated interior as a distinctly feminine materialization of power.

Fig. 19. Greek A factory. Garniture of vases with monogram of William III and Mary II, 1690–95. Tin-glazed earthenware (Delftware). Dyrham Park, Gloucestershire, National Trust (DRY/C/63, DYR/C/64)

The European monarchy had traditionally depended upon the concept of the king's two bodies, one mortal and one eternal; the queen's role was to produce an heir, which left consorts, according to one scholar, "pregnant for much of their reign and reinforced their primarily corporeal, expendable image."[8] Fecundity was thus a common theme in paintings of queens, including Willem Wissing's portrait of Mary from around 1686–87 (pl. 19). Her low-cut dress, edged in lace and jewels, emphasizes her milky white décolletage. She gently fingers a curl of hair near her breast. To the far right of the composition, an orange tree in an urn alludes to her marriage to William, then still Prince of Orange, while a honeysuckle on the right evokes bonds of love. Wissing had in fact made an earlier depiction of Mary wearing a veil, a symbol of chastity, but replaced it with the version of her holding her tresses and the rose to tie her image to Venus, goddess of love. Here, luscious hair, rose, and ruddy complexion together signify Mary's body as a vessel capable of carrying the next Stuart heir.[9] Though she did not ultimately produce a successor, she gave birth to something else: what Defoe called the "fatal excesses" of collecting porcelain, a medium associated with the foreign, the unnatural, and the excessive. Mary not only had two bodies, as both mortal woman and queen, but three. The third body was artificial, inanimate, multiple, heterogeneous, amassed, and purchased: the third body was porcelain.

The oldest surviving daughter of James II and Anne Hyde, Duchess of York, Mary was depicted in a secondary role to her brothers in her youth, since the Stuarts had pinned their political ambitions on a male successor. Mary was thus seen, according to historian Catriona Murray, as primarily a "daughter, wife, and potential mother."[10] After her mother died in 1671, followed by her brother Edgar, the last hope for a Protestant male heir, her father's secret conversion to Catholicism became public. During the Exclusion crisis (1678–81), parliamentary debates focused on the threat that James II's subsequent marriage to Mary of Modena would lead to a Catholic heir to the Stuart throne.[11] Though it had been one hundred years since the Tudors had broken ties with the pope, tensions remained between Catholics and Protestants, as they continued to fight over the religion of England's rulers. Charles II made Mary and her sister Anne children of the state and placed Henry Compton, Bishop of London, in charge of their religious upbringing. Mary and Anne's meager education contrasted with the more robust humanist education that the Tudor queen Elizabeth I received. Instead of reading the classics and learning to read Latin, Mary took lessons in dancing, music, and needlework, with some schooling in religion and French.[12]

Women's domestic arts such as embroidery and needlework were traditionally viewed as inferior to the masculine art of politics. Yet it was within these realms of production that an alternative language of decoration, including Chinoiserie, stoked women's imaginations. *Japanning*, a term that had little to do with Japan itself, described the decorating of objects and furnishings by cutting, pasting, and lacquering. It was directly marketed to women in the seventeenth century in books such as John Stalker and George Parker's *A Treatise of Japanning*

and Varnishing . . . (ca. 1688) (pl. 20). Dismissed as a superficial, frivolous activity, the closely related activity of needlework constituted a pathway of female applied knowledge, a means of changing the storyline of biblical lessons, rote memorization, or manuals on wifely duties. Women often assembled complex patterns and designs into the decorative borders of mirrors, furnishings, caskets, and other prized and costly possessions in a home, such as an example incorporating the biblical story of Jael, the heroine of the Book of Judges, who aids Barak and the Israelites by killing Sisera of Canaan with a tent stake (pl. 21).[13] The biblical story wraps an object associated with women's vanity in a didactic, moral surrounding of female exemplarity. Though professional hands often made such elaborate mirrors, more eccentric figures on the embroidery suggest that the mirror may have been tailor-made by and for a woman. At the top, Charity appears somewhat beleaguered while nursing two fussy children around a canopy. By contrast, her counterimage below is a serene mermaid. A warning against sexual seduction and vanity, the mythical creature nonetheless appears surprisingly self-possessed, taking the time to slowly comb her long wet hair as she gazes contemplatively into a mirror while swimming alone in a lagoon.[14]

Though acquired rather than made by the owner, porcelain gained personal associations among women collectors such as Mary. She developed a taste for foreign luxury after she married her cousin, William, Prince of Orange, and moved to Holland in 1677.[15] Subsequent depictions of the couple tended to portray them as equals, as seen in the many Delftware plates that celebrated their reign as king and queen of England (pl. 22). They were, however, opposites. One historian sardonically wrote that, whereas Mary was "tall and graceful," and someone who "was thoroughly extrovert, enthusiastically indulging in the latest beauty treatments (bathing in asses' milk for example) and running up astronomical dress bills," her husband William was "dour, short, bisexual, asthmatic and chillingly formal."[16] Only fifteen years old when she set sail for the Netherlands to marry her cousin, she "wept grievously all the morning."[17] Despite this inauspicious start, Mary quickly adapted to her new home, which was smaller and less grand than the Restoration court of her uncle Charles II. In Holland, she was actively involved in renovating the many Orange residences, and worked with the Huguenot designer Daniel Marot to create a Baroque vision that became strongly associated with William and Mary's Protestant reign. A centerpiece of these renovations was porcelain displays, as shown in the prints of Marot's designs (pl. 23). During her time in Holland, Mary established contacts with Delftware factories, including Het Moriaanshooft and *De Grieksche A*, or Greek A, which produced monumental vases for her residences. Translating architectonic forms into ceramic objects brought the language of Chinoiserie to bear upon these structures. A contemporary visitor to Honselaarsdijk, an Orange palace near The Hague, described her audience room as "richly decorated with Chinese work and pictures. The ceiling was with mirrors, so that the perspective was extended endlessly. The chimney was full of precious porcelain, part standing half inside it, and so fitted together that

one piece supported another."[18] Mary would bring a similar system of display to the Water Gallery at Hampton Court.

Chinoiserie decoration was a specialty among the women in the House of Orange, initiated by William III's grandmother Amalia van Solms (fig. 20). The wife of Frederick Henry, Prince of Orange, Amalia is widely credited for transforming the princely Renaissance *Kunstkammer* collections, which combined porcelain with examples of *artificialia* and *naturalia*, into Baroque interiors that displayed massed porcelain groups known as garnitures, assembled sets of three, five, or seven vessels.[19] Family inventories indicate that Amalia was the porcelain collector, as they were only listed in her living spaces, initially arranged as a *Kunstkammer*: in 1632, three porcelain cups were located alongside Japanese lacquer boxes, rock crystal, and silver pieces by Adam van Vianen at the Hague residence. Two years later, the inventory listed an additional "set of shelves with three tiers, painted red and gilded, upon which to place porcelain, intended for Her Excellency's gallery."[20] A rare surviving lacquer room made for the Leeuwarden residence of Henriëtte Amalia von Anhalt-Dessau, granddaughter of

Fig. 20. Gerard van Honthorst (Dutch, 1592–1656). *Frederick Henry, His Consort Amalia van Solms, and Their Three Youngest Daughters*, ca. 1647. Oil on canvas, 103 ¾ × 137 in. (263.5 × 347.5 cm). Rijksmuseum, Amsterdam (SK-A-874)

Amalia, evokes the spectacular effect of the glossy material of Coromandel screens, a type of lacquerware, imported by the VOC from China (fig. 21). Such large screens were cut up and repurposed to serve as wainscoting, while in England, the furniture maker Gerrit Jensen transformed sections into other pieces including mirrors (pl. 24).[21] Mary appears to have been an enthusiastic consumer of lacquer. However, Constantjin Huygens, the eminent statesman and secretary to the *stadhouder*, wrote to her criticizing the practice of indiscriminately cutting up the screens while disregarding the Chinese texts on them. The screens were "divided, cut, and split asunder and reduced to a heap of monstrous shivers and splinters."[22]

Porcelain formed part of the maternal lineage of the House of Orange, movable goods passed down from mother to daughters, in contrast to the male inheritance of titles, lands, or residences. Amalia's daughters carried on the tradition of creating porcelain and lacquer rooms. Her daughters formed strategic marriages with the Protestant royalty in the Netherlands and Germany, bringing with them parts of their mothers' porcelain collection,

Fig. 21. Lacquer room made for the Court of the Stadhouders at Leeuwarden, before 1695. Rijksmuseum, Amsterdam (BK-16709)

and her love of incorporating Delft tiles into summer kitchens, where making jams and milk products were acceptable wifely duties.[23] Her older daughter Louise Henriette created one of the most magnificent porcelain rooms in Brandenburg at Oranienburg Palace, in homage to the House of Orange.

When Mary returned to England to take the throne in 1689, she described feeling a sense of estrangement upon arriving in her country of birth: "I did not sleep the whole night, but lay thincking [sic] how much I should suffer in leaving a place where I knew how happy I could be, I knew the persons and way of living, I had some reputation in that condition which I did not know if I could maintain in my own country where I was now grown a perfect stranger."[24] Mary returned to her home country at a perilous moment for the Stuart monarchy. Parliament sought to create the appearance of a natural and legitimate succession of power from the deposed James II to the new rulers, though it was far from the truth. Gender was at the heart of the debates on Stuart succession. A group of Tories argued that Mary alone should serve as regnant queen, citing the unfounded rumors that James's Catholic son was illegitimate and that Mary was in fact the sole and rightful Protestant heir to the throne.[25] Her supporters in the House of Commons made reference to Queen Elizabeth I, and said that women could rule "gloriously," while the opposing side encouraged others to "chuse a King to go before us & fight our battells, ... [which] a Woman cannot so well do."[26] The solution was a dual monarchy, at least in theory; unofficially, Mary was subordinate to her husband. This status was reflected during the coronation ceremony on April 11, 1689, when William was anointed and crowned first.[27] While William was away fighting on military campaigns, however, she was given executive authority to rule on his behalf.[28] To the public, Mary played a vital role in securing support of the Stuart throne because she offered hopes of a new heir. It is thought that she had one or two miscarriages in 1678, with the second possibly having rendered her infertile, although she still sought to conceive as late as 1691.[29] Despite these private losses, portraits of the queen continued to emphasize her youthful beauty, to suggest that she was still able to bear children.

Against the intense pressures of the crown, Mary II sought a space of private refuge. Shortly after arriving, the couple chose to move to Hampton Court, away from Whitehall because the smog was affecting William's asthma. They also purchased Kensington Palace in summer 1689 from the Earl of Nottingham as a winter retreat closer to Whitehall in London.[30] Mary personally sought to oversee the renovations, writing:

> I had very little time to myself, which grieved me, and I was so unsettled
> at Holland House, I could not do as I would. This made me go often to
> Kinsington to hasten the worckmen, and I was to impatient to beat that
> place, imagining to find more ease there. This I often reproved my self for
> and at last it pleased God to shew me the uncertainty of all things below;
> for part of the house which was new built fell down. The same accident
> happened at Hamptoncourt.[31]

One of the defining features of renovations at Kensington consisted of her sizable ceramics collection: nearly 350 pieces of Japanese and Chinese porcelain were located above doors, chimneypieces, pedestals, above the cabinets and under them.[32] Mary's tastes are visible in the drawings that carver Grinling Gibbons prepared for Hampton Court (pl. 25). Large vases clamber for space on the mantel, with teapots, miniature vases, and larger vases massed together. Cups and saucers on the cornice create a visual rhythm, while Gibbons framed small gilded shelves containing smaller vessels with wooden carvings of drapery. Even before the renovation work was completed, Mary had begun incorporating her porcelain collection at Kensington. Gibbons's drawing suggests the range of sizes represented in her collection, corroborated by inventory records. Pieces included small, medium, and large vessels, and several Guanyin figures in blanc de chine or white porcelain from Dehua, some of which were described as "white fine figures of women," while others were "white fine figures being women each with child."[33] An early adopter of Japanese porcelains, she also owned pieces of Kakiemon porcelains, similar to the sparsely painted palette of delicate blues, reds, and greens seen on a pair of lidded jars (pl. 26).[34] She valued her porcelain so highly that when a fire broke out at Kensington in 1691, the "king went to his Cabinet to reassure himself that his paintings were in safety, and found that they had already been carried out into the garden, together with Mary's porcelain."[35]

Alongside porcelain, Delftware shaped the vision of the Water Gallery, a space that was all Mary's own. Originally built in 1536 as a recreational space on the edge of the Thames for the Tudors, it had been most recently occupied by Charles II's scandalous mistress Barbara Villiers, the Duchess of Cleveland, who in the 1670s had used it as a bathing room and dairy.[36] Mary had it tailored to suit her own tastes, with Defoe writing that "she order'd all the little neat curious Things to be done, which suited her own Conveniences, and made it the pleasantest little Thing within Doors that could possibly be made."[37] He went into detail describing the interior. It included a "Gallery of Beauties," with full-length portraits of her female attendants. The apartment "for her private Retreat only" was "exquisitely furnish'd; particularly a fine Chints Bed, then a great Curiosity," alongside "her own Work, while in Holland, very magnificent, and several others." The text suggests that the queen embroidered the textiles herself. Defoe paid particular attention to the ceramics: "and here was also her Majesty's fine Collection of Delft Ware, which indeed was very large and fine; and here was also a vast Stock of fine China Ware, the like whereof was not then to be seen in England; the long Gallery, as above, was fill'd with this China, and every other Place, where it could be plac'd, with Advantage."[38] Below, the Water Gallery also included a bathing room and a dairy, spaces in which "her Majesty took great Delight."[39]

In some ways, the Water Gallery could be perceived as a showcase of power. Mary II would have been aware of Louis XIV's Trianon de Porcelaine, a Chinese-inspired structure fitted with blue-and-white faience tiles, built by Louis Le Vau for the king's trysts with his

mistress Madame de Montespan, as well as the Hall of Mirrors, which had just been completed at Versailles in 1684.[40] Travel writer Celia Fiennes further described the Water Gallery's spaces, noting that the upper level had a balcony that opened onto the Thames River. The gallery was

> decked with China and fine pictures of the Court Ladyes drawn by Nellor: beyond this came several roomes and one was pretty large, at the four corners were little roomes like closets or drawing roomes one pannell'd all with Jappan another with Looking Glass and two with fine work under panels of Glass: there was the Queen's Bath and a place to take boat in the house.[41]

Cabinetmaker and glass seller Gerrit Jensen was paid 171 pounds for "glasses for the Glasse Closett in the Water Gallery and Queen's Bedchamber next to the Bathing Room," while Jacob Bogdani was paid "for work by him done in the Queen's Looking Glasse Clossett in the Thames Gallery."[42] The mirrors were probably positioned across from the portraits of the attendants, so that their images were reflected, creating an infinite extension of beauty, not unlike the way that the Hall of Mirrors at Versailles functioned to reflect and extend the king's realm outside the palace. The "fine work under panels of Glass" probably referred to the eight extant embroidery panels, decorated with the same Marot grotesques found in his printed designs, perhaps the same that Defoe had recognized as "her own Work" (fig. 22). When Fiennes revisited Hampton Court in 1701 and 1703, she described "hangings, chaires, stooles and screen the same, all of satten stitch done in worsteads, beasts, birds, images and fruites all wrought very finely by Queen Mary and her Maids of Honour."[43]

Enormous pieces of Delftware were custom-made for the gallery. A pair of monumental ewers on stands echoed classical forms used for outdoor garden vases typically set on balustrades (pl. 27). More inventive forms included a pyramid vase with multiple spouts for flowers, decorated with the bust of William III, as well as peacocks (fig. 23). The presence of William III on the base of the tall, pyramidal vase is curious. Delftware was a strange medium to commemorate her husband, bringing the king's presence into the space while commingling it with other motifs such as the peacock. While Mary was at Hampton Court, her husband would have been fighting battles abroad, so perhaps the vase was a way to recall him while he was far away. Nonetheless, the unusual medium and shape of the vase, with its multiple spouts and exuberant decoration, were a far cry from the military battle paintings, marble busts, or medals that were the period's more typical language of masculine virtue and power.

Instead of the architectural, absolutist grandeur of Versailles, the material splendor of Mary's space formed a contrast to the inhabited, indistinct exterior of the former Tudor structure. The Trianon de Porcelaine was meant to be seen from the outside; the Water Gallery could only be experienced by walking within the interiors, which had been shaped

Fig. 22. Detail of one of eight wall hangings after designs by Daniel Marot (French, 1661–1752), ca. 1680–1720. Wool, embroidered with colored wools. Royal Collection Trust (RCIN 28228)

by and for the queen's pleasure. Rather than foregrounding the instruments of domination, possession, or objectification, the combination of beautiful women and the reflective and ornamental variation of mirror, lacquer, porcelain, and Delftware created a space of private enjoyment and curiosity, where a woman could explore the range of surfaces and objects and textures. In particular, the Water Gallery's arrangement of paintings suggests a subversion of the display of power by using the mirrors to reflect the image of women ad infinitum. The eight full-length paintings of statuesque beauties by Godfrey Kneller included Diana de Vere, Duchess of Saint Albans, who grasps an orange in reference to the House of Orange (pl. 28).[44] The narrow format of Mary Bentinck, Countess of Essex, coupled with the outdoor scene, suggests that the painting may have been hung at the transverse end of the gallery (fig. 24). The portraits recalled the Windsor Court beauties, a series that Peter Lely had painted for Mary's mother, Anne, Duchess of York, which hung in Windsor Castle in 1688.[45] Scholars have interpreted the images in the Water Gallery as the prudish second generation of the Windsor set, with Kneller's figures misogynistically characterized as

"more upright, less sexually available."[46] Yet on another level, the portraits channeled the earlier commission undertaken by Mary II's mother, Anne, securing a bond to her maternal ties (rather than to her disgraced father).

The queen's body most explicitly shaped the subterranean spaces of bath and dairy. The tiles by the Greek A factory with designs by Marot featuring William III were probably set into a vertical pattern of eight tiles, bringing a sense of grandeur to a space typically associated with the feminine pastoral pursuits of making jams, creams, and milk. Mary even commissioned a series of milk pans from the factory that transformed a quotidian object into elevated blue-and-white wares (pl. 29). Female rulers in early modern Europe had used dairies as symbolic spaces tied to fecundity. Earlier, at Mi-voie, French queen Catherine de' Medici's rural retreat, she created a "beautiful dairy, in order to amuse herself, keep cool, and consume milk products during the summer."[47] As Meredith Martin notes, the dairy "underscored her contribution to the state as distinctly feminine and maternal, initiating an architectural language of female political agency."[48] During the French Renaissance, nature was frequently pictured in the guise of a multi-breasted maternal figure associated with the ancient goddess Cybele. The Italian sculptor Niccolò Tribolo carved an example of *La Nature* for the French king Francis I with her arms raised, nourishing France with her body of abundance (fig. 25).[49] However classical in inspiration, the multiple teats lend such figures a sense of the animalic, which artist Louise Bourgeois later recognize in her surreal porcelain sculpture of a headless beast in *Nature Study* (fig. 26).

Importantly, the Water Gallery grafted the language of Chinoiserie onto the discourse of fertility that had shaped the symbolic meanings of the dairy. Seen through the prism of the pressures to bear an heir, Mary's accumulation of porcelain and Delftware acquires a different significance. On the one hand, the multitude of Delftware pieces aligns with the images of abundance and fruitfulness that were meant to signify the powers of procreation. Yet these ceramic bodies were distinctly unnatural. The monstrous lurks, even in the visually regal flower pyramids with the images of William, where the Chinoiserie fantasies have been replaced with classicized motifs that draw from Marot's work, from the clawed feet at the base to the grotesque faces with sucking orifices. In fact, the pyramidal forms could be seen as inversions of Tribolo's *La Nature* with disembodied, suckling mouths replacing the vertical abundance of swollen breasts.

The blue-and-white medium of Delftware troubles the language of maternal nurturing to which the royal dairy had been bound, by inserting a medium of the artificial and the strange into the language of the natural. Indeed, the Water Gallery appeared at a turning point in metaphors of the maternal body, which was increasingly read in terms of the generative powers of capitalism. A medical treatise from 1694 described pregnancy in terms of a shipping vessel, not unlike the VOC ships laden with porcelain: "The Impregnant Woman, embarques upon a Voyage so long and perilous through such rough and rocky seas . . . that

Fig. 23. Greek A factory (Dutch, 1658–1722). Proprietor Adrianus Kocx (Dutch, act. 1689–1694; d. 1701). Pyramid vase with bust of William III (one of a pair), ca. 1689–99. Tin-glazed earthenware, 58 in. (147.2 cm). Royal Collection Trust, London, acquired by Queen Mary II prior to her death in 1694 (RCIN 1085)

she needs all careful Conduct to save her from these Rocks, upon which else, she . . . lyes miserably Split (especially if more britle and heavy Laden, whome the smallest Blast and Shake easily Shipwracks, sometimes most suddenly, yea, while also near the Harbor)."[50]

Jennifer Ling Datchuk's porcelain work *Pretty Sister, Ugly Sister* disrupts the narrative that would have reduced Mary to an instrument of biological reproduction alone (pl. 30). In the Water Gallery, it is possible to see Mary engendering, on her own terms, a space of fecundity that did not depend upon the pressures to produce an heir, but rather upon the surrogate, highly unnatural and artificial bodies of porcelain. Artifice is also powerfully staged in Datchuk's piece. Two white, breast-like porcelain plaques are positioned upon the wall next to each other, sisters that resemble each other but are nonetheless different. On one oval composition, the artist dyed her hair blue and threaded it through the

Fig. 24. Sir Godfrey Kneller (German-British, 1646–1723). *Mary Bentinck, Countess of Essex*, ca. 1690–91. Oil on canvas, 91 11/16 × 44 in. (232.8 × 112 cm). Royal Collection Trust, London (RCIN 404725)

Fig. 25. Niccolò Tribolo (Italian, 1500–1550). *La Nature*, ca. 1528–29. Marble, H. 45 1/4 in. (115 cm). Musée national du château de Fontainebleau (MR SUP 56; MR 3570)

porcelain body in order to create a delicate floral embroidery pattern, reminiscent of the kinds of pretty, domestic needlework women such as Mary would have performed. Not quite whole, but rather composed of discrete parts, *Pretty Sister, Ugly Sister* can be read as part-objects. This psychoanalytic term is used to indicate the ways in which infants first perceive the world not as a whole environment, but in terms of what psychoanalyst Melanie Klein described as immediately accessible part-objects, such as the breast, through which the infant meted out acts of aggression and love by gnawing, sucking, and biting.[51] Hair functions as a part-object in Datchuk's work, overturning the associations of fertility and sexuality found in Wissing's portrait by revealing its abject side, once it is no longer attached to the head. Drooping strands of blue tresses have been threaded through the same pattern of flowers, creating an eerie pendant to the shorn version on the left plaque. Juxtaposed with memories of porcelain collecting, Datchuk's work envisions porcelain as an abnormally regenerative medium, another body for rethinking the possibilities of growth and beauty through artificial means.

Fig. 26. Louise Bourgeois (American, 1911–2010). *Nature Study*, 1996 (cast 2004). Unglazed biscuit porcelain, 28 ¼ × 16 ¼ × 12 in. (71.8 × 41.3 × 30.5 cm). Courtesy Phillips auction house

18. China, Qing dynasty (1644–1911), Kangxi period (1662–1722), late 17th–early 18th century. Vase with women enjoying scholarly pursuits. Porcelain

21. Mirror with Jael and Barak, 1672. Satin and mixed media

22. Charger with double portrait of William III and Mary II. Dutch, 1690. Tin-glazed earthenware (Delftware)

23. Daniel Marot. Chimneypiece with various porcelain vases, from *Nouvelles cheminées faittes . . . ,*
1703 or 1712. Etching

26. Hexagonal jars (a pair). Japan, late 17th century. Porcelain with overglaze enamels (Arita ware, Kakiemon type)

30. Jennifer Ling Datchuk. *Pretty Sister, Ugly Sister*, 2014. Porcelain and hair

SPILLING TEA: PERFORMING POLITENESS AND DOMESTICITY

A taste for tea arrived in England on May 13, 1662, on a Portuguese ship bearing Catherine of Braganza, the Catholic bride of Charles II. The marriage was strategic: The king had no interest in her, choosing to spend most of his time with his mistresses. Yet, the union brought England access to free trading rights in Brazil and the Portuguese East Indies, and the rights to the port of Bombay, which helped to secure the East India Company's power in the region.[1] As soon as the Portuguese *infanta* disembarked from the ship in Portsmouth, the young bride was said to have asked for a cup of tea. According to one historian, "the embarrassed and luckless attendants only had a glass of ale to offer her which did not satisfy the Queen's thirst."[2] In the queen's apartments at Whitehall, surrounded by cane chairs, lacquer cabinets, and calicoes, she taught her retinue of women how to drink tea "solely for pleasure."[3] While Dutch merchants had imported small quantities of tea in the early 1600s, and Jesuit priests who had traveled to China had extolled its medicinal properties, Catherine of Braganza played a key role in introducing the ritual of drinking the leaves of the *Camellia sinensis* plant into female society, where it became an ingrained part of women's domestic spheres and rituals of politeness.

Tea was a primary vehicle for Chinoiserie. The mythology of tea in Britain, and the ritualized performances of serving, drinking from, and displaying "china" sets constructed gendered stereotypes while also providing forms of agency for women during the seventeenth and eighteenth centuries. Consumption and taste naturalized this foreign commodity into a fully English habit, a process of domestication that took place in parallel with the transformation of porcelain from a coveted luxury good to a part of daily life. Through the art of tea, domestication and naturalization of the foreign took place in tandem with women playing host to newly acquired rituals. The demand of empowered female consumers for porcelain things, decorated to excess in the Chinese taste, was blamed for the economic ruin of the nation, calling to mind Daniel Defoe's criticism of the "fatal excesses" of Mary's porcelain collecting, which contained the threat of an unbridled female desire that conflated

"sexual and material appetites."[4] Conversely, tea was seen as a central ritual in the construction of a femininity that was artificial and tightly controlled in the domestic sphere of politeness. A close look at the history of tea reveals that the practice was not only about politeness; it could equally well conjure a world of unbridled appetites.

Tea began as a rare commodity enjoyed by the courtly elite that surrounded Catherine of Braganza, its preciousness and high price indicated by the small size of early teapots, such as the diminutive Dutch redware example made by Arij de Milde, in imitation of Chinese Yixing clay, a red stoneware (fig. 27). Initially, imported Chinese teapots also featured in wall displays. The 1688 inventory at Burghley House for a mantel shelf garniture belonging to Anne, Countess of Exeter, described "I brown and white relev'd tea pott with gilt handle, spout top and bottoms and a little figure and chaines on the top of it," along with "I white tea pott and cover, guilt spout and chaine to it," the latter suggestive of Dehua vessels, possibly a wine pot that appeared in European collections in the late seventeenth century.[5] Tea cups could also be found in lavish toilet sets, specially made cases filled with necessities

Fig. 27. Arij de Milde (Dutch, 1634–1708). Teapot, 1671–1708. Red earthenware with silver mounts, 4 ³/₄ × 7 ⁵/₁₆ × 4 ⁷/₈ in. (12.1 x 18.6 x 12.4 cm). The Metropolitan Museum of Art, New York, Robert A Ellison Jr. Collection, Gift of Robert A. Ellison Jr., 2014 (2014.712.11a, b)

for the toilette. One German example from about 1743–45 includes among several silver-gilt items, such as a mirror, ewer and basin, brushes, ink stand, and cutlery, a pair of Japanese Imari cups and saucers and a silver-gilt teapot (pl. 31). Wealthy husbands were said to have offered such gifts to their wives the morning after the wedding night, in exchange for consummating the marriage. Women took tea while having their hair dressed and face prepared for the day.

A distinctive shift took place in British cultural meanings of porcelain by the mid-eighteenth century, with more affordable porcelain tea sets used to express middle-class gentility.[6] Among the glossy mahogany tables and domestic furniture that were the genteel status symbols of the eighteenth century, the tea set was high on the list of coveted items. Learning to be a lady started early at the tea table, suggested by the miniature sets designed for children by newly established British porcelain manufactories such as Worcester (fig. 28). Dating around 1760–62, this partial set includes both a teacup and bowl with matching saucers, a miniature milk jug, and a teapot, decorated with the underglaze blue prunus root pattern that Worcester painted on wares made for adults. On May 1, 1778, twelve-year-old Mary Chorley wrote in her diary, "It being my birthday I had many young ladies to drink tea with me."[7] Every tea party was the chance for a lady to turn on the charm and perform her knowledge of the genteel arts. A painting of a British family, a group portrait known as a conversation piece, by an unknown artist portrays a mother seated at a tripod tea table who is about to drop a sugar lump into a dainty teapot, either exported from Asia or a

Fig. 28. Worcester factory. Miniature tea set, ca. 1760–62. Soft-paste porcelain

close copy by a British porcelain factory (pl. 32). The painting may depict the family of Richard Carter (1672–1755) with his wife and two of his three daughters, Martha, Frances, and Jane. The mother looks at one of her daughters playing the clavichord, supported by a bare-breasted female term with wings, an otherworldly creature of freedom at odds with the stuffy portrayal of the family. On the mother's right side, seated upon the same settee, is another daughter, who accepts from her father a token or a medallion with a woman's profile. A servant holding the kettle of tea has just walked through the open door, and creates an air of anticipation, as does the round tabletop, set for a total of five individuals, perhaps suggesting the arrival of a suitor into the scene. Both young women pivot their bodies toward the open door in a flurry of expectation, amplified by the partially opened fan held by the girl in the blue dress. The compositional importance of the heavy silver tea kettle on the left of the canvas, which reflects the artist and causes the servant to pitch sideways, and the tea ware set on the silver tray is perhaps not a coincidence, given the attention that Carter accorded to such status symbols in his will. While complaining of his daughters' "great imprudence," he evidently withheld judgment for his "dear and loving wife." In addition to two horses and a coach, he bequeathed to his wife "all that my Silver Tea Equipage consisting of a Tea Kettle and frame with a Lamp Box a Tea pot and frame a black Shaggareene case with two silver cannisters and a Sugar Box therin a Milk Jugg and a Silver Stand lately fixed in a Wooden frame and also my China belonging thereto."[8] Hefty silver teapots, such as one by silversmith Paul de Lamerie, continued to function as substantial pieces of symbolic exchange (pl. 33). More than one hundred years after it was made, the piece was reinscribed as a gift from "Robert to Louise," engraved on the bottom of the vessel. Though the objects in the painting may have belonged to their father, the women's bodies engage with and are placed in tension with the tea set.

Behind the language of polite conversation, a host of veiled references, innuendos, and coded glances were traded and exchanged, with the help of luxury objects (beyond the valuable silver) deemed "useless" by men. Around the tea table, a ritualized performance of female domesticity emerged, with mahogany furniture often set off with little fretwork fences that evoked the Chinese architecture embraced in the printed works of Thomas Chippendale and William Chambers (pl. 34). As scholar Elizabeth Kowaleski Wallace writes, "Gestures, often organized to show off an expensive tea equipage to its full advantage, were to be predictable and organized. The correct placement of a spoon carried significance, while other facets of the tea ceremony—the placement of the guests themselves, the handing round of cups, and so forth—also conveyed meaning."[9]

The policing of gender and sexuality, which increased in pace with the emergence of Britain as a colonial and commercial empire, was accompanied by the explosion of porcelain and earthenware goods for the table decorated with inventive fantasy figures that contrasted with the restrictions placed upon women at the table.[10] Tea equipage, or the implements

for serving tea, took various forms. At times, leaves were put directly into the cup and infused by pouring hot water, with the saucer used as a cover until the tea had steeped sufficiently. The imaginative saucers painted to match cups by the workshop of the independent "house decorator" Ignaz Preissler suggest that these small dishes were important sites for decoration; drinkers at the time were said to sip directly from the saucer to allow for the tea to cool down (pl. 35).[11] Preissler also turned drinking glasses into playful scenes full of movement (pl. 36). Meissen manufactory's teapots featured the Chinoiserie decorations of Johann Gregor Höroldt, who painted whimsical figures in imaginary landscapes that signal Meissen's drift away from copying Asian vessels to inventing new forms (fig. 29). Tea caddies used for holding leaves often appeared in square form, with the salt-glazed stoneware makers in Staffordshire attempting to bring some erudition to designs by using print sources, such as Jan Nieuhoff's seventeenth-century text on China. Domestic porcelain makers such as the Chelsea porcelain manufactory probably relied upon similar printed albums with "japanning" designs, such as Robert Sayer's *Ladies' Amusement: Or, The Whole Art of Japanning Made Easy*, which catered to women who could hand-color, cut, and paste the fantasy figures onto their own possessions (pl. 37). In England, depictions of sinuous female figures, later known through the Dutch expression "lange lijzen" (long ladies), decorated

Fig. 29. Meissen porcelain manufactory. Teapot, ca. 1735–40. Hard-paste porcelain
Fig. 30. Two sides of pl. 45

dainty ribbed cream jugs that emphasize the curving forms of molded shapes and C-scroll handles (pl. 38). Invention, rather than accuracy, was the primary interest. Imaginary Chinese gardens, filled with bridges, pagodas, rocks, and strolling women, covered plates, saucers, and slop bowls. Though the most famous English decorators of Chinoiserie such as James Giles made their name as independent workers, it is likely that many pieces were painted by unknown women decorators, whom male workers actively discouraged from gaining employment.[12] Tiny bowls, cups, and saucers became vehicles for transporting the user away to gardens decorated with Chinese scholars' rocks, described in one seventeenth-century Dutch account as "so curiously wrought, that Art seems to exceed Nature" (pl. 39).[13]

Tea and table wares owned by women became sites of female possession, indicated by pieces marked with names of women who wished to be remembered, and commemorated by means of their objects: we know Jemima Lupton by way of her teapot (see pl. 100). With so much variety in the range of wares available, a woman could easily fall prey to paying too much attention to objects simply meant to be used. As Stacey Sloboda writes, women's "alleged habit of amassing large numbers of fashionable objects was understood as an indiscriminate or compulsive act of consumption, rhetorically opposed to a rationalized

system of collecting" done by men.[14] The print *Taste in High Life* pictures the effects of allowing female desire to run amok (pl. 40). An old lady is titillated at the idea of joining the tiny cup in her hand to a fop's saucer, while a young woman with her provocatively raised skirt echoed by the painting on the wall partakes in an equally transactional exchange, holding the little Black page's face like an object to be consumed as he proffers a Chinese figurine. Here, the print places the "unnatural" tastes of women under moral scrutiny, calling attention to the artist's own fears not only of "female aesthetic determination, but also of the autonomy of female desire more generally conceived."[15]

The purported exchangeability between the Chinese porcelain figure and the Black page insinuated by the young woman's gesture in Hogarth's print points to the ways in which the objectification of race took the form of luxury objects, such as a silver teapot designed with a blackamoor handle (pl. 41). Africa and Asia were at times paired together in the form of female personifications of the four Allegories of the Continents, which translated colonial ambitions into a language of sexual conquest.[16] Racialized depictions became more troubling in the nineteenth century, when racist hierarchies formed part of nationalist discourse in Europe and America. The intimate tête-à-tête service made by Union porcelain works in 1876, a year after the Page Act banned Chinese women from entering the United States, places the heads of a Black man and a Chinese man atop of the lids of the teapot and the sugar bowl (pl. 42). In the usage of Neo-Rococo ornament, designer Karl L. H. Müller was clearly drawing on decorative motifs of the eighteenth century, which was the point of origin for setting "barbaric" racialized bodies as forms of whimsical decoration for the polite art of taking tea.[17] Figures of whimsy could easily slide into denigrating depictions of Africans and Asians, which were tied to the racist policies of postbellum America. Slavery had ended only ten years before the set was made, and the United States would establish the Chinese Exclusion Act a few years later in 1882.

Small things like cups and saucers have a subtle way of surfacing uncomfortable truths, functioning as the aesthetic subconscious of the eighteenth century. Sex too was a frequent subtext of porcelain, at times even its explicit subject matter. The china shops frequented by women, who both bought and sold objects at this marketplace of material wants, transformed porcelain "into an eroticized vehicle for imaginings of illicit and commoditized desire."[18] A single woman taking tea for herself spelled trouble, as suggested in the mezzotint by Bernard Lens II (pl. 43). The pulled-back curtain suggests a theatrical performance that reveals a topsy-turvy world of a woman left to her own devices: a spotted cat laps milk from a bowl on the table, the parrot is out of its cage, and the chair in which the woman is seated has a distinctly phallic-shaped back. The birdcage in the background would have been seen as a fashionable item of novelty, and a number of inventive examples were even made out of ceramic, such as a Delftware version from the eighteenth century decorated on the underside with free-flying fowl (pl. 44, fig. 31). They were also laden with sexual

Fig. 31. Bottom of pl. 44

connotations. Anyone familiar with Dutch still life paintings would have understood the association of an escaped bird with a woman's lost virginity.[19] Birdcages could equally well function as a metaphor for the strictures of marriage.

Seen through the male gaze, a Chinese export tea service with a woman sewing has an erotic charge (pl. 45). The set, which includes a teapot, teacups, and saucers, as well as a tea caddy, shows her in the act of sewing within an interior. A window to the right shows ships at sea. Unlike Dutch genre scenes of working women mending cloth, the woman on the teapot pulls a threaded needle with a raised pinky, a coquettish action that draws attention to her exposed breasts. Whether it is a mistake on the part of the Chinese enameler or done on purpose, the reverse side of the same teapot has covered her nipples with bits of lace (fig. 30). Even more explicit examples featured pornographic images. On a small teacup, a woman holds an open birdcage over her lap as a man positions the bird in front of her (pl. 46). On a Chinese export ware saucer, a woman provocatively cuts her toenails in front of what resembles a mirror (pl. 47). A different saucer shows a Dutch peasant innocently crossing a field with only her leg exposed. Turning the saucer on the reverse side, she bares her backside (pl. 48). Bawdy visual jokes, such cups and saucers become vehicles of voyeurism. The objectification of the female body strongly suggests a market for tea wares among male consumers. At the same time, they suggest the ways in which these

erotic fantasies mapped onto porcelain transformed "polite" vessels into a volatile medium of provocation, projection, and desire.

Of course, porcelain could always be smashed in a fit of rage. And with the increasing confinement of women to the domestic sphere in the eighteenth century, writers and commentators increasingly drew a link between the destruction of porcelain and women pushing against the confines of politeness and respectability that had been imposed upon them.[20] While some authors associated women's frailty with their breakable porcelain vessels, they were more readily pictured as "agents of violence." A 1698 poem by Thomas D'Urfey titled *Pendragon, or, The Carpet Knight his Kalendar* might be paired with Hogarth's print *A Harlot's Progress*, where Moll is shown in the process of knocking down the table to distract her cuckolded husband from her lover's departure (pl. 49):

> She rants, and swears, and stares, and flings
> About her Clothes, and tears her Things;
> Breaks China, clatters Looking-glasses,
> And calls him Twenty thousand Asses.[21]

A subversive sense of disorder can also be found in paintings by Jean-Etienne Liotard, one of the few artists to endow tea sets with an uncanny sense of liveliness. Liotard specialized in pastel portraits where his sitters have a glassy stillness that renders them into inanimate objects. Though it is probable that he looked to the work of French painter Jean Siméon Chardin as inspiration, the effects of his paintings formed a complete contrast to the moments of intense quietude and concentration conjured by Chardin's paintings of sitter and teapot (fig. 32). Contemporaries often compared his work to Chinese paintings, criticized for being barbaric for lacking shadow and contouring in the manner of European paintings. One critic remarked that his work was "flat, flat, flat, three times flat, and flatter than anything that has ever existed."[22] The tea set depicted in his late still life from around 1781–83 (now in the J. Paul Getty Museum) is a study of topsy-turvy forms. The tray is cluttered with overturned cups and saucers, with a piece of bread that has fallen off the tray. Liotard's evident interest in carefully rendering the repeating figures found decorating the surface of porcelain, a material that fascinated the artist, is set into tension by the seemingly careless arrangement, which suggests that a party has abruptly come to an end: it is time for clean-up.

What could female agency mean in the eighteenth century? Besides acts of rage or disorder, "spilling the tea" in the form of gossip could be a form of ultimate female subversion. By bringing together women in a space that was not dominated by a "phallic masculinity," they were free to converse in a place shaped by the power of women's words.[23] Women's gossip is evidently satirized in the print published by John Bowles entitled *The Tea-Table*,

Fig. 32. Jean Siméon Chardin (French, 1699–1779). *A Lady Taking Tea*, 1735. Oil on canvas, 31 7/8 × 39 in. (81 × 99 cm). The Hunterian, University of Glasgow (GLAHA_43512)

where a group of women is seated around a circular table conversing and drinking tea (pl. 50). At table, they daintily hold cups in their hands, while a fan, a muff, and a book open to the words "Chit-Chat"—the instruments of female guile—are strewn around a tray containing a cup, bowl, tongs, and teaspoons. Accompanying the print is a text that describes in verse the gathering's creation of "thick scandal," which "spreads, improves on ev'ry Tongue / Who is the charming Fair, if any ask . . . And loose her dear lov'd Volubility." The women are so busy gabbing that they fail to notice the devil hiding under the table in the shadows, who eavesdrops on their conversation while enjoying a cup of tea. In the back of the room, on either side of a roaring fire, a niche filled with porcelain objects, including vases, tea and coffee pots, cups, and saucers, are arranged for display, while a mirror, functioning as a symbol of vanity, is shown on the other side. The painting in the center depicts the popular image of a Franciscan friar hiding a woman in a bundle of wheat, suggesting temptation. To the left, before a broken sword and a tiny cup, the allegorical figure of eloquence chases away truth and justice with a snake and a torch. Outside the

window on the right, two men angle to listen in on the gossip, in the hopes of gaining from the "thick scandal." Loose lips at the tea table were not the only means for renegotiating the terms of discourse. Writing too became a vehicle for female imaginations. Women found ways to write on a myriad of confined surfaces, with vanity tables typically reserving space for ink and paper.

In a contemporary act of subversion, artist Candice Lin takes the understated visual cues of *The Tea-Table* print and turns them on their head once more in her own satirical take on the image (pl. 51). In Lin's etching, she visualizes the unspoken ties of the tea table to the colonial products that made the ritual of taking tea possible, including crops of tea, opium, and sugar brought indoors into the culturally refined space of the interior. The figures seated at the table are accompanied by a host of female laborers refining crops for consumption, while a woman lying on the ground smoking opium has a pipe dream that conjures a multi-breasted figure meant to wreak havoc on the entire scene. To the far right, a cartouche contains an imaginary "guard chamber recipe" for fidelity, which includes "1 lizard, a pinch of tea / pounded to a fine / dust, mix't with cinnabar / dotted on the emperor's / concubines to ensure fidelity." Lin's work constructs mythologies, constellations

Fig. 33. Candice Lin (American, b. 1979). *System for a Stain*, 2016. Wood, glass jars, cochineal, poppy seeds, metal castings, water, tea, sugar, copper still, hot plate, ceramic, mortar and pestle, mud, microbial mud battery, vinyl. Installation view, Gasworks, London

of meaning, and alternative material circuits that question the desire for colonial commodities like porcelain, silk, opium, and tea, which relied upon exploitative forms of labor and the "racialized anxieties of their production and origin."[24] Parodying the vast imperial systems of shipping, distilling, and refining necessary to transform raw materials harvested in colonial territories into consumable goods, Lin's 2016 exhibition, *A Body Reduced to Brilliant Color*, created a vast refining process that ultimately produced nothing more than residue: "rather than producing a singular, alluring product, the system in this installation created a foul-smelling amalgamation, a stain" (fig. 33).[25] The touted white purity of porcelain, as Lin points out, was always accompanied by the construction of its racial others positioned as the opposite of the polished and the polite world. Spilled tea becomes a stain.

31. German goldsmiths and artisans; Japanese Imari-type porcelain maker, ca. 1743–45. Toilet set. Gilt silver, hard-paste porcelain, cut glass, walnut

32. Unknown artist. *A Family Being Served with Tea, Possibly the Carter Family*, ca. 1745. Oil on canvas

34. After a design by Thomas Chippendale. China table, ca. 1755. Mahogany

37. Jean Pillement; published by Robert Sayer. *Ladies' Amusement: Or, The Whole Art of Japanning Made Easy*, 1760. Etching and engraving

38. Worcester factory. Milk jug, ca. 1753. Soft-paste porcelain

39. Worcester factory. Teabowl and saucer, ca. 1755. Soft-paste porcelain

40. Samuel Phillips after William Hogarth. *Taste in High Life*, 1798. Engraving and aquatint
41. I. M. P. (French). Teapot, mid-18th century. Silver, ebony
42. Union porcelain works. Partial tea set, 1876. Porcelain

43. Bernard Lens II. *Woman Drinking Tea*, before 1725. Mezzotint
44. Dutch. Birdcage, first half of the 18th century. Tin-glazed earthenware

45. Chinese, made for the European market. Tea set, 1750–70. Hard-paste porcelain

46. Cup with two figures and birdcage. Chinese, made for the European market, ca. 1750. Porcelain
47. Cup and saucer with woman trimming toenails. Chinese, made for the European market, ca. 1740. Porcelain
48. Pair of saucers with Dutch maid. Chinese, made for the European market, ca. 1750. Porcelain

49. William Hogarth. *A Harlot's Progress*, 1732. Etching and engraving

51. Candice Lin. *The Tea Table*, 2016. Etching on Japanese Kozo paper

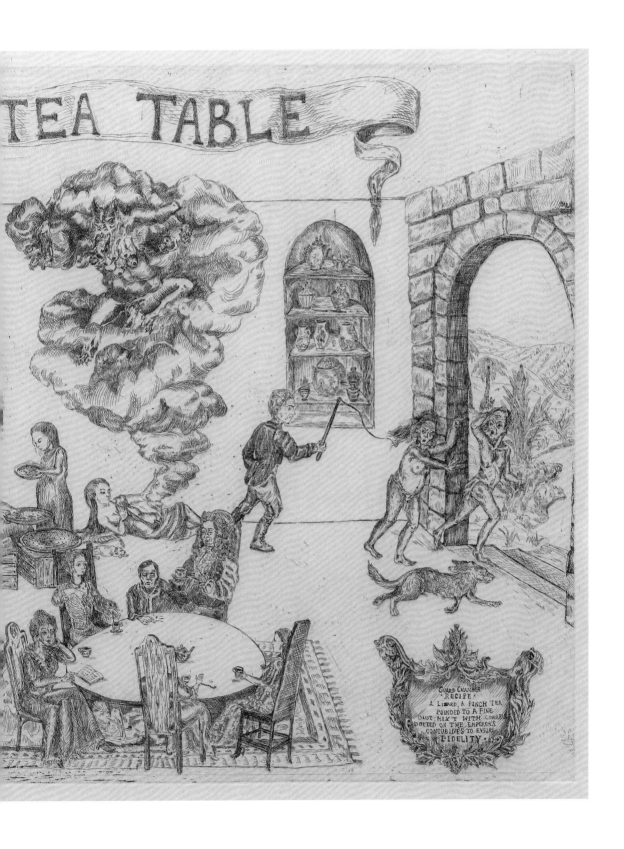

ARTIFICIAL MOTHERS: FIGURINES AND FANTASIES OF THE FEMALE SUBJECT

In eighteenth-century Europe, Asian women appeared on mantels, dinner tables, and display cabinets in the form of porcelain figurines that inhabited a miniature universe designed for courtly entertainments. Initially, the Meissen porcelain manufactory copied deities imported from China. Soon after, European manufactories began producing a range of goddesses, female allegories, empresses, entertainers, mothers, and maidens in the "Chinese taste," who jostled for space alongside the "pagods and magots" that were seen as the symbols of Chinoiserie's exaggerated aesthetic. Before actual Asian women arrived in Europe, these synthetic fantasy figures proposed an image of foreign femininity that was colorful and gaudy, a world of artificial performance tied to the theater, where China was a favored subject for stages across Europe. They formed a striking contrast to the female nude that academic artists claimed as the ideal standard of beauty, such as Etienne-Maurice Falconet's *Pygmalion and Galatea* (ca. 1764–73), a porcelain biscuit sculpture by the Sèvres manufactory (fig. 34).[1] In the ancient myth, the sculptor falls in love with his own creation, and miraculously turns her into flesh and blood. The story fascinated Enlightenment artists and philosophers, who sought to understand how the senses and reason could animate matter.[2] In contrast, no philosophical meaning is attached to works such as *Chinese Musicians* by the Chelsea porcelain manufactory, which may have once functioned as a light fixture (pl. 52). A contortion of colorful, twisting forms, the figures do not even seem human at first, but simply parts of the decoration. The four musicians suggest excess. Yet how might these alternative models of the female and feminized form that inhabited the lively, artificial language of Chinoiserie have provided new visions of womanhood outside of the strict boundaries of classicized, ideal beauty?

Fig. 34. Etienne-Maurice Falconet (French, 1716–1791), modeler. Sèvres manufactory. *Pygmalion and Galatea*, ca. 1764–73. Soft-paste biscuit porcelain, H. 14 ¼ in. (36.1 cm). British Museum, London (1948,1203.38)

Otherworldly Guanyin, a Chinese female deity, became one of the first figures copied by the Meissen porcelain manufactory, in imitation of the Chinese hard-paste porcelain that gave its patron, Augustus II the Strong, the "porcelain sickness" (pl. 53). Far from being a static, fixed figure, Guanyin was a fluid symbol that was adapted to changing cultural contexts. Originating from the Indian bodhisattva of compassion, Avalokiteśvara, early depictions of Guanyin represented a male deity. While China had a long history of ceramic figurines incorporated into burial practices as early as the third century BCE, Buddhist and Taoist ceramic figures helped to disseminate religious beliefs to illiterate worshippers.[3] In the twelfth century, as Buddhism spread across China, female depictions of Guanyin first began to appear, appealing to women who prayed to her for protection and for children, especially sons.[4] According to one scholar, she, "alone among the Buddhist gods, is loved rather than feared and is the model of Chinese beauty."[5] The figure alternately adopts a standing or seated pose of *maharajalilasana*, the position of royal ease, with her bare feet peeping out from under long robes (fig. 35). In Qing China, women placed porcelain figures of Guanyin in domestic altars. Hopeful worshippers would allegedly break off the finger of a Guanyin statue after giving birth to a son, as a reminder of a wish fulfilled.[6] While the French Jesuit missionary Père François Xavier d'Entrecolles lived in China in the early eighteenth century, he sent letters to France that provided details on the production of porcelain. He

Fig. 35. Dehua, China, Qing dynasty (1644–1911), Kangxi period (1662–1722). Guanyin. Porcelain, 17 ³⁄₈ × 4 ³⁄₄ in. (44.2 × 12 cm). Porzellansammlung, Dresden (PO 8638)

commented on the popularity of porcelain figures of the goddess for the domestic market: "[Jingdezhen potters] also make an abunduance of Statues of Kuan-in, a Goddess famous in China. She is represented holding a Child in her arms, and is invok'd by barren Women desirous of Children. We may compare her to the antique Statues of Venus and Diana, with the difference that the statues of Kuan-in are extremely modest."[7] D'Entrecolles clearly sought to distinguish the "pagan" practices of the Chinese worshippers and Catholic believers of the "true faith," even though figures made for the Christian communities throughout Asia transformed Guanyin into depictions of Mary.

In European collections, Guanyin gained Christian connotations, at the same time functioning as a display object of prestige that could be paired alongside other figures, such as standing Japanese beauties, or *bijin* (pl. 54). Made for export to the European market about 1670–90, the *bijin* wears a *uchikake*, or over robe, decorated in a Kakiemon style with foliage, fruit, and rectangles with stylized Chinese characters. The Burghley House inventory of 1688 lists in Lord Exeter's room "1 Indian queen, 2 wt fryars, 2 hawkes, 2 Dogs blue." The "Indian queen" figure has traditionally been tied to the type of Kakiemon standing beauty, while the "2 white Nunns" paired with "2 white Criples" found in Lady Exeter's closet were probably blanc-de-chine figures of Guanyin and Taoist immortals.[8]

Crawling up the walls and over the cornices of interiors were human figures, beasts, and decorative porcelain vessels with dazzling mirrors aimed at impressing visitors. An etching shows the porcelain room at Charlottenburg Palace that Frederick III commissioned from Johann Friedrich Eosander von Göthe on behalf of Sophie Charlotte. A pair of racialized Chinese men wearing porcelain bowls as hats emerge from the wall on either side of the mantel mirror, proffering the actual bowls, vases, cups, and saucers mounted on shelves and into gilded wainscoting (pl. 55). Seated buddha figures on shelves are paired with standing Guanyin pieces, with the repetition of cups and saucers creating a visual rhythm across the cornice. Mirrors were central elements of porcelain rooms. Suggesting the precursor to contemporary artist Yayoi Kusama's *Infinity Mirror Rooms*, strategically placed mirrors multiplied surfaces and dissolved the structural integrity of architectural envelopes. One German author explained: "Such rooms have the characteristic that they numerously multiply everything brought into them, and represent a grand openness in a narrow room, and therefore they are an appropriate ornament in the pleasure palaces of the higher aristocracy."[9]

Before the Seven Years' War (1756–63), Meissen dominated porcelain production in Europe, establishing the models copied by European porcelain manufacturers elsewhere in France, Germany, and England. In the first years of the Meissen manufactory, alchemist Johann Friedrich Böttger closely copied objects in Augustus's Chinese porcelain collection, including a Guanyin, out of the redware clay stoneware body that he developed, before Meissen eventually focused its production on white porcelain. Johann Gottlieb Kirchner

produced the first figurative models at Meissen beginning in 1727. He was quickly eclipsed by ambitious sculptor Johann Joachim Kändler, who was responsible for creating many of the original models of Chinoiserie figurines. Aside from sculpture, painter-decorator Johann Gregor Höroldt codified Chinoiserie designs and models in the Schulz Codex, which transformed Meissen's productions from strict copies of Asian porcelains to "light, ludic, gently mocking fantasies of Chinese life."[10] Höroldt's decorations turned Meissen's porcelain from a mimicry of Asian types to parody, by which he "toyed with the idea and presentation of China."[11] This was pushed further by Kändler's sculptural figurines, including the *Allegorical Figures Representing the Continents*, first produced in 1747.[12]

While the majority of Meissen's porcelain figurines were made for the Saxon court, pieces were also sold in local Dresden shops and by "chinamen" in London, established by the 1730s. In Paris, *marchands-merciers* like Gilles Bazin and Jean-Charles Huet combined Meissen porcelain figurines, such as a female allegory of Asia, with French gilt bronze mounts (pl. 56).[13] Meredith Chilton and Vanessa Sigalas note that Meissen figures were typically intended as *Kabinettstücke*, or cabinet pieces, for themed dinners at courtly banquets, or as diplomatic gifts.[14] They could also appear separately on a dessert table. Disguised with a cloth, a *dormant* (or sleeping) display could suddenly spring to life when the table was revealed to be teeming with miniature figures.[15]

Sibylla Augusta, margravine of Baden-Baden, was an early consumer of Meissen porcelain, which formed part of the "Chinese feast" she threw at her palace at Ettlingen in 1729, held in honor of her son's departure for Italy. She was involved in the display, personally sculpting the wax buddha figures that were set alongside ceramic dishes from her vast collection from Asia and 160 pieces of Meissen porcelain.[16] Banquets granted women collectors the chance to rearrange porcelain that would otherwise sit inert on the shelves. Queen Sophie Charlotte of Hanover wrote in a letter to her stepdaughter: "It is a diversion for you to arrange the beautiful porcelain . . . I shall do the same at Lietzenburg, following the festivities."[17] At the Chinese feast, Sibylla Augusta commissioned special music, costumes, and food courses that included three plates for each guest and Chinese-inspired garnishes served on her best porcelain. Augsburg printmaker Johann Christian Leopold captured the cacophonous Chinese feast (pl. 57). The prints show the colorful delicacies, which included pastries and oysters, and a main course of "juniper berry-filled thrushes served on pagod-supported pyramids." At the same time, the caricatured Asian figures nested in pyramids of food conjure a carnivalesque appetite for Chinoiserie gone too far.

The eighteenth-century *pagode* was one of the most prevalent character types in Chinoiserie, evoking the period's fascination with animating the inanimate.[18] Meissen copied Chinese figures with movable heads that could be manipulated with an internal lever (fig. 36). These toylike, emasculated automata were seen as objects of ridicule and

Fig. 36. Meissen porcelain manufactory (German, 1710–present). Nodding *pagode*, ca. 1760. Hard-paste porcelain, 8 ½ in. (21.5 cm). The Metropolitan Museum of Art, New York, The Jack and Belle Linsky Collection, 1982 (1982.60.325)

derision. Definitions of *pagode* in eighteenth-century French dictionaries were used to describe the servile imitation of individuals lacking agency (or what might be described as an early instance of colonial mimicry): "the little figures ordinarily of porcelain and which often have a mobile head; which has resulted in the common expressions, he moves his head like a *pagode*. He does the *pagode*. It's nothing but a *pagode*."[19]

The circulation of French painter François Boucher's prints provided influential models for porcelain manufacturers. Boucher's early work derived from designs after Antoine Watteau, though his most significant Chinoiserie prints were undertaken between 1738 and 1749 with the French engraver Gabriel Huquier. Chinoiserie figures were combined with the Five Senses, the Four Elements, and domestic genre scenes of women and children in imaginary landscapes (fig. 37).[20] Boucher's prints created a visible link between sexually alluring female fantasy figures and the commodities associated with Asian luxury goods. Women set in a landscape would be positioned next to lacquered cabinets, porcelain vases, and teapots. Desire for bodies and objects was part of the same serpentine line. Meissen based a series of porcelain figurines on Boucher's prints. They include women modeled by Johann Joachim Kändler, Peter Reinicke, and Friedrich Elias Meyer, in colorful floral robes and pouring tea into a cup held by little boys (pl. 58). Boucher's *Scènes de la vie chinoise* provided

Meissen with inspiration for other figural groups.[21] The French painter also worked with the English engraver John Ingram on prints used by English manufacturers, such as *The Master Gardener* (1741–63) (pl. 59). A figurine, probably by Chelsea, copied the elaborate headdress, costume, and table, adding a pair of coquettish face patches to the woman's cheek and chin (pl. 60).

Boucher drew upon Chinese objects and images as source material, rearranging, cropping, and editing texts such as *Yuzhi gengzhi tu*, a book showing the cultivation of silk.[22] An avid collector, Boucher owned a remarkable number of Asian objects and curiosities at the time of his death in 1770. They included porcelains, lacquers, and Chinese statuettes.[23] Even if he used his collection as inspiration, his Chinoiserie fantasies depended upon the effacement of sources, claiming them as his own "original" artistic inventions. Significantly, he never used Chinese figures in grand history paintings intended for the academy, given that China remained "a territory in the margins of the most valued subject (of history) and format (of the easel) in painting."[24]

Fig. 37. Gabriel Huquier (French, 1695–1772). *Two Women Leading a Child Toward a Teapot on a Table Near a Pond*, ca. 1742. Etching and engraving, sheet (trimmed) 11 13/16 × 9 5/16 in. (30 × 23.7 cm). The Metropolitan Museum of Art, New York, Harris Brisbane Dick Fund, 1953 (53.600.1019[9])

The Asian woman, a key trope in Boucher's vast printed repertoire, was never seen as the main figure in grand narratives. She existed at the fault lines of an internalized aesthetic division between subjects reserved for history painting and posterity, and those considered less important commercial images for the marketplace, not worthy of deeper contemplation. Paradoxically, a parallel situation existed in Qing China when it came to the genre known as *meiren*, or beauty paintings, which were often dismissed as commercial works for the market, in contrast to the black-and-white calligraphic landscapes made for the enjoyment of the literati (pl. 61). These pictures—of generic courtesans, court ladies, and also women of ambiguous social status—were for use and pleasure. James Cahill writes that *meiren* paintings, far from generic images, could be understood as the experiments undertaken in urban painting studios based in commercial centers such as Suzhou, where women and men were depicted in paintings that reflected the popular interest in *qing*, or emotional feeling, and everyday "passages of felt life."[25] Not limited to the domestic market, *meiren* became a predominant visual theme in luxury objects exported to Europe, such as a remarkable inkstand decorated with miniature interior scenes with two beauties engaged in acts of reading and writing, paired with a black, calligraphic landscape, still life paintings, and depictions of flora and fauna (pl. 62).

In France, Chinoiserie beauties were connected in the collective imagination with an aesthetics of *métissage*, which conjured fears and fantasies of cultural mixing not only with China but colonial territories.[26] One of Sèvres's most unusual designs features Boucher's Chinoiserie compositions of the senses on a pair of elephant vases made for Madame de Pompadour, a royal mistress to Louis XV (see pl. 106, fig. 52). A patron of Boucher, Madame de Pompadour was also an avid collector of Chinese works, and probably commissioned a pair of potpourri vases with a composition of Chinese women and children in an outdoor garden, inspired by the *Yuzhi gengzhi tu*, the Chinese text on sericulture (pl. 63).[27] Though not exactly figurative examples of porcelain, the colorful and ornate shapes of the potpourri vases were intended to be read alongside the vignettes. In the case of the elephant vases, the doubled trunks paired with Boucher's allegories provoke a sensory overload, in what Chi-ming Yang has recently described as a synesthesia tied to European anxieties of miscegenation.[28] Certainly, an earlier tradition of creating hybrid creatures in a Chinoiserie vein existed. The Vienna porcelain manufactory owned by Claudius Innocentius du Paquier created inventive figures, including a manticore with a smiling, human face and coiling dragons (pls. 64, 65). Later, during the French Revolution, Chinoiserie's whimsical motifs were weaponized, as Revolutionaries turned to the beastly in propaganda images that demonized Marie Antoinette as an unnatural creature with the spots of a leopard and the snake-hair of Medusa (pl. 66).[29]

The types of womanhood that circulated in the miniature world of Chinoiserie were far from fixed. They were subject to the changing tastes of consumers and the artistic

visions of their modelers. Though inspired by Boucher, the Chelsea porcelain modeler Joseph Willems found inspiration but often departed from the French artist's two-dimensional prints, such as *Les délices de l'enfance* (*Delights of Childhood*), which shows a young woman with two young boys teasing a cat with a *diabolo*, or yo-yo. This image ostensibly served as the point of departure for Willems's figurative group of a mother and child playing with a cat, from around 1749–50, made when Chelsea was still experimenting with figurative compositions (pl. 67). Only two examples are known of this model. The white one reveals Willems's careful attention to the folds in the two figures' clothing, and the challenge of firing the rambunctious toddler's precarious pose without losing limbs in the kiln. In the enameled version, the painter has heightened the mother's concentrated gaze as she steadies the toddler and holds him back from the potential harm of the cat's claws (pl. 68). In Willems's take, the woman becomes a mother who, rather than participating in the "delights of childhood," protectively pulls her child back from getting hurt. His modeling endows the figures with life in a way that is less about drawing attention to his own mastery, and more about being drawn into a sympathetic engagement with the mother and child.

Porcelain figurines, like Chinoiserie ornament, are iterative, meaning that they consist of the repetition of molds, models, gestures, and costumes, so that what once appeared strange looks familiar.[30] We are meant to see the repertory of figures as fantastical constructions and idealized types, but hardly as real individuals. Could a woman ever see herself in these miniature porcelain portrayals of motherhood? Was she a good mother or a bad mother? Or did she imagine herself instead among the other types of models that emerged in the miniature universe of Chinoiserie figures, as an allegory of taste, of the elements, or of Asia herself? Motherhood became a generative source for one of the most unusual porcelain models made in China for export to the European market around 1750. A reclining, possibly pregnant woman holds a picture book of a landscape while casually resting her other arm on a stack of books (pl. 69). She is erudite and elegant, her open eyes and relaxed smile are serene, and her head could be manipulated to turn it toward the book in her hand or away from it. The protruding belly, found in an identical model, strongly suggests the depiction of a pregnant woman, a subject not found in Chinese paintings of the period. The figure possibly represents the Chinese metaphor that associated reading books with the growth of ideas in the mind like a child growing in the womb.[31] Here is a radical model of womanhood, who is not a nude model representing a male artist's fantasies or genius, but a figure swelling with intellection, repose, and generative possibilities.

Such an unusual object would have resonated for Margravine Friederike Sophie Wilhelmine of Bayreuth, an avid collector of Chinese porcelain who penned her memoirs in the Chinese mirror cabinet of the Hermitage in Bayreuth, Germany (fig. 38).[32] Found in one of the most secluded areas of the palace, the margravine's cabinet consisted of pieces of fragmented mirrors covering nearly every surface of the interior, with the ceilings decorated

Fig. 38. Antoine Pesne (French, 1683–1757). *Wilhelmine of Bayreuth*, 1740s. Oil on canvas. Neues Palais Potsdam

with Chinoiserie motifs (fig. 39). The mirrors were originally paired with shelves that contained more than three hundred small Asian sculptures and vases.[33] Fragmented mirrors, rather than symbols of vanity, could be seen as a reflection of the margravine's contemplative nature and how she "imbued every detail with content."[34] Instead of fragmentation, the mirrors could be recuperatively seen as devices for diffraction, used by the margravine while she was writing to see herself from multiple angles, positions, and viewpoints, imagining woman as a multiplicity rather than a singular, fixed identity.

Wilhelmina's mirror cabinet suggests the ways in which porcelain and reflective surfaces could function as tools for Chinoiserie's system of philosophical reflection. When

you look in the mirror, whom do you want to see? Mirrors, as symbols of ideal beauty, truth, and vanity, also served as thresholds into new worlds. Chinoiserie reverse-painted mirrors of women, which gained popularity in the eighteenth century, became devices for picturing the self elsewhere, or forms of wish fulfillment. At the turn of the eighteenth century, European merchants began exporting poor-quality mercury mirrored glass to Canton to be painted and sent back to Europe. An increasing number of wealthy clients incorporated the painted mirrors into Chinoiserie interiors, combining them with porcelains, wallpaper, and fretwork furniture.[35] In Qing China, the emperor also delighted in the illusions of these reverse-painted mirrors. It is possible that a number of examples, such as an illusionistically painted mirror of a young woman and a scholar, may have been made for domestic consumption in China (pl. 71). In 1741, the French Jesuit painter Jean Denis Attiret, who was active at the court of Qianlong, first mentioned reverse glass painting in a letter to France. He described in detail the process of transferring images onto the back of the mirror without silvering, so that "the pencil or coloured lines remain imprinted on the silvering only in the places to be painted and the rest is left as a mirror." He further described the picturesque effects of these looking glasses: "This type of painting is all the more beautiful because, when seen from a short distance, it seems as if the figures, animals,

Fig. 39. Mirror cabinet, ca. 1736. Hermitage Old Palace, Bayreuth

landscape or any other design is not painted on the mirror but reflected; one's face can be seen in the gaps left by the painting, which makes for very attractive variety."[36]

Few scholars have commented on the ways in which women occupied a large amount of space on reverse-painted mirrors that defy simple explanations. For example, one mirror shows Mrs. and Miss Revell seated on a veranda overlooking the Pearl River in Canton (pl. 70). Yet this realistic-looking painting was improbable: the wife and daughter of an East India Company merchant could not have "officially" gone to Canton to visit Mr. Revell and worn elaborate Manchu robes, since women were banned from the trading season (though it is possible that they could have been waiting in Macao for the season to end). Fantasy and reality are again blurred in another pair of mirrors showing the twin sisters Elizabeth and Christian Graham (pls. 72, 73). Commissioned in Canton around 1785 by Captain John Lennox, a merchant with the East India Company, they were based on miniature portraits of his neighbor's daughters. Lennox was allegedly in love with Elizabeth, who looks off into the distance, though he evidently thought of marrying her sister. He also commissioned a portrait of himself, suggesting that he was using the mirrors as a way to "try himself out" with each of the sisters in a fantasy (or delusional) scenario. It is not difficult to see why neither sister ended up marrying him, rich as he may have been. In some ways, these staged realities were more imaginary than a mirror showing an idealized image of a courtesan in Manchu dress (pl. 74). She gazes directly at the viewer, touching a silk handkerchief, smoking a pipe, and fingering the fur on her cape in a suggestive way. There is hardly any reflective space remaining. The fantasy figure occupies more space than is allotted to the viewer supposedly doing the work of producing the fantasy. At first glance, her white skin resembles the porcelain vase behind her, creating a visual link between object and subject. Yet her assertive gaze raises discomforting questions about who has the agency, who is real flesh and blood, and who is a painted illusion.

For modern viewers it is difficult to imagine the cultural power wielded by painted mirrors or miniature porcelain figurines of women molded from an artificial material, rendered in bright, colorful enamels, and modeled in exaggerated poses that seemingly have little to do with reality. Racial exaggerations and grotesque caricatures, once understood as comical entertainments for the European court, resonate differently today in ways that can make looking at these portrayals complicated. Yet they are worth another look, because they allow us to see how seemingly innocuous porcelain figures shaped the racial imaginary that we have inherited from the past. They also point to which historical types need to be reframed, shattered, or shaped by new visions of women, for which the past did not have an adequate model.

52. Chelsea porcelain manufactory. Joseph Willems, modeler. *Chinese Musicians*, ca. 1755. Soft-paste porcelain
53. China, Qing dynasty (1644–1911), 18th–19th century. Bodhisattva Guanyin seated on a rock. Porcelain
54. Japan, Edo period (1615–1868), 1670–90. Figure of a standing beauty. Porcelain

55. Martin Engelbrecht after Johann Friedrich Eosander von Göthe. *Design for the Porcelain Cabinet at the Charlottenburg Palace*, ca. 1711–56. Etching

56. Meissen porcelain manufactory, modeled by Johann Joachim Kändler, Peter Reinicke, and Johann Friedrich Eberlein. *Asia* (one of a pair), ca. 1745–55. Hard-paste porcelain with French gilt-bronze mounts

57. Published by Johann Christian Leopold. *Accurate Representation . . .* , ca. 1730. Engraving

58. Meissen porcelain manufactory, modeled by Johann Joachim Kändler and Peter Reinicke, based on a design by François Boucher. *Asian woman with children*, ca. 1750. Hard-paste porcelain

59. John Ingram after François Boucher. *The Master Gardener*, ca. 1741–63. Etching and engraving

60. Probably Chelsea porcelain manufactory, based on a design by François Boucher. *Chinoiserie figure*, ca. 1750. Soft-paste porcelain

Dessiné par Fr. Boucher Gravé par Ingram

LA MAITRESSE DU JARDIN

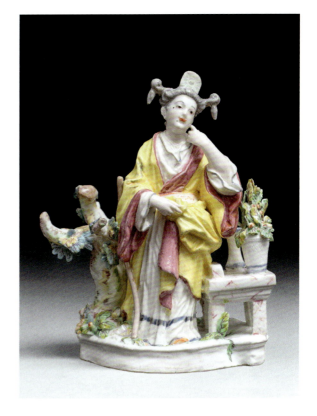

61. China, Qing dynasty (1644–1911), late 18th–early 19th century. Interior with woman, child, and nurse.
Hanging scroll; ink and color on silk

67. Chelsea porcelain manufactory, modeled by Joseph Willems. Lady with a child and a cat playing with a string toy, ca. 1750–52. Soft-paste porcelain
68. Chelsea porcelain manufactory, modeled by Joseph Willems. Mother and child, based on the print *Le mérite de tout pais by François Boucher*, ca. 1749–50. Soft-paste porcelain
69. Chinese, made for the European market. Figurines of possibly pregnant ladies in repose, ca. 1750. Porcelain

70. Chinese, made for the European market. *Mrs. and Miss Revell on a Veranda*, ca. 1768–87. Reverse painting on glass
71. China, Qing dynasty (1644–1911), Qianlong period (1736–95). Woman and scholar, 18th century. Gold, wood, and reverse painting on glass

72. China, Qing dynasty (1644–1911), Qianlong period (1736–95). *Portrait of Elizabeth Graham*, 1785. Reverse painting on European (probably French) mirror glass, gilded wood frame

73. China, Qing dynasty (1644–1911). Qianlong period (1736–95). *Portrait of Christian Graham*, 1785. Reverse painting on European (probably French) mirror glass, gilded wood frame

AFTERLIVES
OF CHINOISERIE

Porcelain was the primary vehicle for Chinoiserie in Europe in the early modern period. In America, this former sign of European royal power and prestige also became a fraught means of disempowerment within the complex geopolitics of the late nineteenth century. At a moment when Japan came to signify an avant-garde modernity in the imagination of artists and manufacturers, China came to represent an obsolete, abject nation caught in a feudal, outdated past.[1] Film and photography became technological media through which the American imagination shaped the "afterlives" of the style. Like porcelain, photography and film provided a glossy substratum upon which fantasy images of the Asian woman were projected, reproduced, and stereotyped. Two modern figures at the turn of the century had to contend with the afterlives of Chinoiserie: Empress Dowager Cixi (1835–1908) and the Chinese American screen siren Anna May Wong (1905–1961). They were two of the most recognized Asian and Asian American women who embodied the complex politics of a style that had repeatedly associated an Asian femininity with traditional luxury objects. Whereas the porcelain vessels and figurines that had become a mainstay of European consumption and material desires offered up the vision of a faraway culture, the appearance of these two flesh-and-blood Asian women as subjects of modern reproductive media revealed the long shadow cast by Chinoiserie, raising the question of what kind of agency the Asian woman's body represented on- and off-screen.

In nineteenth-century Europe, Chinoiserie returned in repressed form against the Neoclassical tide, accompanying the Rococo revivals that periodically resurfaced after the French Revolution.[2] As late as 1791, Sèvres continued integrating the fantasy designs of Jean-Baptiste Pillement, pairing a novel ground color that imitated black and gold lacquer with Rococo floral garlands. Such belated taste appeared at odds with the prevailing patriotic iconography of the revolutionary period. Where it had once stood for novelty and the strange, Chinoiserie reappeared as a nostalgic, reliable source tied to the world of ancien régime sociability. In 1839, Sèvres began making a series of tea and coffee sets, such

as the *déjeuner chinois réticulé*, a model favored by Queen Marie Amélie. Apparently directly inspired by Chinese fretwork, the pink and gold hues used a color scheme that the manufactory had pioneered in the eighteenth century, when it had first been established by Louis XV (pl. 75).

By contrast, America viewed Chinoiserie as part of its new political identity after independence in 1783. On February 22, 1784, the *Empress of China* set sail from New York for Canton, representing the first American trading vessel to establish the China Trade. Hundreds of American ships funded by private investors followed in its wake.[3] Tea, a charged symbol used to protest unfair taxation during the American Revolution, became an accessible commodity via direct trade. Chinese objects filled the elite homes of America, from James River mansions in Virginia to the stately residences of wealthy merchants in Boston, Philadelphia, Salem, New York, and Providence.[4] American consumers desired porcelain. In lieu of the coats of arms on British armorial services, plates made for the American market had monograms paired with patriotic emblems such as the eagle (pl. 76). The allegorical figure of Lady Liberty appeared on reverse glass paintings that celebrated American independence (pl. 77).

Opium was directly entangled with porcelain sickness, as two commodities that fed the establishment of modern capitalism.[5] American traders amassed fortunes from opium. At the end of the eighteenth century, the British Empire had begun establishing factories producing the substance in India, which was privately smuggled into China. Cash-strapped and lacking the silver demanded by the Chinese, the British sought to bargain by creating an artificial demand for opium in China, in exchange for other commodities coveted by Western markets. By 1817, Americans constituted 10 percent of the market for all opium smuggled into China by way of Turkey.[6] China attempted to put a stop to the illicit trade in 1839 by destroying three million pounds of British opium and refusing to pay for damages, fueling the first Opium War. An enamel-on-copper painting of the Hongs, home to the foreign traders in Canton, on fire possibly depicts incidents during the first war, in 1841 (pl. 78). In retaliation for a situation that Britain itself had manufactured, the country declared war on China and forced it to sign the Treaty of Nanjing, which unfairly required China to repay Western powers for losses.

The volatile context of the Opium War lends a sinister aspect to seemingly innocuous souvenirs bought by American traders, such as a pair of Chinese embroidered silk and leather shoes made for bound feet (pl. 79). The size of a doll's shoes, the pair is embroidered with metallic threads, with curved wooden embroidered heels, accompanied by an imitation lacquer box for storage. Captain C. E. Barker was said to have gifted the shoes to his wife in 1852 after returning to New York from China.[7] Perhaps such "authentic" curios evoked the idea of a distant Chinese culture far removed from American values, including foot-binding, a cultural practice that was the subject of reform-minded Christian missionaries in China. In striking contrast, contemporary artist Lee Bul's cyborg leg resists the fetishizing language of Chinoiserie by using the delicate medium of porcelain to create the powerful, protective armor for a half-machine being (pl. 80). The soft, bendable, and diminutive shoes call to mind the ways in which gendered collectors' curiosities had become yoked to erotic fixations, perversions, and fetishes, by the end of the nineteenth

century. Once a site of wonder and rarity, the curiosity cabinet, as a space where "assembled treasures nested and multiplied, habitually contained familial icons, objets d'art, and private papers," intersected with the peep show and the brothel, and the spaces of "morally tainted connotations of closet sexuality."[8] Though James McNeill Whistler's *Purple and Rose: The Lange Lijzen of the Six Marks* (1864) has often been read in terms of his connoisseurship of Asian ceramics and its role in the Aesthetic movement, the cramped proximity of Whistler's own ceramics collection around the languid model pretending to paint "long Eliza" figures on a vase recalls the erotically charged space of the bric-a-brac curio cabinet (pl. 81).[9]

Violent looting and erotic fixations reshaped the language of Chinoiserie in the nineteenth century. The looting of the Summer Palace (Yuanmingyuan) in 1860, according to one scholar, was a rupture that "sounded the death knell" on prior fantasies of China as a faraway, mythic place.[10] Chinoiserie became a style that symbolized Europe's aggressive imperial ambitions. During the second Opium War (1856–60), as British and French troops advanced from the south to the Qing capital of Peking, they laid siege to the Yuanmingyuan, or Garden of Perfect Clarity, which included a Baroque-style residence that had been built by the Qianlong emperor from 1747 to 1783.[11] In addition to widespread looting, British troops torched the palace and reduced it to ruins. Along with the objects given to the soldiers who ransacked the palace, the prized possessions of porcelains, jade, imperial robes, and armor were ceremoniously gifted to Queen Victoria of England and Empress Eugénie of France, the latter of whom established a Musée Chinois at the Château de Fontainebleau. Before establishing the museum, Empress Eugénie reserved certain objects for her personal apartments at the Tuileries, such as colorful cloisonné enamels. When contemporary poet Sally Wen Mao recently encountered Eugénie's famed cloisonné enamel chimera at Fontainebleau, she saw "Inside a vitrine / That held my century of humiliation / My looted histories."[12]

Loot prompted imitations by ceramics manufacturers including Minton, which combined the brilliant colors with designs created by Christopher Dresser. Minton displayed the wares at world expositions, and competed with works by other British manufacturers such as Royal Worcester, which appealed to a growing European interest in Japan after American commodore Matthew C. Perry forcibly opened isolationist Japan to the West in 1853, under the American banner of manifest destiny. Japan captivated Europe, creating a division between Japonisme and Chinoiserie, to which it had formerly been associated without much distinction. Regardless of their points of origin, both styles were grafted onto racialized fantasies of Asian beauties. Royal Worcester modeler James Hadley was celebrated for his Japanese-themed pieces, including a figure of a Japanese woman in a kimono reading a letter, seemingly the ceramic precursor to Giacomo Puccini's *Madama Butterfly*, based on an 1898 short story by the American writer John Luther Long. *The New York Times* quoted Long as a self-described "sentimentalist and a feminist, and proud of it" (pl. 82).[13]

The missionary zeal of American imperialism, and the attempt to bring the capitalist culture of the "New World" to territories around the globe, appears on a pair of vases with female allegories of the continents painted by the American diplomat Joseph S. Potter, while stationed in Germany around 1886–89 (pl. 83). Based on the shape of Sèvres vases, one vessel depicts female allegories of the "Old World": Africa is a dark-skinned Nubian-Egyptian princess with bare breasts, and Europe is an enthroned queen surrounded by spoils and monuments. Asia is a South Asian woman accompanied by the architecture of India on the left and China on the right, with a blue-and-white porcelain vessel in the foreground. To this group, Potter added the "Old World" in the form of an impoverished, barefoot Mary Magdalen–type figure situated in a cramped workroom. The "New World" shows a young woman enriched by consumer goods afforded by American commerce, from a richly decorated mantel to a field ripe with a rich harvest, and mountains and a sun to suggest the iconography of manifest destiny. Highly sexualized, the woman has raised her skirt to reveal a glimpse of her stockinged foot and pink shoes. North America is further represented by a woman on a throne surrounded by the American flag and the Statue of Liberty. Australia is a dark-skinned aboriginal figure set between a desert and the Pacific Ocean, a pair to South America, imagined as an indigenous princess with exposed breasts. Despite the addition of new geographies, Potter's imperial male gaze fetishizes the territories as gendered acquisitions in an ongoing process of sexual conquest.

Potter's vases reveal the many ways in which the fixed European metaphor of the Four Continents could not possibly account for the complexity of modern diasporic communities in America, among them Chinese immigrants who toiled on the transcontinental railroad in order to fulfill the American notion of manifest destiny.[14] The illicit activities of American merchants in the first Opium War directly impacted American attitudes toward the Chinese. Loath to acknowledge their role in fueling the market for opium, American traders shifted the blame to the Chinese. The American diplomat Edmund Roberts claimed that it was the "depraved habits" of the Chinese that were directly to blame, in addition to a government "conceived by a people refined in cruelty, blood-thirsty and inhuman": "In their habits, they are most depraved and vicious: gambling is universal and is carried to a most ruinous and criminal extent; they use pernicious drugs as well as the most intoxicating liquors."[15] From 1850 to 1880, the Chinese population in the United States went from under 8,000 to 105,465, mostly composed of male laborers.[16] The rarity of women among the early Chinese communities in America made them unsettling anomalies, such as the figure of Afong Moy, who was displayed as part of a traveling United States circus tableau during the 1830s to 1850s, when she was simply known as "the Chinese Lady."[17] In 1874, when a group of so-called unaccompanied Chinese women arrived in San Francisco on the SS *Japan* from Hong Kong, they were immediately presumed to be prostitutes and prevented from disembarking, leading to the sensational

legal case known as the "Case of the Twenty-Two Lewd Chinese Women."[18] As scholar Anne Anlin Cheng observed, for such a monumental case in the history of immigration law policy, a surprising amount of the legal arguments focused upon the question of their "superficial feminine style," as lawyers attempted to determine whether or not the women were "lewd": "the presumptions about their character, which were directly linked to their eligibility for legal personhood, rest on the seemingly frivolous category of ornaments."[19]

Newspapers and other forms of mass media in the late nineteenth century played a central role in circulating stereotyped images of the Chinese as effeminized laborers and female prostitutes without morals, who could not possibly be assimilated into American "values."[20] The rapid dissemination of the press at the turn of the century brought the racial politics of "the immigrant question" in the United States to bear upon the perception of Qing China. In a broader European context, political cartoons that appeared in 1900 satirized Empress Dowager Cixi as a bloodthirsty and cruel tyrant and the power behind the Boxer Rebellion, a xenophobic popular uprising that targeted foreigners in China. Like the allegorical figures, Cixi wielded attributes in a caricature in the French periodical *Le Rire*, yet the ornate fan, elaborate robe, and feathered Manchu hat were used to cloak the bloody dagger in her talon-like left hand (fig. 40). The same year, the German periodical *Der Floh* depicted her as a witch riding a dragon and holding a broomstick against the West's fully armed figures to create the indelible image of the dragon lady (fig. 41). In both images, Cixi was pictured as a monstrous figure who represented the opposite of the idealized, youthful female figures circulated through *meiren* fantasies of the past.

Cixi's association with the racist stereotype of the dragon lady joined the repertoire of Chinoiserie's cultural types circulating in the popular imagination at a moment of heightened racial divisions, particularly in the United States. In a deliberate attempt to soften her image in the foreign press, Empress Dowager Cixi invited Yu Xunling, the brother of two of her royal attendants, Yu Deling and Yu Rongling, to take photographs of her in the palace in 1903. The first and last Chinese ruler to publicly circulate her likeness, Cixi sought to stage her image to political advantage, which would allow her to hold on to power for as long as possible.[21] More official portraits of Cixi, distributed to European and American diplomats, including American president Theodore Roosevelt, showed her in the fully frontal pose of ancestor portraits on a throne. Such portraits were intended to show Cixi as an approachable woman, civilized and willing to extend her hand in a gesture of friendship to foreigners.

Widely disseminated photographs of the Empress Dowager showed a carefully staged femininity that had been crucial to Cixi's ascent and consolidation of power at the Qing court (pl. 84). Since arriving at the Forbidden City in 1851 as a sixth-ranked consort, titled Worthy Lady Orchid, to the Xianfeng emperor (1831–61), she used her feminine wiles to gain the favor of the emperor. She ultimately secured her position by giving birth

Fig. 40. Caricature of Cixi in *Le Rire*, 1900
Fig. 41. Caricature of Cixi in *Der Floh*, 1900

to the emperor's only male heir, Zaichun, in 1856, and moved up in rank to Imperial Consort Virtue, second only to Empress Ci'an (1837–1881), with whom she would become co-regent after Xianfeng's death in 1861.[22] Speaking from behind a screen, because the two female co-regents were not meant to be seen, Cixi began to wield considerable political power while ruling on behalf of her son. After Zaichun's death from smallpox in 1875, Cixi appointed her four-year-old nephew Zaitian as the Guangxu emperor. When he attempted to implement reforms in 1898, Cixi seized power again, placing him under house arrest and initiating a third regency period, during which time she supported the peasant-led Boxer Rebellion. Throughout these moves to consolidate power, Cixi carefully crafted an image that outwardly represented her secondary status as a woman and a consort, even as she subverted the tropes of objectified female beauty found in *meiren* paintings. In a portrait of Cixi painted by American artist Katharine Augusta Carl, she intentionally included the more feminine symbol of peacocks in the background in reference to her status as a consort (fig. 42). American viewers of the portrait at the St. Louis World's Fair in 1904 nonetheless found it imposing, primarily because of the heavy, masculine carved frame (apparently approved by the dowager empress) into which it had been set.

The unofficial images of Cixi playfully subvert the official ones sent to foreign diplomats. In one image she is shown posing in front of a small hand-held mirror, while

rearranging her hair with a hand decorated with nail guards. Nail guards, a clawlike, prosthetic extension of the body, were a fashionable status symbol that also functioned as an expression of her power, which the Western press had transformed into a long talon or claw (pls. 84, 85). Cixi was not the only one to wear these enhancements, added to the fingers because one did not work and could have these elegant extensions with minimal distraction. Shanghai courtesans, who were widely copied for their fashions and were the first real "celebrities" of the late Qing dynasty, wore them, as suggested by the *Fille de Shanghai* shot by the Yokohama-based Austrian photographer Baron Raimund von Stillfried during a trip to the city in April 1876 (pl. 86).[23] Stillfried's photographs recall studio portraits of courtesans, commissioned as calling cards for clients. Typical wardrobes included elaborate ornaments and costumes that deliberately made reference to characters from *Dream of the Red Chamber*, the famous mid-eighteenth-century novel that had been turned into a popular opera.[24]

Fashion tied Cixi in unexpected ways to the world of "playground Shanghai," where courtesans functioned as the ciphers of an urban modernity.[25] No longer relegated to the "inner chambers," these modern women were seen in public riding around the city with clients, while their interior decorations and fashions were publicized in periodicals. Like the Shanghai courtesans, Cixi too found modernity in self-adornment and ornament, and declared: "A woman's life is meaningless if she does not make an effort to refine and enjoy self-adornment."[26] After the imperial manufactories could not keep up with her orders for textiles and accessories, she established a personal manufactory in Zhonghai in 1890 to cater to her fashion demands. Butterflies, formerly a marginal element of women's dress, became a central repeat pattern on the main fabric for jackets and on sleeve borders, while bamboo, incorporated as a textile motif, was a symbol of "wishing for someone's longevity."[27] A sleeveless jacket with a bamboo and rock motif is similar to one that Cixi wore in a photograph from 1903 (pl. 87). Most unusually, Cixi favored the court embroiderers to the extent that she asked them to provide the designs for imperial porcelains, which was unprecedented for the Qing court. She was the only Qing imperial woman to commission porcelain from the imperial workshops in Jingdezhen, a privilege that had belonged to male authority.[28] The Daya zhai ware, originally commissioned in 1874 and completed two years later, featured flowers and birds, incorporating the same design logic of Cixi's costumes.[29] A bowl associated with this group is marked with the typical red characters of Daya zhai (meaning "studio of utmost grace") and is decorated with flowers painted in the so-called boneless style without an outline, set off against the bright yellow ground (pl. 88).[30]

Though two decades separate the caricatures of Cixi and the moment when Anna May Wong appeared on the silver screen in the 1920s, the shadow of these racist and sexist tropes followed the Chinese American actor to Hollywood in the form of the dragon. Cixi tapped into Qing imperial traditions reserved for men even as she carefully circumvented the social and cultural strictures of imperial hierarchy. One symbol she emphatically did not use was

Fig. 42. Katharine Augusta Carl (American, 1865–1938). *The Empress Dowager, Tze Hsi, of China*, 1903. Oil on canvas with camphor wood frame, 117 × 68 ¼ in. (297.2 × 173.4 cm). National Museum of Asian Art, Smithsonian Institution (S2011.16.1-2a-ap)

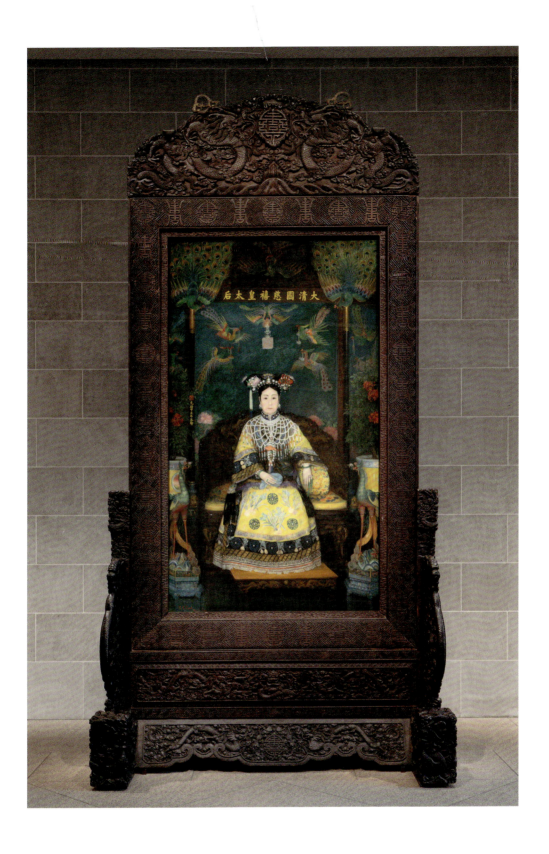

the dragon, the symbol of the monarchs, which makes the irony of the term *dragon lady* even more striking. The dragon was adopted with abandon by Western manufacturers such as Old Hall Porcelain Works, with little regard for its imperial importance. By the time Wong appeared in the 1934 film *Limehouse Blues* wearing a dragon dress, the image had become a cipher for the Asian femmes fatales that Wong had to repeatedly perform on screen, before she was eventually killed off, never to reach a happy ending.[31] In the publicity images for *Daughter of the Dragon* (1931), the white dragon being ridden by Cixi has reappeared in the form of an apparition that Wong appears both beholden to and frightened by (fig. 43).

Chinoiserie cast a long shadow over the career of Wong, born on January 3, 1905, in Los Angeles, who became the first Asian American actor to dance, sing, and act in Hollywood films. She donned elaborate, expensive costumes that showed off her figure, even though she could not be kissed because of the Motion Picture Production Code, which banned any insinuations of miscegenation and interracial romance.[32] She played courtesans, seductresses, villains, assassins, prostitutes, and co-conspirators, but never the female lead role who got the guy. Even when she left Hollywood for England, Germany, and France, she encountered racist segregation laws that would never allow her to consummate a relationship with a character on-screen. Her body was the object of desire and fascination, but also forbidden, a source of poison. She nearly always died at the end of movies, leading her to half-jokingly say that her tombstone should read "she died a death by a thousand cuts."

In film stills, miniature cigarette postcards, and publicity shoots, the specters of Chinoiserie clung about her face and body, paired with the shadows of dragons. Porcelain and flowers, which were also featured in courtesan photography of the nineteenth century, served as props to channel a certain kind of Asian femininity that could be packaged alongside cigarettes. Although Wong began her work in silent pictures, she transitioned to talking pictures, which apparently shocked audiences when they heard an Asian woman with an American accent. The need to explain her voice, and to contextualize it, probably led her to learn multiple languages when she traveled to Europe. The need to explain her origins, "where she really came from," even if it was entirely made up, is the subject of a song that she penned and sang as part of her cabaret routine (pl. 89).

Wong used glamour as a shield to undercut the humiliating, degrading, and ultimately limited roles she was forced to play in Hollywood films, which reduced her to a one-dimensional figure built not only from racial fantasies but also from misogynistic and racist stereotypes of the Asian woman. Legally, the Chinese Exclusion Act, implemented in 1882, had banned Asian immigration to the United States, making the appearance of an Asian woman on screen even more unusual. The films she starred in thus focused on her as an ornamented body, rendered glamorous through costume changes and fashion, rather than conveying any inner depth. These allowed filmgoers to escape confronting the paradox of

Fig. 43. Promotional image for *Daughter of the Dragon*, 1931

Wong's position as the only ethnically Asian actor to play Asian roles alongside white actors in yellow face, or as an American woman forced to perform Asian roles.[33] One of the most fascinating interviews with the actor took place with the German philosopher and cultural critic Walter Benjamin in Berlin in 1928. Published as "Speaking with Anna May Wong: A Chinoiserie from the Old West," in *Die Literarische Welt*, the interview included Wong revealing details of her life stitched together like a Surrealist collage. She told Benjamin that her favorite dress was cut from her father's wedding coat; he wrote that the "fabric was donned divinely / But the face was even finer."[34] She also described one of the earliest moments in her childhood when she realized she wanted to be an actor. Having played hooky from school, she bought a ticket to the theater and returned home to rehearse the scenes in front of a mirror. Wong's mother caught her and reprimanded her. Wong then expressed her desire to play one role: "The best are mothers. I've played one before, at fifteen. Why not? There are so many young mothers." Often discussed in terms of the unusual encounter between the film star and one of the most important German philosophers of the twentieth century, the interview is also revealing for the ways in which Wong attempts to sew a story for herself. Spun in another way, the

many costumes she had made for herself, both on and off screen, evoke the notion of self-invention. She is armed with a piece of her father's coat and plays (her) mother; Wong births herself (pl. 90).

A year after Wong's interview with Benjamin, German Bauhaus artist Marianne Brandt created a photomontage that included the Asian American starlet from 1929 (pl. 91). Abandoning the tropes of Chinoiserie and its ornamentation, Brandt pastes glamorous women and animals together, capturing them under layers of transparent material. What at first appears as liberating, the Surrealist juxtaposition of random pieces taken from mass media, on second glance lends itself to a reinterpretation of the Four Continents, and the ways that women are entrapped and exoticized much like the zebra and giraffe cut out and arranged on the picture plane. Reduced to parts, Brandt's montage inadvertently restages the violence implicit in Chinoiserie's fantasies in the age of commodities: an exotic machine that reduced women to fetishized body parts, ready to be consumed by the masses with no moral repercussions.

Fig. 44. Anna May Wong in *Piccadilly*, 1929. Film still

In 1929, the same year that Brandt made her collage, Wong achieved a new level of fame with the British film *Piccadilly*, the last film she made before she transitioned to talking pictures. She plays the role of Shosho, a poor dishwasher working in the back of a glamorous West End nightclub that happens to be located in Limehouse, then home to London's diasporic Chinese community, who outshines the English blond headliner Mabel Greenfield with her dance (fig. 44). Although Wong had left Hollywood for Europe to escape the blatant racism of Hollywood, she discovered that things were hardly different in England, where her performances on stage were seen through the prism of Chinoiserie. Besides pitting Wong against her white rival, which eventually necessitated her death on screen, she could not share an on-screen kiss with her male costar. Although *Piccadilly* proved to be a critical success, Wong was viewed as simply a mechanical, performing body. The *Picturegoer* wrote, "By her immobility, her reposeful body movements that are certainly her Oriental heritage, she gave a touch of dignity to the siren she portrayed."[35] Anne Anlin Cheng has offered an alternative reading of Wong's dazzling performance in *Piccadilly*. On the one hand, her central performance at the nightclub, where she dons a Thai-inspired headdress and armor-like suit, enacts a primary example of what Cheng describes as "Orientalized femininity," which relies "on the spectacularization not of naked skin but of ornament: the excessive coverings and decorations that supposedly symptomize the East's overdeveloped and hence feminized and corrupt civilization."[36] On the other hand, Shosho's body uses the very mechanisms of Chinoiserie—shine, ornamentation, slick surface, and the gleam of lacquer—to deflect the gaze that seeks to arrest and objectify her, where the viewer is "thrown back at our own watching, our own dwelling, reminded that the true object of fascination in the cinematic experience is light and what it means to be held by light."[37] Resistant for a moment to the gaze, Wong's body is protected by the brilliant, scalelike armor covering her body, so that it cannot be captured, not even by the camera. The shimmering, gleaming monster lurking under the surface of Chinoiserie is a figure shedding its skin, always changing, twisting, turning, with scales flying. This rematerialization hovering at the margins of Chinoiserie in porcelain provides a meaningful context for the contemporary artist Lee Bul's reclaiming of the monstrous as a means of interrogating the strictures of feminine discourse. In her piece *Monster: Black*, first created in 1998 and reconstructed in 2011, the artist reconfigures elements associated with the feminine, from sequins, soft cotton fillings, dried flowers, and beads (pl. 92). She uses them to construct a towering and writhing figure of indescribable shape that resists attempts to be caged or contained, limbs that resemble those of the Hydra, the mythological creature associated with the dangers of the sea, traversed by ships that first brought the shiny bodies of white porcelain to Europe.

76. Chinese, made for the American market. Tureen with cover, early 19th century. Hard-paste porcelain

78. Chinese, made for the American market. *Burning of the "Factories" in Canton*, 19th century. Oil on copper

79. Chinese, made for the American market. Lacquer box and shoes, ca. 1852

81. James McNeill Whistler. *Purple and Rose: The Lange Lijzen of the Six Marks*, 1864. Oil on canvas

83. Decorated by Joseph S. Potter. Vase (*Old World*) (one of a pair), ca. 1886–89. Porcelain with enameled and gilded decoration

人清國今當慈禧端佑康頤昭豫莊誠壽恭欽獻崇熙聖母皇太后

EMPIRE DAUGHTER TJIHSI TAI HAO

85. China, Qing dynasty (1644–1911), 18th–19th century. Nail guard. Silver

87. China, Qing dynasty (1644–1911), Guangxu period (1875–1908), late 19th century. Woman's sleeveless jacket with bamboo and rock design. Silk and metallic thread tapestry (*kesi*)

89. Anna May Wong. Manuscript for "I'm Anna May Wong." Sheet music
90. Augusto, Ltd. Evening coat, ca. 1934. Silk, paper, metallic thread

OBJECT
ENCOUNTERS

THE STRANDED BEAUTY OF YEESOOKYUNG

ANNE ANLIN CHENG

Is this *she* or *it*, what with those
empty bowls and vases miming hips
and those self-interrupting
lines acting
as gestures or broken speech?
Are we bearing witness
to organic remains or synthetic creations,
feral proliferation or arrested development?

Such delicate beauty
born out of fire:
too beautiful to be used,
too beautiful not to abuse.

1851, Charles Dickens: "The word 'Porcelain'
came out of the Portuguese [who] fingered
much Oriental money in the shape of shells,
which, on account of a fanciful resemblance
between their backs and the backs of little
pigs, were commonly called *porcellana*. That
name presently was transferred by merchants
to the thin, shell-kind substance of the
Oriental cups."[1]

1852, 34th Congress, 1st Session, House
Executive Document No. 105 on the "Slave
and Coolie Trade": "The port of Macao
engaged in the traffic of buying and selling
Chinese [in] '*Chu-tszt Kwan*,' or Pig Pens.
Each barracoon procures its men from swindlers,
who obtain them through deception. They
wait to embark together, and all are shipped
to foreign countries, where they are resold
for perhaps over a hundred dollars per head.
After their persons are thus sold they then
turn the bodies of the [leftover] Chinese into
fish baits."[2]

1857, Karl Marx, "Some Official Correspon-
dences": "The Doctor knows perfectly well,
nobody better, that the true cause of the
present and former difficulties between the
Chinese and the English was and is, not as he
pretends 'the unwillingness of the Chinese to
acknowledge England, France, and America
and other great nations of the West as her
equals,' but the unwillingness of the Chinese
authorities to allow their subjects to be
poisoned with opium for the pecuniary
benefit of the British East India Company."[3]

Before the trade in "pigs and poison,"
there was porcelain.
Porcelain, porcellana, materia nova, white gold.
The stuff of alchemy:
silicate to form,
clay to treasure,
human to animal,
animal to goods.

Money, ruins, and beauty
have long been companions . . .
inventors as well.

2010, Alden Cavanaugh and Michael E. Yonan,
eds., *The Cultural Aesthetics of Eighteenth-
Century Porcelain*: "With the exception of
tapestry and silver, no artistic medium [was]
more coveted or more valued than [porcelain],
[along with] its continual association with
exotic lands, a semi-magical material, a
'white gold.'"[4]

93. Yeesookyung. *Translated Vase*, begun ca. 2002,
ongoing. Ceramic shards, epoxy, 24K gold leaf

Queen Victoria went to her grave clutching
her china doll and her Wedgwood.
George Washington counted his ceramics
in a ledger by candlelight.
(George be nimble, George be quick.)

Shakespeare should have named porcelain
one of his three caskets.

And the magic spreads
like a fairy tale, like gas.

1298–99, Marco Polo: "[Chinese women] are
extremely accomplished in the arts of
allurement in so much that strangers who
have once tasted their attractions seem to
get bewitched."[5]

1996, *The New York Times* on the Olympics:
"The Chinese remain the world's most erratic
top gymnasts, and today, like many a Ming
vase, their routines looked lovely but had
cracks in several places."[6]

2023, YouTube tutorial, "How to Achieve
K-Pop Idol's Clear, Glass Skin": "Glassy skin
[is] the global holy grail."[7]

Hard, soft, bone,
fetish and flesh

Translucent porcelain = Asiatic female flesh
Asiatic female flesh = translucent porcelain
a mirror of wounding beauty

Before pigs and poison, there was porcelain.

July 6, 1992, Koichi Kato, chief cabinet
secretary of Japan: "The Government again
would like to express its sincere apology and
remorse to all those who have suffered
indescribable hardship as so-called 'wartime
comfort women,' irrespective of their
nationality or place of birth."[8]

The war zone is not only between
East and West
but also intra-Asia.

The war zone is not only geopolitical
but also women's bodies,
that trinity of
Comfort, Convenience, Concupiscence.

Yeesookyung: "I have no intention of healing
or fixing the objects. Rather, my work can be
seen as glorification of the fateful weakness
of being, including myself. Gold, one of the
most important materials in my work, is used
not to restore or heal, but to highlight that
breakage and find a unique beauty in objects
that sparkle in the midst of ruins."[9]

Fig. 45. Yeesookyung (South Korean, b. 1963).
Translated Vase, begun ca. 2002. Ceramic shards,
epoxy, 24K gold leaf

A landscape of abandonment and retrieval

No eyes, no mouths.
Yet nothing but body parts:
a trailing song of
spleens, ovaries, hearts, teacups, and plates

Where are the objects that you made?
Where is the "you" made of objects?

Hers is a self-portraiture in parts,
a dream of singular multiplicity.

To find beauty in the cracks
is to know transformation
where there is nowhere else to go.

What can survival look like?

Repetition and seriality
as decomposition,
as formal growth.
A doing that is an undoing.

Each broken piece moves toward
self-formation, an agentless agent,
generating proliferations toward an
unexpected fabrication,
an assemblage of fictitious loquacity and
stuttering discards.

Art and waste, human and inhuman.
At once more Woman and more Thing.

Sure, woman is vessel,
but did you notice that
the cups, urns, and bowls here are
all sealed?

This is how we talk about beauty
in a broken world.

INTERIOR OF
A CHINESE SHOP

DAVID PORTER

Amsterdam in the seventeenth century was Europe's leading global entrepôt. Its two rivers, the Amstel and the IJ, teemed with ships bearing treasures from far-off corners of the earth destined for trade depots amply stocked with dazzling wares that would brighten the dusky interiors and virtuosic canvases of the Dutch Golden Age. Most conspicuous among these novel luxury goods were the matchless fineries of the Far East. The dozens of East India shops that sprung up in the city's bustling business districts overflowed with novel luxury goods the likes of which Europeans had never seen and, for decades to come, would lack the know-how to create themselves: exquisite porcelain vessels, gleaming lacquerware, colorful silks, fanciful figurines in exotic garb.[1]

Acquiring and displaying such wondrous objects quickly became a mark of status among the fashionable elite, representing at once cosmopolitan taste and commercial success. Visual and written sources like this rare and remarkable fan leaf, make clear that Asian imports exercised a particular fascination for women, with whom they soon became closely identified in the popular imagination across Europe. Painters of domestic scenes regularly paired wives and mothers with their beloved chinaware, while essayists and poets riffed predictably on the resemblances between shapes, textures, and colors of fine porcelains and physical attributes associated with the feminine ideal.[2]

The form and function of this fan leaf took the early gendering of Eastern exoticism well beyond a simple cliché (pl. 94). Painted in gouache on paper in the late seventeenth century, this extravagantly illustrated scene of an imagined china shop was originally designed and likely used as a woman's folding fan. Faint lines radiating upward and outward from the center of the base—at least two can be seen

on the right side with the naked eye—betray the original creases, while vestiges of a rounded edge across the top suggest that its two upper corners were added to form a rectangular image at a later date after the fan was retired from use.[3]

The opulent display of wares sprawled across every surface of the spacious shop conjures the bounty of the East India trade. Equally striking is the depiction of the shop's customers, who are all women, a notable contrast to the connoisseurs depicted in the conventional *Kunstkammer* canvases by Pieter Bruegel the Elder and other contemporary painters to which the unknown fan artist alludes. Clusters of well-dressed women, their garments and appearance suggestive of Persian or Indian provenance, examine the wares, perhaps discussing their merits and faults among themselves. The only men appearing in the scene are several seemingly incidental figures lingering in the back hallway and gazing out from paintings on the gallery wall.[4]

The implied connection between these women and their favored Asian wares is reinforced by the artist's conspicuous use of formal patterning within the scene. The rounded contours of the standing women's elegantly draped bodies are echoed by those of the oversize porcelain pots and vases that surround them, while multiple female figurines, most likely depicting the Chinese goddess of mercy, Guanyin, are interspersed among the shapely vessels arrayed on the countertops (see pl. 104). One cluster of three women seated near the center of the image and a second standing behind a counter toward the right are both accompanied by pell-mell collections of folding fans spread out across the surfaces before them. The fans' concealed pleats and folds are conspicuously echoed throughout the painting by the crests on the customers' headpieces, a large folding lacquerware screen, and the heavy

draperies that have been pulled back from several openings in the gallery walls to reveal, teasingly, additional collections of furniture and vases behind them.[5]

We have no evidence concerning the original purchaser of the fan. Based on contemporary paintings and estate inventories, however, we might surmise that she was an elite Dutch woman associated with a successful merchant family. Their wealth may have stemmed from the same East India trade whose bounty the fan's design so vibrantly evokes. The scene might have reminded beholders of the commercial success behind the owner's elevated social status. In turn, the owner might have identified with the worldliness of the shop milieu and the cosmopolitanism of its customers, imagining herself as a citizen of an expansive and interconnected globe that would have been inconceivable to her foremothers only a few decades earlier. Unfurling and displaying her fan would have been a gesture that not only revealed and invited admiration of its sumptuously rendered gallery space but that also encouraged recognition of her own metonymic association with its inhabitants. Surely the fan's owner, like the customers in the china shop, prided herself on being a fashionable consumer, a seasoned connoisseur of exotic wares, and with the help

of her accessory, an artfully presented token of aesthetic appreciation in her own right.[6]

Apart from its multilayered workings as a status symbol for its original owner, the scene displayed on the fan simultaneously presented a reminder of a broader transformation, just getting underway in late seventeenth-century Europe, of the spatial configurations of female agency. The fortunes created by expanding international trade would fuel the rise over the next several decades of a recognizably modern consumer society, with its invention of shopping as a leisure activity, the spread of previously rare luxury goods, and a growing preoccupation with fashionable taste among broader sectors of society. Women's activity in this extensive marketplace as buyers and sellers would be widely commented on as a source of both empowerment and social disruption. By the mid-eighteenth century, a misogynistic backlash against these changes would contribute to a dramatic degradation in the aesthetic assessment of the Chinese taste, transforming the scene evoked in the fan from a space of wondrous novelty to one of clichéd and even monstrous kitsch.[7]

94. Unknown artist (The Netherlands). *Interior of a Chinese Shop* (fan leaf), 1680–1700. Gouache on paper

DRAGOON VASE

PENGLIANG LU

This monumental vessel is among the rare and celebrated Chinese porcelains with their own nondescriptive name—"Dragoon Vase" (pl. 95). The moniker is not derived from the vivid dragons encircling its body, but from a legend that emerged in Europe when Chinese porcelains were frantically pursued.

In 1717, Augustus II the Strong, elector of Saxony and king of Poland, forged an unusual agreement with the Prussian king Friedrich Wilhelm I. Augustus managed to obtain 151 pieces of Chinese blue-and-white porcelain from the Prussian king's castles in Oranienburg and Charlottenburg near Berlin. In exchange, he agreed to pay for the vases not with money, but instead with six hundred Saxony soldiers, who later formed a dragoon (mounted infantry) regiment in Prussia. Among the porcelains that were in the transaction are eighteen monumental vases later known as "soldier vases" or "dragoon vases."[1] The vases were intended not only as interior decoration but to highlight the Saxon ruler's ambitious plan to create an entire castle called the Japanese Palace dedicated to East Asia porcelains, a symbol of artistic, scientific, and political power.

The most prominent set of dragoon vases remaining in the former collection of Augustus II the Strong includes seven that are now on display together in the Zwinger Palace, Dresden (fig. 46). This type of monumental vase decorated with dragons and floral scrolls is also found in other collections in Europe and the United States.[2] Some have records dating before or slightly after the 1717 exchange. Two examples now in

Fig. 46. China, Qing dynasty (1644–1911), Kangxi period (1662–1722), ca. 1700. Seven "dragoon vases" on display at the Zwinger Palace. Staatliche Kunstsammlungen Dresden

Petworth House (Sussex) were acquired in the early 1690s by the Duke and Duchess of Somerset.[3] A pair owned by Princess Sophia, daughter of George III, is now in the Royal Collection at Windsor Castle.[4] Some of the Dresden porcelains were later sold at different times, including one dragoon vase auctioned in 1920 to pay for war debt.[5] After more than eighty years in private hands, the vase was acquired in 2001 by the Peabody Essex Museum, Salem, Massachusetts.[6]

The piece in The Met was bequested by Mary Clark Thompson, one of the founders of the Museum. Related archival records do not indicate where and when Thompson obtained the vase. Without direct proof, it is difficult to confirm whether it was once in the Dresden collection and part of the exchange of

dragoon soldiers.[7] Given the consistency in design, size, and style, however, it is certain that the vase in The Met and those in Dresden were originally from the same workshop, possibly by the same hands, in Jingdezhen, during the mid-Kangxi period, a golden age of Chinese blue-and-white ware.

Notably, no examples of this type have been found in China. Such monumental vessels seem to have been made exclusively for the European market. Leaping dragons, the vivid tone of blue and white, the shining porcelain surface, and the massive size composed a dream work of art satisfying Baroque monarchs' and aristocrats' pursuit of a fantastical East. Augustus's trade is direct evidence of this frenzy, suggesting the high price he was willing to pay in exchanging

human soldiers for vases made of porcelain. In China, however, such large vessels would have been out of scale for home use and extremely difficult to make.[8] Therefore, these porcelains, unusual for the Chinese domestic market, reflect a market-oriented effort to satisfy the European image of China. They may be considered "Chinoiserie" works made in China.

95. China. Qing dynasty (1644–1911), Kangxi period (1662–1722), late 17th–early 18th century. Jar with dragons and floral designs. Porcelain painted with cobalt blue under a transparent glaze (Jingdezhen ware)

CHINOISERIE AND THE MEXICAN GARDEN

RONDA KASL

Between 1573 and 1815, the transpacific trade route that connected the port cities of Manila and Acapulco made possible the exchange of Spanish American silver for Asian luxury goods, especially silk and porcelain, the bulk of which originated in China. An indication of the sheer volume of trade is registered by the 22,300 pieces of "fine gilt china and porcelain ware" included in the cargo of the inaugural shipment of the so-called Manila Galleon.[1] Although some of the imported merchandise brought by the annual fleet was relayed to Spain, much of it remained in New Spain (present-day Mexico), where it had an enduring impact on the material culture of the viceroyalty. Colonial elites wore clothing made from imported silk, drank chocolate from porcelain cups, and socialized in salons brightened with Chinese wallpaper and furnished with lacquer screens. European imports, including Chinoiserie, and "orientalized" local imitations in various media (described as *achinado* or *al remedo de la China*) were apt to be found in the same domestic settings. The display of such possessions not only signaled wealth and social status, it also informed an ongoing creole discourse of self-identification that celebrated New Spain's prominence in global trade and its privileged access to the riches of China.

The production of a distinctive Chinese-inspired style of tin-glazed earthenware was already well established in the city of Puebla de los Ángeles when, in 1682, the ordinances of its potters' guild were revised to reflect existing practice. One new clause stipulated that the painting of fine ware (*loza fina*) "must imitate that of China and be done in very bright blue."[2] The guild ordinances document not only the explicit intent to imitate Chinese porcelain, but the professional resolve to control and authorize material aspects of the process, thereby identifying decoration in "bright blue" as its defining trait.[3] Puebla potters also copied the distinctive shapes of Chinese porcelain. The barrel-shaped form of this large, thickly potted earthenware planter is reminiscent of ceramic garden seats (pl. 96, fig. 47). Its blue-and-white ornamentation is likewise inspired by imported porcelain, while its figural decoration, which conjures four Chinese types or occupations, is indebted to European Chinoiserie. The fanciful figures are separated by four pendant lappets in blue with floral sprays in white reserve. The outlandish dress of the barefooted figures—a musician, a dancer, a merchant, and a mariner—marks them as "foreign," if not specifically Chinese in every instance. The ethnicity of the mariner, who brandishes a navigation compass and peers through a telescope, is more ambiguous than the other three figures. Such imprecision is consistent with the tendency in New Spain to identify nearly all Asians (and Asian goods), regardless of their exact origin, as "Chinese." Characterized as entertainers and maritime traders, their representation on a flowerpot all but assures that they were read as amusing or even comical figures, well-suited for the adornment of a place of recreation.

With a few exceptions, the patio and garden settings where pots like this one once sat filled with flowering plants and small trees survive only as descriptions in archival documents,

travelogues, and urban panegyrics. By the seventeenth century, it had become fashionable among Mexico City's wealthiest residents to build country houses (*casas de recreo*) and gardens on the rural outskirts of the capital or in nearby provincial towns.[4] The barrel in The Met is roughly contemporaneous with the 1784 inventory of the residence of the counts of Xala in Mexico City, which lists forty-one large porcelain vases (*tibores*) from China, used as planters. There were more than ninety blue-and-white pots from Puebla filled with carnations and orange trees in the patio of their country residence.[5] Similarly, the nine-acre garden begun by Xala's close friend José de la Borda in Cuernavaca and completed in 1783 was accessed through a corridor arcade that featured caged songbirds and flowering plants in Pueblan pots.[6]

The spare language of inventories stands in stark contrast to the vivid descriptions of Mexican gardens written by travelers and sojourners. Frances Calderón de la Barca, the Scottish wife of a Spanish diplomat who resided in Mexico from 1839 to 1842, described a "singularly pretty" garden in Tulancingo (Hidalgo), about which she observed: "There is something extremely oriental in its appearance, and the fountains are ornamented with China

vases and Chinese figures of great value." She singled out sparkling fountains and a profusion of roses for praise, while admiring a pool of water with a draped garden pavilion, which she called a "Chinese building." "They call this an English garden," she wrote, "than which it rather resembles the summer retreat of a sultan."[7] Structures known as *cenadores* or *chocolateros* were characteristic features in Mexican gardens, where they were used to receive and entertain visitors, and serve meals and refreshments, including beverages like chocolate. The garden pavilion was the outdoor analogue of the *estrado*, a partitioned domestic space within the main reception room, where women gathered to engage in activities like reading, sewing, and playing music. A tradition of Hispano-Islamic origin, the *estrado* takes its name from the low wooden platform furnished with carpets and cushions where women sat and socialized. It is not possible to trace the original setting of the planter in The Met, which might just as easily have adorned the patio or balcony of an urban residence as the garden or orchard of a rural retreat. In any case, it would have occupied a liminal space, somewhere between indoors and outdoors, openness and enclosure, informality and decorum. In a garden setting cultivated for the leisure pursuits of Spanish colonial elites, the blurred spatial and social boundaries would have been further complicated by the literary resonances of the *locus amoenus* and its associations with sensuous enjoyment and amorous intrigue.[8]

96. New Spain (present-day Mexico). Barrel-shaped planter with Chinese figures, ca. 1760. Tin-glazed earthenware

Fig. 47. Detail of pl. 96

TOILETTE OF THE PRINCESS
TAPESTRIES FOR THE
PRIVY CHAMBER OF THE QUEEN

ELIZABETH CLELAND

In 1690, Queen Mary II acquired a set of four tapestries—the quintessential prestige wall-covering—to adorn her private apartments at Kensington Palace.[1] The queen's new tapestries were supplied by the official Yeoman Arras Worker to the Great Wardrobe, John Vanderbank, a talented weaver working in London, who was Parisian-born and of Flemish parentage.[2] Mary evidently liked the tapestries, commissioning extensions and additions from Vanderbank over subsequent years until her death in 1694. By 1696, the four tapestries measuring 99 square ells had expanded to seven tapestries, covering more than 177 square ells of the late queen's private apartments.[3] Although the current whereabouts of Queen Mary's tapestries are unknown (if indeed they survive), their appearance is recorded in a duplicate set woven by Vanderbank for Sir John Brownlow in 1691 "according to ye pattern of the Queens wch are at Kensington," remaining in Belton House (Lincolnshire) (see pl. 97).[4]

At first glance, the tapestries seem as conventional as the circumstances of their acquisition: woven in wool and silk, narrow frames bordering decorative expanses of dark, blank color ground, dotted with miniature floating islands supporting figures, out-of-scale foliage, and wildlife. However, traditional verdures of this type, developed in the early fifteenth century, coined *millefleurs* by nineteenth-century scholars, were limited to a repertoire of pale, northern European falconers, shepherds, and shepherdesses, often on floating islands, against dark blank grounds interspersed with indigenous plants, alongside local and exotic beasts.[5] Unlike any tapestry that had come before, the hangings that Vanderbank supplied to the queen, in contrast, sported pagodas, coconut palms, parrots, fantastic mountain rocks, bridges, and figures with tawny coloring in pan-Asian dress, taking tea, playing musical instruments, stargazing, or cavorting together.

The royal accounts called these tapestries "after the Indian manner"; subsequent inventories of the queen's apartments at Kensington Palace singled them out as "with Indian figures."[6]

Queen Mary II chose to furnish her private apartments at Kensington with millefleurs-style tapestries specifically decorated with Asian rather than traditional European or mythological vignettes, complementing her remarkable displays of Chinese porcelain. Indeed, a subsequent edition of the series, woven not by Vanderbank but by another London-based weaver, Michael Mazarind, includes idiosyncratic borders, arranging Chinese porcelain bowls, urns, and teapots against a warm orange ground (fig. 48).[7] Tapestry historian Edith Standen convincingly suggested that the effect of Mary's tapestries alongside the porcelain displays at Kensington is recorded in the *Nouvelle cheminée* published by Daniel Marot, designer of the palace interiors (see pl. 23).[8] Above and beyond the importance even of porcelain as inspiration to develop such tapestry designs was Queen Mary's taste for Coromandel lacquer rooms (see fig. 21). This extraordinarily evocative interior architecture enveloped its privileged inhabitants in a lush world of black, pastel, and gold, with floating islands of Chinese palaces, trees, mountain rocks, and tiny courtly figures. From 1685 onward, at the Stadholder's House in The Hague and at their nearby country home, Honselaarsdijk, Mary and William created rooms covered from wainscot to ceiling with large, lacquered panels repurposed from wall-scaled Chinese screens.[9] When Mary returned to Britain as queen, she further popularized an existing taste for such Coromandel lacquer rooms, just as her Dutch husband's aunts spread the fashion to Berlin, Munich, and Dresden. Though the lacquerwork was Chinese, the rooms were called Coromandel after the Indian coastline, imported as they were to the West via

Madras (present-day Chennai) and Pondicherry (Puducherry).[10]

The description of Queen Mary's tapestries as "Indian" has traditionally been interpreted as the British muddling Asian identities, with Standen tracing a mishmash of motifs sourced from Japanese lacquered furniture, Chinese lacquer screens, Persian and Mughal manuscripts, and European illustrated printed travel books by Athanasius Kircher (1667) and Arnold Montanus (1669) for these tapestries and others made in imitation of them.[11] More likely, though, is that the Kensington series was intentionally called "Indian" to signal Mary's inspirational Coromandel lacquer rooms. In the same spirit, the clerk inventorying tapestries from this series at Belton House as "Dutch hangings" was referring to William and Mary's court taste and Dutch trade links, rather than suggesting their representations reflected life in the Netherlands. Once divorced from that original royal context, this series and its imitations were described as Japanese:

"tapissirie Jappan" (1700), "fine Jappan tapestry" (1700), or Chinese: "tapisserie noire dessein chinois" (1783).[12]

With a tapestry version of a Coromandel lacquer room, Queen Mary enveloped her private apartments in a textile translation of their dark ground with alternative perspective landscapes, bringing a rainbow of color to enhance her lacquered furniture and blue-and-white porcelain. She was harnessing the traditional connotations of millefleurs as a site for fantastical projection, but replacing unicorns, pansies, and maidens with Asian vignettes— injecting new life into an otherwise staid convention. Commissioning her extraordinarily novel tapestries, the queen looked not to Britain's royal-sponsored Mortlake Tapestry

97. Probably workshop of John or Sarah Vanderbank. *Tapestry "After the Indian Manner,"* called *Toilette of the Princess*, after 1690. Wool and silk

Factory, but instead to her Yeoman Arras Worker and his local workshop in London's Great Queen Street. Mortlake's great competitors, the smaller, more commercial London-based workshops, once again proved their nimble expertise to develop brand-new, idiosyncratic tapestry designs, just as Vanderbank's predecessor, Arras Worker Francis Poyntz, had done for Queen Catherine of Braganza by weaving the equally radical *Grotesques with Don Quixote*.[13] Even more than the *Don Quixote Grotesques*, Mary's millefleurs "after the Indian manner" proved incredibly popular. Subsequent to Sir John Brownlow's 1691 request for "hangings [. . .] of Indian figures according to ye pattern of the Queens," Vanderbank developed an alternative version of these designs, with smaller figure groups, darker grounds, and fewer motifs from printed sources. The so-called Indian tapestries were fashionable among female patrons who emulated the queen. Documented acquisitions include those by Lady Mary Bridgeman of Castle Bromwich Hall (Warwickshire) and Elihu Yale—enormously wealthy via the East India Company—who presented a set to his daughter, Catherine, for her marital home, Glemham Hall (Suffolk) after 1692.[14] The particular appeal, or appropriateness, of this series for women perhaps chimed to the same chords of

femininity that shrouded porcelain collecting and the way British women were enamored of tea-taking. Indeed, the twentieth-century name accorded *Toilette of the Princess* prioritizes the vignette at the lower right—which, in fact, more likely represents a group taking tea. Across genders, these floating dream states were perceived as ideal for furnishing private spaces, as the queen had done. Vanderbank's distinctive tapestries were recorded in the bedchamber of Lord Carlisle at Castle Howard (Yorkshire) in 1706, and Edward Chute hung them in the "North Bedroom" of The Vyne (Hampshire) by 1754.[15]

Multiple editions were woven via commission and on speculation by Vanderbank and other commercial London-based weavers, including Michael Mazarind, Leonard Chabaneix, Joshua Morris, and Sarah Vanderbank, who, once widowed, maintained the family's workshop.[16] They were, however, ignored by the French, who instead confined a parallel curiosity about East Asia in the literal, conventional *Histoire de l'Empereur de Chine*, heavily dependent on printed illustrative accounts and totally different in effect and motivation.[17] Unlike the French impetus to record, even visually annex, East Asia, the London tapestries designed "after the Indian manner" developed the decorative but dreamlike tradition of the best millefleurs unicorn tapestries: enveloping and transporting the queen into an alternate world of fantastic enchantment that posterity would call *Chinoiserie*.

Fig. 48. Workshop of Michael Mazarind. *Tapestry "After the Indian Manner,"* ca. 1695. Wool and silk, 92 1/8 × 154 5/16 in. (234 × 392 cm). Victoria and Albert Museum, London (T.1601-2017)

FAUX-DAIRYING FOR PLEASURE

PATRICIA F. FERGUSON

Queen Mary II once proclaimed that she could live in a dairy, presumably expressing a preference for the rustic simplicity of country life and its produce above royal life and elaborate delicacies. However, this sentiment did not extend to her costly interiors and furnishings, such as this opulent Dutch faience milk pan, typical of the frivolous extravagances for which she was posthumously critiqued (pl. 98).[1] Mary owned several ornamental or pleasure dairies, but also adapted clean, fountain-cooled spaces such as bathing rooms for her dairying. At Het Loo Palace there was a glazed tile–lined room in the cellar kitchen, while at Honselaarsdijk, the bathing quarters in the stable block were preferred. Hampton Court Palace was the most elaborate, where the ground floor of the Water Gallery (demolished in 1700) contained a blue-and-white homage to Chinese porcelain described by Daniel Defoe as "a Dairy, with all its Conveniencies, in which her Majesty took great delight."[2] Evidence suggests these rooms were actually for the mass display of Delftware and porcelain overflowing with cut flowers, complementing the appearance of the queen and her entourage dressed as Eastern princesses on this milk pan.[3]

Known in England as a milk house, the dairy was a female-dominated territory, where the laborious production of "white meat"—milk, clotted cream, butter, cheese, and desserts—was executed by dairymaids. Although servants performed the real work, owners and guests in such pleasure dairies presented themselves as the embodiment of ideal domesticity: purity, patience, gentleness, delicacy, charity, and fertility.[4] Mary laid claim to most of these qualities; however, ill health throughout her married life and the stress of politics and building works meant she never produced an heir to the throne. The dairy, therefore, offered a refuge, a place to temporarily drop the masquerade of formal courtly appearances, surrounded by intimates, and enjoy her passion for objects, her "fatal excesses," while avoiding the anxiety of her infertility.

An earlier dairy had been created on the site in the 1670s in the obsolete Tudor watergate for her uncle Charles II's former mistress-in-chief, Barbara Villiers, Countess of Castlemaine, and later Duchess of Cleveland, whose behavior garnered her the moniker the "uncrowned Queen of England." As a metaphor for feminine virtue, dairies offered a genteel mask of purity, as another European mistress, Louise de la Vallière, kept an inspirational *grande laiterie* at Versailles.[5] The artistry of domesticity as well as queenship may have been schooled by the transgressive Villiers—another porcelain collector—to an innocent Princess Mary while she played in the dairy.[6]

The performative aspect of faux-dairying at Mary's court is captured in the vignettes encircling this remarkable pan, the legacy of an artistic coterie including Mary, Daniel Marot, *Architecte de roi* from 1686, and the proprietor of The Greek A (De Grieksche A) Delft factory, Adrianus Kocx (act. 1689–1694; d. 1701), a royal favorite. Once on English soil, accurate Delft imitations of Chinese porcelain no longer satisfied Mary, who commissioned ever more capricious objects championing Dutch design, such as the large blue-and-white tiles copied from Marot designs, also used for needlework panels in a dedicated room in the piano nobile of the Water Gallery.

The milk pan is one of six such surviving pans, a European form that often has a spout for slowly draining out the milk, once the cream has separated and floated to the top. The decoration is en suite with the set of large tiles often associated with the dairy; however, their regal iconography may indicate they were actually installed in the Delft Ware Closett above it. All six pans share the same basic template, four scenes divided by panels

resembling gilt-metal mounted details on Baroque furniture, again after Marot designs.[7] The other five have scenes of bucolic landscapes visualizing a Dutch arcadia. One pair with cattle is based on engravings by Abraham Bloemaert, published in Amsterdam in 1620, and another is painted in a polychrome mixed technique that includes iron-red enamel and gold. In use, the scenery would only be revealed gradually, once the remaining cream was removed.[8]

Here, however, figural vignettes resembling a triumphant ceremonial parade evoke Chinoiserie fantasies with dairying themes, but on inspection, are primarily European women in masquerade, appropriating the costumes of others. Trumpeting figures lead a procession with an African queen on a lion accompanied

by its tamer; women surround a garlanded cow being milked; and a woman heralds another procession with a trophy including a large bowl carried on poles above their shoulders.[9] The source for these three vignettes has yet to be identified, but the fourth, depicting three women around a table supporting a large dish, a milk pan being stirred, while another holds a large jug and a tall beaker, perhaps of milk, relates to a medallion in a Marot design for a tabletop, about 1689–1702 (fig. 49).[10] In the print, the three women wearing theatrical costumes are drinking tea under a baldachin, a canopy of state.[11] The Delft painter may have adapted the design from Marot's engraving or the original drawings celebrating Mary's triumphant arrival in England in 1689 and the morally ambiguous blue-and-white world she created in the dairy as a place of performance and masquerade. There, women were empowered, escaping the pressure of societal constraints and expectations of royalty and the aristocracy, to experience unrestrained joy, companionship, and freedom in a fanciful world of Mary's creation, even if only for a few hours.

98. Greek A factory. Designed by Daniel Marot. Milk pan, ca. 1689–94. Tin-glazed earthenware

Fig. 49. After a design by Daniel Marot (French, 1661–1752). Design for a tabletop after 1703–before 1800. Etching, 7 1/4 × 6 3/4 in. (18.5 × 17.1 cm). Rijksmuseum, Amsterdam (RP-P-1964-3174)

NOT THE METAPHOR OF THE EYES, BUT THE CORPOREALITY OF THE MOUTH

PATTY CHANG

The flower pyramid is the size of a petite person (pl. 99). It has nine ascending levels with small heads on each corner, the mouths wide open where you can place a single flower. Each head resembles the next, all with their mouths agape (fig. 50). When I first saw the image, I imagined they were female heads, but on close inspection, I saw that they all have beards, and their cheeks are rendered as if stuffed like a squirrel's. At the top is a bust of a lady slightly bemused. I could say that what is of interest to me, however, lies below her waist.

The way the case is situated at the V&A, raised on a pedestal behind glass, I can't actually see what the flower pyramid would look like on the floor of someone's home, or palace. When flowers are inserted into the holes formed like small human mouths, what does the face look like? I raise my phone on its selfie stand up toward the pyramid and shoot photos and videos in front of the heads. I hope to get an image from dead center, as if I am looking down onto the face as I am inserting the flower shaft inside the mouth and down the porcelain throat. I want to know if it will look back up at me. It does.

The mouth is our primary opening. You might think it is the eyes because we are such a visual culture, but without the mouth we wouldn't eat, we wouldn't breathe, we wouldn't kiss, we wouldn't survive. When newborn babies are placed on their mother's chest, their mouths instinctively, out of genetic or deeply embodied knowledge, begin to suckle and search for the breast—the source of survival, and eventually of comfort.

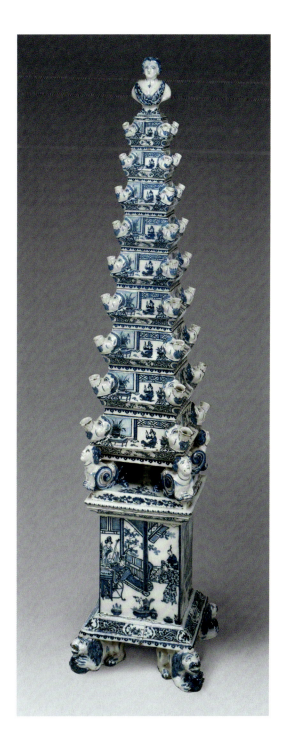

99. Greek A factory. Flower pyramid, ca. 1695. Tin-glazed earthenware

immobile and forced food down her throat with a smile (fig. 51).

Where should the eyes look when a funnel is forced down your throat? Do they squeeze shut, hoping to push out the reality of the situation or seizing in pain? Do they look to the side for someone, anyone to help? Or do they look up at the perpetrator, the eyes connecting the feeder and the feedee— a connection of sexual submission?

In *A History of Force Feeding: Hunger Strikes, Prisons and Medical Ethics, 1909–1974*, Ian Miller explains that being force-fed "involves inserting a stomach tube into the mouth of a prisoner/patient which is then passed downwards through the throat and oesophagus before eventually arriving in the stomach. The passing of the tube causes most patients to gag, choke and vomit over themselves."[1]

When the mouth is open by force, it cannot speak for itself. Not only are the lips a resealable enclosure, but they also make sounds that, when pursed, pinched, puckered, or stretched wide, form the contours of our language.

Roland Barthes writes in "The Metaphor of the Eye" of George Bataille's transgressive, erotic novella, *Story of the Eye*, that the text is not about the individual characters and the sex they perform, but the radical play with language and image. Barthes writes, *Story of the Eye* "is actually the story of an object. How can an object have a story? No doubt it can pass from hand to hand . . . it can also pass from *image to image*."[2] From hand to hand and image to image, in telling a story, an object undergoes arcane transformations—body parts swap for animal parts, waste supplants food, body fluids surrogate, power and pleasure collapse.

> flower head eye
> tears dirt gold
> fire skin liquid light
> mouth multitudes water waste

The lips form an endlessly resealable closure to the mouth—a seductive entry into the soft and vulnerable interior of the body. What does it mean to have a perpetually open mouth, where the lips are pulled into an inhuman and disquieting circle? When the lips resemble not a soft and supple body part but a machine or manmade device?

The invention of the hunger strike as a political tool is often attributed to Scottish artist, writer, and suffragette Marion Wallace Dunlop in 1909 when she was thrown in prison and marked a petty criminal. She refused to eat or drink until they relabeled her a political prisoner for her civil disobedience to fight for women's right to vote. She didn't consider this a petty crime, but one with a moral agenda to change the world for the better. In a postcard lampooning this serious and eventually effective strategy, an oversize funnel was placed in the mouth of a woman in Victorian dress while a man held her body

Fig. 50. Detail of pl. 99
Fig. 51. "Feeding a Suffragette by Force" postcard, ca. 1909

WOMEN INSIDE
AND OUTDOORS

ELIZABETH KOWALESKI WALLACE

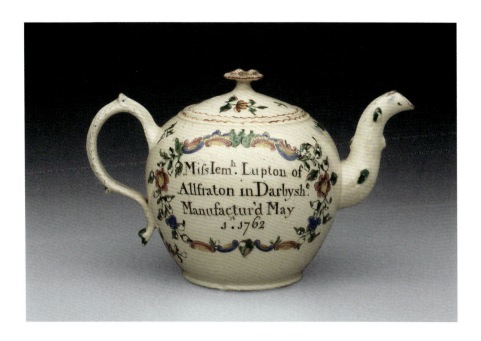

Taken together, the two teapots shown here address the complex narratives of British scientific and technological advancement leading to wide-scale consumerism and the role of women in British national identity.

The first teapot boldly bears the name of its owner, Miss Jemima Lupton (1743–1837) of Derbyshire, England (pl. 100). Stamped with the date 1762, it is the earliest known dated, enamel-painted English creamware teapot and is made from a white clay found in Dorset and Devonshire combined with calcined flint. But creamware also contains kaolin, which had long been a crucial ingredient in hard-paste porcelain imported from China. Until its discovery in 1745 in Cornwall, British manufacturers did not know of its importance to the manufacturing process and therefore were not able to compete with the Chinese imports. (Rumors circulated that superior Chinese pottery was a mixture of plaster, eggshells, oyster shells, sea locust, and sea creatures. Or were its ingredients buried and hoarded by secretive Chinese families?)[1] Thus the discovery of kaolin and its chemical properties, along with related, significant scientific advances in glazing and firing techniques, finally allowed the British to create a product that could outsell the Chinese import. Around the same time, the introduction of new techniques of molding ceramic ware using plaster of paris (or a type of treated gypsum) facilitated the implementation of widespread mass production. Soon domestically produced, affordable cups, saucers, plates, and teapots like this one could be found in nearly every British home.

As a popular consumer item, such a teapot, along with cups and saucers, sugar bowl and creamer, was part of the typical equipage for an eighteenth-century British tea table. In a practice still referred to as "being mother," a woman would serve tea to a small assembly of family members or friends. This act was also performative: the motions of a

100. Jemima Lupton. Teapot, 1762. Lead-glazed earthenware

proper lady were carefully choreographed to signal the bodily discipline and refinement required by her rank. Tea itself had been associated with femininity and female society at least since the time of the Portuguese princess Catherine of Braganza (1638–1705) who, upon her marriage to Charles II in 1662, brought with her trading rights to the "Isle of Bombay" and thereby launched the national craze for tea. The entire event—the pouring, the stirring in of sugar and milk, the careful passing around of the delicate, handleless cups and the saucers—most often occurred under the watchful eye of men. Fathers, brothers, or suitors might use the occasion to evaluate a woman's femininity. Yet women at the tea table could also thwart patriarchal control: when not under a watchful male gaze, they might use the opportunity to talk freely or gossip. In such moments, the fluid conversation could be metaphorically connected to the liquid tea, both being "spilled" too freely. In addition, as lower-rank women also began to enjoy the pleasures of the tea table, their tea drinking was decried as a wasteful and inappropriate expenditure, since their bodies were meant not for leisurely, feminine display but to be employed as nurses, servants, or laborers.[2]

The second teapot presents a curious amalgam of several design traditions suggesting an uneven process of cultural appropriation (pl. 101). The repeating scene features two seated figures, one playing a flute and the other holding a fan; a standing boy holding a *ruah* (or a practice scepter); a hovering nurse with a fan; and a large, intricately rendered butterfly. This arrangement appears to echo a traditional Chinese motif, showing people in an outdoor setting. Yet the gender of the figures is difficult to read. One holding a fan wears indeterminate dress, as well as a wig suggestive of early modern Dutch fashion. In addition, all the faces are curiously highlighted with red enamel to suggest flesh tones or perhaps they attempt to signal their racial difference. Who, exactly, are these individuals meant to be? Though they are vaguely located in a "Chinese" scene, they belong neither to the East nor to the West. They relax outside enjoying innocent pleasures. The fanciful scene on the teapot contrasts with the structured indoor space of the tea table and its limited possibilities for movement. In this way, the teapot brings home the foreign and exotic as an imaginary alternative. The vibrant butterfly evokes female pleasure in the natural world. About the time this teapot was made, women Aurelians— or amateur lepidopterists (butterfly catchers)—were beginning to leave the confines of the tea table and venture outdoors in order to encounter and catalogue all that nature had to offer.[3]

101. Worcester factory. Teapot, ca. 1768–78. Soft-paste porcelain

PATTY CHANG

LESLEY MA

In the mid-1990s, Patty Chang became known for her daring, visceral, and playful performances and experimental videos that interrogate the constructs and discourse around women's bodies. Born in the Bay Area to Chinese immigrant parents and trained in painting at the University of California, San Diego, Chang turned to performance, video, and photography after graduation and relocated to New York. Works by Yoko Ono, Marina Abramović, Ana Mendieta, and others who used their bodies to provoke preconceptions of femininity, and Surrealist cinema's aesthetics of slicing and grafting narratives and images, were among her influences. In her solo debut at New York's Jack Tilton Gallery in 1999, she presented *Melons (At a Loss)* (1998) and *Fountain* (1999), now considered iconic works in feminist, video, and Asian American art.

In *Melons (At a Loss)*, Chang tells a fictional story about a commemorative plate she received after her aunt's death from breast cancer. With her upper body in the center of the frame and her eyes fixed on the camera, Chang, in a white bustier, balances a plate on her head, raises a long knife, and slices through her left breast—which reveals a cantaloupe melon. Chang scoops and eats from the flesh-colored fruit, and finally smashes the plate when she is done (pl. 102).

By reconstituting the elements of European still life and portraiture—ripe fruit, precious porcelain, and fancy garment adorning a young female sitter, Chang teases and disrupts the art historical canon. She joins her feminist predecessors such as Hannah Wilke and Cindy Sherman in questioning the objectification and stereotypes of women through self-representation and erotic associations. Her direct address at the camera and use of domestic objects recall Martha Rosler's *Semiotics of the Kitchen* (1975), which epitomizes women's frustration toward their roles in society. However, Chang complicates the use of her body and politics by centering not only her sexuality and gender, but her race. In this vein, *Melons* is a passionate reimagination of the eroticized and exoticized violence in Ono's *Cut Piece* (1964), in which she invited audience members to cut away her clothes as she sat vulnerably in discomfort and defiance.

In Chang's *Melons*, the titillating fantasy of an Asian female—the subject of colonial desire and sexual exploitation in history and popular culture—is used as both bait and weapon of reeducation. Chang first establishes her filial position as daughter/niece, typically associated with obedience and prudence in Asian cultures, embodied by her proper posture in front of the camera. She then tricks the viewer into a moment of anxiety as she engages in a fake act of self-inflicted violence, before diffusing it with humor as her voluptuous "melon" is revealed. Chang devours the melon's flesh aggressively, in a manner both childlike and barbaric, shattering the perfect image of polite and timid Asian women. As she consumes the juicy fruit in a deadpan manner, the viewer is perhaps disappointed, relieved, and aroused at the same time. Even if her image and actions risk being sexualized, she resists by disrupting stereotypical readings. Her smile at the end of the video is mischievous and proud, like a prankster satisfied by the reactions of an embarrassed and possibly also entertained viewer.

The critical possibilities of self-objectification that elicit audience discomfort through performative actions and camera manipulation are further explored in *Fountain* (pl. 103). With direct reference to canonical works by Marcel Duchamp and Bruce Nauman, Chang doubles down on subverting expectations. *Fountain* was first performed on the floor of a male public bathroom for forty-five minutes and later presented as a photograph and a video. In the video, Chang is seen in a close-up,

facing herself. She stares at her reflection, closes her eyes, leans in, and sucks her image from a mirrored surface filled with water until it runs dry. Through this action, she retells the myth of Narcissus with her female Asian body and focuses on corporeal sensations. The slurping action and sound, associated with passion and pleasure, accentuates her concentration in confronting, consuming, and reconciling with her split identity. Her slightly grimaced face—the prolonged kiss tested her endurance as she crouched on her hands and knees—suggests labor and struggle to control and rejects the easy, erotic impulse of the male gaze. By flipping the recorded footage vertically, she alters the visual reality, while offering nuanced readings of the mirror as the carrier of both illusion and representation, an object of vanity, objectification, transformation, and mortality.

While many mainstream art critics at the time praised Chang for advancing the discourse of feminist and video art, most did not acknowledge her Asian identity as the core of her concept.[1] It is an odd omission, given that the art establishment and the public had debated issues of identity in art throughout the 1990s. Additionally, the forces of globalization and Asia's rising economic power during the last decade of the twentieth century had ushered many Asian artists into international prominence. The contemporary art world clumsily began a course of correction as it learned how to appropriately address and theorize art by the foreigner and the Other.[2] At the same time, a desire to deepen the cultural understanding manifested in institutional exhibitions that both celebrated the glory of ancient Asian cultures and placed Asia and Asians in a distant, historical past.[3] Thus, Asian artists had to juggle the assets and the baggage of their race and culture. Chang said of her negotiation, "The fact that I am in almost all the pieces makes it very difficult not to reference Asian female identity; either as fitting within the confines of Asian female representation or else consciously rejecting that identity."[4] Her work builds on the pioneering videos and performances by Ono, Shigeko Kubota, and Theresa Hak Kyung Cha that expressed their attitudes and experiences as Asian émigrés in postwar America. Chang, a second-generation Chinese American, treaded a precarious balance between active agency and self-objectification as she spotlighted her race and gender, in an era when the Spice Girls, Britney Spears, and Disney's *Mulan* (1998) and *Pocahontas* (1995) shaped the public consciousness toward femininity, the body, and the Other in popular culture. In many ways, the biases that *Melons* and *Fountain* and the discourse around them sought to address linger today and reflect a sustained urgency in her work.

102. Patty Chang. *Melons (At a Loss)*, 1998. Video still
103. Patty Chang. *Fountain*, 1999. Video still

RECLAIMING THE DEITY

YAO-FEN YOU

Guanyin ("Perceiver of Sounds") is the Chinese name for Avalokiteśvara, the bodhisattva of compassion, originally a male deity and one of the most popular and revered figures of Buddhism. Milky white porcelain statuettes of her clad in long flowing robes were a specialty of the kilns of Dehua starting in the seventeenth century. Located along China's southeast coast in the province of Fujian, Dehua was home to large deposits of clay high in kaolin and low in iron oxide that made for quality white porcelain when fired—earning them the name *blanc de chine* in the West. Whether standing (pl. 104) or seated (pl. 105), Guanyin is traditionally depicted with her hair in a topknot and her face set in a serene expression. In the instances the deity is shown with a seated naked child, she is known as a "Child-Giving Guanyin." The delicacy of her tapered fingers and various jeweled adornments exemplifies the skill of the Dehua potters, but also reveals the inherent stiffness of the local clay, which lent itself to press molding rather than throwing.[1] Generally made from piece-mold construction, such elegant images circulated by the thousands both for domestic and for international markets from the late seventeenth century onward.

While in China such figures would have furnished a house altar or a temple, in Europe they were sought after as luxury collectibles. Six large Guanyin figures, dated to 1660–90, are recorded at Hampton Court Palace in the Kensington inventory of 1696–97, where they decorated the inner chambers dedicated to Mary II.[2] In 1690, Anne Cavendish, Countess of Exeter, inherited from her mother, Elizabeth Cavendish, Countess of Devonshire, a pair of Child-Giving Guanyin figures, now in Burghley House.[3]

Among the first objects made at the Meissen porcelain manufactory in red stoneware is the figure of Guanyin now in The Met (pl. 104). Dated 1710–13, its design derives from one in the collection of Augustus II the Strong, elector of Saxony and king of Poland. It is likely that the figure in The Met was cast from plaster molds taken from a Chinese original owned by Augustus, of which there were many.[4] By 1721, Augustus had amassed more than 1,250 pieces of Dehua porcelain, part of his extensive holdings of East Asian porcelain, composed of small and large statuettes representing a variety of deities, the mainstay of Dehua production.

The popularity of these pure white Guanyin figures is often attributed to the insatiable desire for "white gold" in Europe. Their beauty

and demure demeanor contributed to their collectibility. The 1721 inventory of Augustus's extensive holdings of East Asian porcelain, which refers to them generically as "female figures" (*Weibs Persohnen*), offers us a glimpse into how they were coded as ornamental and hyperfeminine. A particular point of slippage concerns their topknots—when covered by the hoods of their cloaks, they could be mistaken for ornate towering headdresses supported by a wireframe, or *fontages* (*mit Fontagen*), the most feminine of European fashion trends in the late seventeenth and early eighteenth centuries.[5]

The sizable market force in China that shaped the domestic demand for images of Guanyin as female allows us to reclaim Guanyin's role as a divine intercessor instead of as a mere collectible doll that reinforces the gendering of porcelain as female. Guanyin, as a compassionate universal savior who responded to all cries for help regardless of class, gender, or even moral qualifications, represented an idea unfamiliar to the Chinese. Imported from India, Avalokiteśvara has thirty-three manifestations ranging from male to female and gender neutral. The female manifestation prevailed as the cult of Avalokiteśvara took root in China with the indigenization of Buddhism.[6] By the late Ming dynasty, Guanyin had become the most popular female deity in China, even developing a cult following among Buddhist laywomen in late imperial China who sought to emulate her, with some using their own hair to embroider her image.[7]

The wide circulation of these feminine porcelain manifestations throughout Europe thus coincided with the historical transformation of Guanyin from unambiguously male to decidedly female in China, as part of how Buddhism became Chinese in late Imperial China. Certainly, my own relationship to Buddhism as a Chinese American was mediated through a polychrome porcelain figure of Guanyin that graced our home altar, as well as those of my grandparents, whether in Taiwan or the United States. Although my mother was not a devout Buddhist, she always laid out fresh fruit for Guanyin, as did her mother. That they, as contemporary Chinese women, could have this relationship with Figure of Guanyin was exactly why late imperial Chinese women negotiating the patriarchal confines of Confucianism found Buddhism increasingly attractive. A universal savior in a female form not only held special significance for them, but also created opportunities for them to participate in shaping the religion.

104. Meissen porcelain manufactory. Figure of Guanyin, 1710–13. Red stoneware with gilding
105. Bodhisattva Guanyin seated on a rock. China, Qing dynasty (1644–1911), Dehua, 18th century. Porcelain

THE QUEER TOUCH OF THE ELEPHANT IN A PAIR OF SÈVRES VASES

CHI-MING YANG

Are they hideous or delightful? The Sèvres porcelain "elephant-head vases" enthrall with their painted detail (polychrome encirclings of florets, feathers, and Chinese figures), and two meticulously sculpted white elephant heads attached, handle-like, to the necks of each vase (pl. 106). Even when viewed from all sides, the effect can only be partial, as the elephants' trunks have been modified from their original design—to hold, on the now painted-over nostril tips, sockets for candles. As two-headed candelabras, this pair might also have been part of a garniture that included a boat-shaped potpourri vase. The set of ostentatious pink and white enameled wares would have caught the candlelight sitting atop one of Madame de Pompadour's mantelpieces, about 1761. The Sèvres factory's famed patron, and mistress of Louis XV, bought a number of these elephant-vase models (as well as inspiring the invention of the Rose Pompadour pink ground color in 1757). Designed by the royal workshop of Jean-Claude Duplessis and painted by the skilled Chinoiserie miniaturist Charles Nicolas Dodin, the objects retain their impact as miniature spectacles of elite interior decor, just as they continue to divide popular taste.

The elephant ears are perhaps the most distinctive element of the vases. In shape, they depart from printed images of the creature, which tended to depict the large fan-like appendages of African elephants. Even the smaller ears of Asian elephants bear slim resemblance to these anthropomorphized auricles that have been molded with the curvature of cartilage and prominently exposed ear canal of a human ear. They echo, in color and form, the milky white ears of the Dehua export porcelain figures of Buddhas displayed on European mantelpieces or mounted in ornate frames and rendered pieces of fantastical Chinoiserie. Here, the fleshiness of the open ears, humanoid and creaturely, neither Asian, African, nor European, enlivens the vases. The cross-sensory references of hearing, touch, smell, taste, and sight evoked through elephant body parts interact with the flat, painted Chinoiseries of the Chinese figures on the body of the vase to create an "Orient-animalist" sensorium at once feminine and monstrous. These two orders of Chinoiserie ornament—fleshly and flat, grotesque and picturesque—conjoin elephant with Asian into a hybrid form of anatomical enchantment, one that seems to call forth, yet confound, the hierarchization of religion, race, species, and culture being promoted by Enlightenment intellectuals and naturalists of the time.

In eighteenth-century natural history, elephant body parts—including the ears, eyes, and trunk—were thought to have heightened powers of sensation. As Georges-Louis Leclerc, Comte de Buffon, declared: "the elephant is . . . a miracle of intelligence, and a *monster of matter*."[1] It is praised, in racialized terms, for its moral virtue. Buffon writes that unlike the orangutan or African woman, considered by him and his peers to be lascivious and prone to interspecies attraction, the chaste female elephant refuses to copulate in public or in the presence of humans; even in private, she has sex in the missionary position. Elephants, due to their virtuous sensibilities, thus have an innate love of freedom, "not like these born slaves, which we train or multiply for our use. . . . This alone shews in the elephant elevated sentiments superior to the nature of common brutes."[2] The hypersensitive elephant, in other words, is a good monster, touchable in all the right ways.

Asian bodies also evoke the senses on these vases, in complex Chinoiserie fashion. Three sizes of elephant-head vases were produced by Sèvres between 1756 and 1762.[3] Of the twenty-two surviving examples, the pair in the Walters Art Museum, Baltimore, is

unusual in featuring Chinoiserie scenes, painted by Charles Dodin, within the floral-framed reserves. One reserve displays a version of François Boucher's 1740 Chinoiserie design, *Smell* (*l'Odorat*), engraved by Gabriel Huquier. A rosy-cheeked woman presides over an incense vessel, her hand enveloped by clouds of pungent smoke that demarcate the standing and bowing positions of the two servile figures who share the scene. The print source is one of Boucher's *Five Senses*, in which each sense is allegorized by an ensemble of lithe Chinese figures engaged in a central tactile activity. (Scholars have misidentified *Hearing* [*l'Ouïe*] as the source for the image painted on the second Walters vase. That vase features a male priest with arms outstretched, holding small pouches or castanets, facing an audience of two, a woman bent over a toddler.) Interestingly, Boucher's set contains two versions of *Touch*.

One pictures a Chinese man and woman petting feline figures; the woman's bare foot rests on the man's knee. The second version of *Touch* is differently erotic. Two men, one turbaned and another bald, tickle a loosely robed, partially bare-legged woman seated at the base of a pedestal (fig. 52). The stimulation, explicitly sensual and yet mediated through the slender reeds, captures the deviance of many Chinoiserie vignettes: in lacquerware, tapestry, and porcelain designs, sexually androgynous master and servant figures engage in lavish leisure activities, often accompanied by lissome animals and plants, and sometimes

106. Sèvres manufactory. Charles Nicolas Dodin. Elephant vases, ca. 1761. Soft-paste porcelain with enamels and gilding

even in scenes of torture. In his study of human senses, French anatomist Claude Nicolas Le Cat privileged hearing but praised touch thus: "One Perfection of the Touch . . . is *Tickling*, a Sort of Hermaphrodite Sensation; productive of Pleasure, of which it is an Extreme; and of Pain, of which it is as it were the first Degree."[4] Here, the term *hermaphrodite* connotes the combination of contrasting qualities and sexual nonconformity. One of the disorienting effects of Chinoiserie's combinatory style is a queer unsettling of gender norms and an Orientalist effeminizing and sexualizing of Chinese figures. When Asian bodies erotically exemplify the extremes of the human sensorium, from smell to hearing to touch, queerness ensues.

Hermaphroditic ticklishness could describe the two orders of haptic Chinoiserie brought together on the body of each vase. Each conjures vitality and multisensory interaction, but the contrast and interplay of their color and form—what Jonathan Hay has called a "cross-referencing of surfaces"[5]—

create their combined disorientation of fixed categories of human-animal-gender. The vases also exhibit a value along the lines of what Anne Anlin Cheng terms *ornamentalism*, or how artifice constitutes racialized personhood.[6] When animals mediate this process, the effect is the animalizing (and feminizing) of foreignness, and the ornamentalizing of animals. Two vases with four elephant heads, organized by central Chinoiserie allegories of sensory perception: this European experiment in porcelain activates a synesthesia—monstrous, elephantine, cross-cultural—befitting of Chinoiserie's excesses and unsettling persistence.

Fig. 52. François Boucher (French, 1703–1770). *Touch* from *The Five Senses*, 1720–70. The Metropolitan Museum of Art, New York, Harris Brisbane Dick Fund, 1953 (53.600.1003[6])

202

LAOTIAN GODDESS KI MAO SAO AND WORSHIPPERS

MARLISE BROWN

In eighteenth-century Europe many porcelain manufacturers created small figurines like *The Laotian Goddess Ki Mao Sao and Worshippers* to adorn tabletops and mantels, taking the place of edible sugar sculptures. At the apex of this porcelain figure group, the goddess Ki Mao Sao extends her arms at her sides, with her hands balled into tight fists (pl. 107). The heavy lids of her downcast eyes draw our attention to the kneeling unnamed attendants flanking her, forming a triangle with her body. *The Laotian Goddess Ki Mao Sao and Worshippers* was made during the early days of the London-based Bow porcelain manufactory, when modelers experimented with complex arrangements inspired by French Chinoiserie prints and portraits of actors from the London stage.

Based on a French engraving by Michel Aubert after painted *boiserie* by Antoine Watteau at Château de la Muette, Bow's porcelain goddess probably once held a parasol and fan in each hand, as in Watteau's original design (fig. 53).[1] The composition was likely a product of the Western imagination, crafted from an amalgam of exported Chinese prints

107. Bow porcelain manufactory. After an engraving by Michel Aubert, after a design by Antoine Watteau. *The Laotian Goddess Ki Mao Sao and Worshippers*, ca. 1750–52. Soft-paste porcelain

Idole de la Déesse KI MÂO SÁO dans le Royaume de Mang au pays des Laos

and porcelain vessels and augmented by illustrated European travel diaries, Chinoiserie decorative arts, and stories of idol worship.

Bow modelers transformed the scholar's rock in Aubert's engraving into a Rococo cartouche with painted pseudo-Chinese characters. The most potent alteration, however, lies in the relationship between the goddess and her kneeling attendants. In Aubert's arrangement, the worshipper at left barely lifts his head from deep genuflection at the goddess's feet. However, in the Bow model, the attendant, now donning a phallic-shaped hat, gazes upward at the goddess's face. When the figurine is turned around, we can see that his left arm is fully extended and appears to be grasping Ki Mao Sao's bottom (fig. 54). The erotic nature was underscored by the now missing feather

duster in Ki Mao Sao's hand—a double entendre suggesting the sensorial pleasures and coquettish play of soft plumes on skin. Overt sexual humor was typical in European porcelain figurines produced in the eighteenth century, especially in British toy shops. It was an asset for shops to sell objects that were novel, witty, shocking, and even a bit vulgar. Bow's *Ki Mao Sao* would have been placed on a fireplace mantel with a mirror behind it so that the worshipper's indecorous behavior could be fully appreciated in the round. The reflective properties of the mirror naturally complemented the visual splendor of porcelain's translucent qualities and beckoned the viewer's participation in discovering the bawdy game afoot.

Dignified, idealized, and small-scale characterizations of Asian femininity were

Fig. 53. Michel Aubert (French, 1700–1757) after Antoine Watteau (French, 1684–1721). *Idole de la Déesse Ki Mâo dans le Royaume de Mang au pays des Laos* from *L'Oeuvre d'Antoine Watteau Pientre du Roy en son Academie Roïale de Peinture et Sculpture Gravé...*, ca. 1740. Engraving, plate 16 ¹⁵⁄₁₆ × 12 ⁵⁄₁₆ in. (43 × 31.2 cm). The Metropolitan Museum of Art, New York, Gift of Mr. and Mrs. Herbert N. Straus, 1928 (28.113[1-3])

served to British women and young girls as models of decorum and virtue.[2] At a quick glance, Bow's *The Laotian Goddess Ki Mao Sao and Worshippers* would have fulfilled this didactic role. However, the tensions between the seemingly decorous front of the object and the lighthearted humor of the crude backside disrupt any moralizing message. Evidence of offensive characterizations of Asian people in European art can be seen as early as the seventeenth century when racial caricatures were increasingly incorporated into the Commedia dell'arte.[3] The humor of racialized otherness embedded in popular theater was amplified by ostensibly innocuous decorative objects like *The Laotian Goddess Ki Mao Sao and Worshippers*. Porcelain figurines conveyed in miniature Europe's fetishization of the East while revealing the growing discomfort of many British men with the popularization of Chinoiserie in domestic spaces. By the eighteenth century, critics associated Chinoiserie—and, by extension, porcelain—with women as the primary consumers. Chinoiserie ceramics were frequently featured in satirical prints as symbols of femininity, unbridled luxury, and the risks of international trade, which preyed on the anxieties of the British patriarchy.[4]

Fig. 54. Back view of pl. 107

ASIA AND AFRICA

JOAN KEE

As inherent to the geometries of imperialism as the separation between East and West is the pairing of Asia and Africa in allegorical representations of the continents, most especially in ceramics.[1] Forever marooned on the same rocky terrain, two figures in this glazed assembly coexist awkwardly with a lion and an elaborate tureen garlanded with flowers (pl. 108). Supported by what appears to be a backboard, *Asia* stands upright with her left arm indicating an unspecified horizon. Conspicuously smaller is *Africa* reclining on the lion's back. Unclothed save for a casually wrapped loincloth, she looks in a different direction as if in response to another voice or entity.

Most Asia-Africa couplings in European painting and decorative arts of the eighteenth and nineteenth centuries pit Asian refinement against African wildness, or presume an inextricable entanglement in which all things Asia must be seen through the lens of Africa and vice versa.[2] The casting of Asia and Africa as voluptuous women, strapping young men, or as cherubic children elegantly contains the threat of multitudes populating the Asian and African continents. When glazed in obsidian tones, *Africa* becomes the visible foil of an *Asia* whose pallor against brightly colored robes verges on the sickly.[3] In *Asia and Africa*, the racialization of Africa as a Black continent persists. The facial features of *Africa* mirror preconceived ideas of racial difference, as opposed to *Asia* whose depiction conforms to a neoclassicism in France dating back to at least the late seventeenth century and unaffiliated with the appetite for Chinoiserie.[4] In works

such as Giovanni Battista Tiepolo's sketch for the *Allegory of the Planets and Continents*, African and Asian figures edge pictorial space to form an unintended coalition of the melanin-rich.[5] Conversely, both protagonists in *Asia and Africa* are glazed in milky white with a sheen and texture straddling the boundary between glowing and unctuous. Among the rare examples of figural groups produced by the Vincennes manufactory, the work intersects chronologically with the Nantes slave trade that saw hundreds of thousands of Africans forcibly displaced and enslaved in the French Caribbean as well as with French intervention in Burmese political affairs resulting in full-blown colonization in the nineteenth century.

Mediating the relationship between *Asia and Africa* and these vast scales of operation is Chinoiserie, examples of which frequently imply how the linkage between aesthetics and politics is part of a larger practice of racial categorization. Another Vincennes group likely contemporaneous with *Asia and Africa* features two white figures purportedly based on depictions of Chinese faces, although gold embellishments added in the nineteenth century made the racialized features less overt (fig. 55). So crudely exaggerated are their slanted eyes and bulbous eyelids that it emphasizes Chinese bodies as nonhuman or even inhuman while directing attention away from the intricate openwork basket of algae, reeds, and coral in the center. By comparison, the racialization of *Asia and Africa* appears less pronounced than does the suggestion of human triumph over the natural world. *Africa* physically sits on nature as embodied by the tame lion whose downward gaze betrays a hint of resignation.

Yet both *Asia* and *Africa* are themselves subject to handling and domestication. Contorted torsos, bent arms, and strategically placed feet emphasize the subordination of bodies to an unseen force. The particular shade of whites

108. Vincennes manufactory. *Asia and Africa*, ca. 1752. Soft-paste porcelain

and the refractive properties of porcelain render what should read as human flesh closer to the lifeless durability of marble statuary. Folds of cloth and skin writhe and undulate, yet not even the filigree of shadows produced by the massing of drapery can dispel a lingering sense of rigor mortis shrouding the ensemble. As if suffocated by layers of glaze, the figures are stilled into permanent silence.

Asia and Africa unexpectedly aligns with the distinction between liveness and existence made by the Nzema philosopher Anton Wilhelm Amo, the first Black professor of philosophy of the Enlightenment. Responding to Cartesian dualities of mind and body in his treatise of 1734,

Inaugural Dissertation on the Impassivity of the Human Mind, Amo wrote, "to live and to exist are not synonyms. Everything that lives exists, but not everything that exists lives."[6] Having been himself presented as a live gift to Dukes Augustus William and Ludwig Rudolf of Brunswick-Wolfenbüttel, and then later subject to public persecution, Amo may have drawn from personal experience.[7] Augustus William's father, Anthony Ulrich, amassed an extensive collection of artworks that later became the Herzog Anton Ulrich Museum in Braunschweig. Among its holdings is a seventeenth-century bronze head of an African man by an associate of the Flemish Baroque sculptor Artus Quellinus

the Elder. It is unknown if Amo ever saw the work while living with the dukes. But the question of liveness versus existence surfaces forcefully through the head: it looks more like a decoy tasked with lulling viewers into mistaking the likeness as an encounter with a living subject.

By applying Amo's concepts to *Asia and Africa* we can see how human forms can be emptied of their specificity so that they exist only as general types. More than an example of style, an orientation to cultural intersections, or even as a moral quandary centered on the collapse of personhood into objects for pleasure and profit, the work implies how symbolic representations can reduce the living into base existence. Summoning a host of others like it, *Asia and Africa* haunts modernity, eventually hollowing it out from within so that the very term loses its footing on grounds we know are purloined. Even when locked away, the work comes for us, still.

Fig. 55. Vincennes manufactory (French, ca. 1740–1756). Group of Chinese people supporting a basket, ca. 1752–54. Soft-paste porcelain, gilding, and gilt bronze. Royal Collection Trust (RCIN 3150)

EXEMPLARY WOMEN
BY CAO ZHENXIU AND GAI QI

JOSEPH SCHEIER-DOLBERG

The historical status of the calligrapher Wei Shuo (272–349 CE) reveals a familiar and frustrating dynamic. Although she taught the most famous calligrapher in Chinese history, Wang Xizhi (303–361 CE), and although she was traditionally considered the author of the seminal text *Battle Array of the Brush* (*Bizhen tu*), Madame Wei herself remains a nebulous figure whose own calligraphy is scarcely documented. When she is celebrated at all, it is usually for association with her storied male disciple.

This selective historical neglect is what the scholar-artist Cao Zhenxiu sought to redress when she authored the following poem in 1799:

Wei Shuo Practicing Calligraphy

How impenetrable it is, this *Battle Array*, with strokes like *zhi* and *bo*,

She created the "flowered hairpin" style of calligraphy, however wrongly transmitted [it has been].

Zhong, Wang, Yu, and Chu each sought a personal style,

But none could excel this old woman.[1]

Wei Shuo would have been known to Cao's educated contemporaries. However, before reading this verse, few would have considered her a protagonist of her own story or a master at the level of her famous student. What Cao's poem asserts is that Madame Wei has been hiding in plain sight. The poetic tone, more insistent than polemic, suggests that if the reader has failed to recognize the centrality of this fountainhead figure, it is not because the evidence has been lacking, but rather because they have not been paying the right kind of attention.

Wei Shuo Practicing Calligraphy is one of a cycle of sixteen poems that Cao Zhenxiu wrote extolling various women from Chinese history and legend. Transcribed by Cao on pink paper, the poems were then illustrated by a virtuosic young artist named Gai Qi (1773–1828) and bound into an album that has come to be called *Exemplary Women* (pl. 109, fig. 56).[2] Lionizing a group of praiseworthy women in this way was not a new idea; anthologies of female role models, a literary genre called "exemplary women" (*lienü*), were nearly two millennia old when the album was made. Often included in official dynastic histories, *lienü* tended to celebrate women as exemplifying sanctioned Confucian virtues, such as loyalty to one's husband, fidelity

Fig. 56. Detail of pl. 109

衛鑠臨池

筆陣森巖礫與波蕃花有帖幾傳訛鍾王

雲褚尋書派咄咄人間覬阿婆

貞秀

紅拂梳頭

眼底英雄一拂中曉妝逆旅話鬖公絳仙

此際朝醒懶猶未梳頭大業宮

墨琴

210

after his death, or exceptional devotion to the family.[3] Cao's album is a calculated intervention into the genre, meant to play on its conventions but also to expand its possibilities.

The notion of female virtue that Cao offers in *Exemplary Women* extends beyond fidelity and chastity to embrace calligraphy, painting, scholarship, and other skills traditionally celebrated only in men. In addition to Wei Shuo, Cao selected scholars such as Ban Zhao (ca. 45–ca. 120 CE), who helped complete her father's seminal historical treatise after his death, and Shangguan Wan'er (ca. 664–710), whose literary skill earned her a role as a high official and poetry critic at the court of the Tang dynasty empress Wu Zetian (624–705). Even more daring is the inclusion of women known for martial skill, such as Lady Xian (512–602), a famed warrior and military strategist of the sixth century. These selections, absent from earlier official collections of *lienü*, seem to reflect a significant reworking of canons of propriety for a new age.

Existing alongside these novel additions are exemplars that seem more familiar from traditional *lienü* collections. These include the legendary Luofu, a faithful wife acclaimed in poetry for refusing the advances of an aggressive local official while her husband was away from home, and Meng Guang (first century CE) who worked tirelessly to support her family after her husband was unjustly exiled for criticizing the emperor's wasteful extravagance. Cao herself belonged to a famous literary power couple—she and her husband, Wang Qisun (1755–1817), were a team well known in elite circles for their devotion to one another and their support of each other's artistic endeavors—and one senses that these examples, too, contain an element of autobiography, celebrating the joys of companionate marriage built on mutual respect.[4]

If Cao's selection of role models encodes a subtle, nuanced rebellion—one that both honors and challenges tradition—she could scarcely have chosen a more apposite artist than Gai Qi to illustrate her poems. At first glance, Gai's images are quiet and demure, but at close range they reveal originality, dynamism, and boldness. The painter's command of textural brushwork effects is on full display in his depiction of Wei Shuo: from the pinpoint fine lines of the robe to the fuzzy, dry brush of the rocks and rootwood chair to the painstakingly drawn parallel lines of hair, each is calculated to enhance the representational clarity of the painting while also revealing the artist's virtuosity (pl. 109). In another leaf, a depiction of the heroic courtesan-turned-warrior Zhang Chuchen (the Lady in the Red Sleeves), Gai demonstrates a daring and witty approach to composition on par with his brushwork (pl. 110). Combing her hair in a rustic inn, Zhang, with her face hidden from the viewer, appears to look into a mirror at her reflection; upon closer examination, one realizes that she is looking through an open door at the mane of a horse, a false reflection that momentarily startles the eye. The surprise and delight engendered by moments such as these provide visual counterpoints to Cao's poems and selections of figures, which consistently challenge expectations, but with a sly and knowing wink.

109. *Wei Shuo Practicing Calligraphy*. Page from double leaf from an album of sixteen double leaves. Painting by Gai Qi. Calligraphy by Cao Zhenxiu. China, Qing dynasty (1644–1911). *Exemplary Women*, dated 1799. Ink on paper

110. *The Lady in the Red Sleeves Combs Her Hair*. Page from double leaf from an album of sixteen double leaves. Painting by Gai Qi. Calligraphy by Cao Zhenxiu. China, Qing dynasty (1644–1911). *Exemplary Women*, dated 1799. Ink on paper

ANNA MAY WONG: GLAMOUR AS RESISTANCE

CINDY KANG

Chinese American actor Anna May Wong wore this dress for her role in the 1934 Hollywood film *Limehouse Blues*, a Paramount drama set in the Limehouse district of London among its significant Chinese immigrant population (pl. 111).[1] She had previously starred in the British film *Piccadilly* (1929), also set in Limehouse, as an upstart dishwasher turned nightclub dancer. Wong had been periodically living and working since the late 1920s in Europe, where she found opportunity for more substantial roles, as opposed to the stereotyped bit parts she was offered in Hollywood at the beginning of her career. After her success in *Piccadilly*, Paramount lured Wong back to the United States in 1934 to play the role of Tu Tuan, the strong-willed dancer and mistress of the nightclub owner Harry Young.

For the first scene in which Tu Tuan appears, undulating sinuously on stage, the costume designer Travis Banton conceived this black, long-sleeved, high-necked dress.[2] It is lavishly embroidered with a gold-and-silver-sequined dragon that runs the length of the entire garment, with the mythical beast's tail curling around the train and its whiskers and horns splayed across the shoulders.

Banton's design was part of a new wave of Chinoiserie that swept 1930s Art Deco fashion. The black and metallic palette evoked the trendy decor of black lacquer screens decorated with gold and silver leaf. His dragon motif was likewise more evocative and fantastical than reflective of the way the symbol was employed in historical Chinese clothing. During the Ming and Qing dynasties, for example, the use of dragons on robes was restricted to

the imperial family; they generally appeared in a medallion format among a field of stylized waves and clouds. The creature on Wong's dress seems to have been inspired by a different kind of object, one that lies at the heart of Chinoiserie—the vase with coiling dragon.[3]

These vases, prevalent during the Ming and Qing dynasties, feature a fully modeled dragon encircling the neck of the vessel, sometimes with its tail wrapped around the body. They were collected in Europe in the eighteenth and nineteenth centuries and subsequently inspired Chinoiserie designs (see, for example, pl. 65). On Wong's dress, the golden beast is entwined around her entire figure, its tail extending beyond the body onto the floor, a surplus and excess that is a classic marker of Chinoiserie.

The dragon here is of course an overdetermined symbol; not only is it used as a cipher for Chineseness, but it also inevitably suggests a stereotype that began to coalesce around Wong's persona in the 1930s—the Dragon Lady. The term, referring to an Asian woman who is powerful, alluring, and cruel, came into use in the mid-1930s. It was partly inspired by Wong's roles, including the seductive and duplicitous Princess Ling Moy in the 1931 film *Daughter of the Dragon*.[4] Banton's dress, which seems designed to incarnate this new term, nevertheless became an ambivalent site of resistance to the myriad tropes that inexorably accrued on Wong's racialized body and image. In this costume, the actor not only is an embodied ceramic vase, but becomes a porcelain idol that could talk back.[5]

In 1933, Wong gave a candid interview in which she criticized the parts she had to play: "Why should we always scheme—rob—kill? I got so weary of it all—of the scenarist's conception of Chinese character, that I told myself I was done with the films forever."[6] Although the assertive and relatively

111. Travis Banton. Evening dress, ca. 1934. Black silk charmeuse embroidered with gold and silver sequins

sympathetic character of Tu Tuan does not completely escape stereotype—she betrays Harry and kills herself in the end—a hint of Wong's agency is evident in a publicity photograph for *Limehouse Blues* featuring The Met's dress (fig. 57).

Wong stands in front of a backdrop from the Limehouse nightclub set, looking straight out at the viewer. Leaning to form a slight S-curve with her figure, she joins her hands in front of her chest. The angle of her body and the position of her hands render the dragon almost illegible; it becomes a river of sequins as the black silk train pools around her sandaled feet. Her hair is styled not as Tu Tuan but as herself, a fashion icon with her signature bangs.[7] Was this Wong's way of asserting her own celebrity image over the crystallizing stereotype of the Dragon Lady? Or is this obscuring of the dragon a manifestation of the impossibility of her position—a woman of color playing racialized roles that she could not fully embrace?[8]

The dragon dress is the auratic object in this ambivalent dynamic, where the celluloid image of Wong meets the reality of the individual, physical woman. While the dress is in good condition, it has clearly been worn. Slight tears on the underside of the train and along the sleeves as well as sweat stains along the neckline and armpits are evidence of Wong's body and labor, of the work she put into pioneering roles for Asian women (even if they were circumscribed by race), promoting her films, and crafting her glamorous image.

Fig. 57. Anna May Wong in a publicity photograph for *Limehouse Blues*, 1934

Anne Anlin Cheng has argued that glamour, which makes the starlet a seductive yet unassimilable object, was particularly liberating for women of color who tended to be both invisible and overly visible in the white European media landscape; it provided relief from navigating individuality in a racialized body and away to enact agency as an object.[9] In the dragon dress, Wong became a "resistant object" that could address the legacy of Chinoisierie.[10] The worn garment thus likened her to a porcelain vase or black lacquer screen as well as affirming her corporeality. It transformed her into an ornament with a sense of personhood, one that mesmerized and yet thwarted easy consumption of her being. In the dragon dress, Wong became an international icon, encrusted with but extending beyond Chinoiserie aesthetics.

PORCELAIN CYBORG /
CYBORG PORCELAIN

ELEANOR SOO-AH HYUN

Cyborg and *porcelain*, two terms that are not usually linked conceptually or materially, are coupled into seemingly impossible opposites in Lee Bul's two porcelain objects, which are a combination of traditional and futuristic, natural and artificial, fragile and unbreakable. In connecting and not juxtaposing porcelain and cyborg, Lee exposes layers, superimpositions, and confrontations of meaning and materiality centered on the Asian female body.[1]

Born in 1964 in South Korea, Lee Bul was trained in sculpture, but in the late 1980s and early 1990s she gained recognition for performance art pieces that addressed state and social controls over women's bodies, along with cultural and political oppression. In *Cravings*, a performance from 1988 at IL Gallery in Seoul, Lee wore a large sculptural form made of padded cloth, which distorted and expanded her body and gave it multiple limbs, transforming the human into a monstrous form that walked through the space with slow, deliberate movements. She considered the body a "battlefield where political and social issues collide."[2] Many of the costumes from her performances served as the starting point for sculptures she created from the mid-1990s that focus intensely on the body and humanity, such as *Cyborg* (pl. 112, fig. 58) and *Monster* (pl. 92).

Drawing from science fiction and Japanese manga, *Cyborg* and *Monster* incorporate ostensibly disparate characteristics that push beyond the boundaries of the human body: light versus dark; hard versus soft; sleek versus disorderly; alluring versus grotesque. Yet, Lee does not consider them as antipodes, but as "doppelgangers" and "anagrams" of one another.[3] The cyborg can be grotesque, and the monster alluring. Both have enticing sensual characteristics that can also induce fear and anxiety. Lee uses *Frankenstein*, an 1818 novel written by Mary Shelley about a young scientist named Victor Frankenstein who brings to life a nightmarish monster from dead, discarded body parts, to elucidate the fate of technology in the hands of humans. Frankenstein creates "a cyborg, an organism combined with technology that birthed a new life. But it is called a monster because it was a failure."[4]

Although appearing futuristic, *Cyborg* addresses the hierarchies that have historically informed standards of beauty and aesthetics. Lee recognizes that materials have connotations. Working with concepts of human skin and new, industrial substances, Lee creates the cyborgs in silicone and polyurethane. At the same time, she counters the sense of pliability and lifelikeness by deliberately suggesting stone and marble sculpture through the color white, stating that "people associate white with [Western classical] sculpture."[5] She also alludes to archetypal images of Western femininity through limbless, *contrapposto* forms that reference *Venus de Milo* and Michelangelo's *Pièta*, Botticelli's *Birth of Venus*, and Manet's *Olympia*.[6] She astutely discerns that cyborgs in popular culture replicate the genius creator narrative that underpins most of art historical discourse. Even as futuristic objects with superhuman powers, cyborgs "always have a master, usually a young man or boy who programs and controls."[7] With *Cyborg*, Lee says that it was inevitable to have references to high art and popular culture, due to her larger interests in "how concepts and representations of femininity proliferate through various channels in the culture at large . . . [as seen] in art history and also in popular media images of women."[8]

Lee extends this inquiry to the cyborg porcelain, revealing processes related to Korean sociocultural contexts. If in Western art, sculpture and marble represent tradition and orthodoxy, then their equivalents in Korean art are ceramics and porcelain. From Three Kingdoms stoneware to Goryeo celadon to Joseon porcelain, ceramics have been used to

trace and celebrate the long history of Korean art. Since the establishment of the Joseon dynasty (1392–1910), undecorated white porcelain was coveted for its restrained elegance as a visual interpretation of the Confucian ideals of purity and frugality.[9] Lee knows that these ideals are part of the patriarchal ideologies of Confucianism that permeate nearly every aspect of Korean society. In making a porcelain cyborg, Lee not only connects past and present, but also challenges established Korean art traditions and patriarchal norms.

Lee's use of porcelain does not limit her critique to Korea. Porcelain has been coveted by the West, even considered synonymous with China, specifically, and East Asia, generally. By making cyborg parts in porcelain at a scale that is similar to vessels, and leaving them untitled, Lee deprivileges Western materials, aesthetics, and discourse. In turn, stating "assumptions operate beneath shiny surfaces," she refuses to allow porcelain and technology to reinforce

traditional mechanisms of masculine privilege and Western misguided fantasies that constitute Asian femininity.[10] Even more fragmented than the silicone sculptures, the porcelain cyborg parts are difficult to identify, and the pelvis is particularly ambiguous, appearing as a sculptural vessel. Lee explores beneath the shiny surface to look critically at the systems of commodification, exoticization, and objectification that transformed Asian women's bodies into fantasy figurations of technological perfection, seen in cyborg films like *Ghost in the Shell* (1995).[11] By combining porcelain and cyborgs, Lee implicates the material of porcelain in the fetishization of Asian women's bodies and counters Japonisme and Chinoiserie as benign aesthetic styles.[12] In making monstrously beautiful, ambiguous cyborg porcelain, Lee illustrates the intertwined, often difficult to decipher, systems to which Asian women and their bodies are subjected.

112. Lee Bul. *Untitled (Cyborg Pelvis)*, 2000. Porcelain

Fig. 58. Lee Bul (South Korean, b. 1964). *Cyborgs
W1-W4*, 1998. Cast silicone and mixed media

NOTES
TO THE ESSAYS

INTRODUCTION:
THE WOMAN IN THE MIRROR

1. Wu Hung, *The Double Screen: Medium and Representation in Chinese Painting* (Chicago: University of Chicago Press, 1996), pp. 85–133; and Julia M. White, "Educated and Probably Dangerous Women in Seventeenth- and Eighteenth-Century Chinese Painting," in *Beauty Revealed: Images of Women in Qing Dynasty Chinese Painting*, ed. James Cahill, exh. cat. (Berkeley: University of California, Berkeley Art Museum and Pacific Film Archive, 2013), pp. 23–33.
2. See Emile de Bruijn, *Chinese Wallpaper in Britain and Ireland* (London: Philip Wilson, 2017), pp. 37–44.
3. Quoted in Patrick Conner, "Chinese Style in 19th-Century Britain," in *Chinese Whispers: Chinoiserie in Britain, 1650–1930*, ed. David Beevers, exh. cat. (Brighton: Royal Pavilion and Museums, 2008), p. 66. On the Macartney Embassy, see James L. Hevia, *Cherishing Men from Afar: Qing Guest Ritual and the Macartney Embassy of 1793* (Durham, NC: Duke University Press, 1995).
4. The accompanying publications are Karina H. Corrigan, Jan van Campen, and Femke Diercks, eds., *Asia in Amsterdam: The Culture of Luxury in the Golden Age*, exh. cat. (Salem, MA: Peabody Essex Museum, 2015); and Virginie Frelin, ed., *Une des provinces du rococo: La Chine rêvée de François Boucher*, exh. cat. (Paris: In Fine éditions d'art, 2019).
5. Hugh Honour, *Chinoiserie: The Vision of Cathay* (London: John Murray, 1961), p. 2.
6. Aileen Kwun, "It's Time to Rethink Chinoiserie," *Elle Décor*, May 27, 2021, https://www .elledecor.com/life-culture /a36548998/time-to-rethink -chinoiserie/.
7. David Porter, "Monstrous Beauty: Eighteenth-Century Fashion and the Aesthetics of the Chinese Taste," in "Aesthetics and the Disciplines," special issue, *Eighteenth-Century Studies* 35, no. 3 (Spring 2002), p. 403.
8. Porter, "Monstrous Beauty," p. 402.
9. Anne Anlin Cheng, *Ornamentalism* (New York: Oxford University Press, 2019), p. 3.
10. On the European obsession with porcelain, see, for example, Edmund de Waal, *The White Road: Journey into an Obsession* (New York: Picador, 2016).
11. Donna Haraway, "The Promises of Monsters: A Regenerative Politics for Inappropriate/d Others," in *Cultural Studies*, ed. Lawrence Grossberg, Cary Nelson, and Paula Treichler (New York: Routledge, 1992), p. 300.
12. Stacey Sloboda, *Chinoiserie: Commerce and Critical Ornament in Eighteenth-Century Britain* (Manchester: Manchester University Press, 2014), p. 121.
13. Jonathan Hay, *Sensuous Surfaces: The Decorative Object in Early Modern China* (London: Reaktion Books, 2010).
14. Maxine Hong Kingston, *The Woman Warrior: Memoirs of a Girlhood among Ghosts* (New York: Vintage International, 1989), p. 10.
15. Chi-ming Yang, *Performing China: Virtue, Commerce, and Orientalism in Eighteenth-Century England, 1660–1760* (Baltimore: Johns Hopkins University Press, 2011), p. 146.
16. Thomas Fuller and Jill Cowan, "8 Dead in Atlanta Spa Shootings, with Fears of Anti-Asian Bias," *New York Times*, updated March 26, 2021, https://www .nytimes.com/live/2021/03/17 /us/shooting-atlanta-acworth.
17. For a different take on this question, see Meyer Schapiro, "Style," in *Anthropology Today: An Encyclopedic Inventory*, ed. A. L. Kroeber (Chicago: University of Chicago Press, 1953), pp. 287–311.
18. For the former stance, see Frelin, *Provinces du rococo*; for the latter, see Johannes Franz Hallinger, *Das Ende der Chinoiserie: Die Auflösung eines Phänomens der Kunst in der Zeit der Aufklärung* (Munich: Scaneg, 1996), p. 9.

SHIPWRECKS AND SIRENS:
EARLY ARRIVALS OF
PORCELAIN IN EUROPE

1. Jeroen ter Brugge, "De Witte Leeuw," in *Gezonken schatten: Vondsten uit scheepswrakken van de maritieme zijderoute, 800–1900 = Sunken Treasures: Discoveries in Shipwrecks from the Maritime Silk Road, 800–1900*, ed. Karin Gaillard and Eline van den Berg, exh. cat. (Zwolle: Waanders & De Kunst, 2019), p. 100.
2. Anthony Farrington, *Trading Places: The East India Company and Asia, 1600–1834*, exh. cat. (London: British Library, 2002), p. 13.
3. Clare Le Corbeiller, "China into Delft: A Note on Visual Translation," in "Art Forgery," special issue, *The Metropolitan Museum of Art Bulletin* 26, no. 6 (February 1968), p. 269.
4. Ter Brugge, "Witte Leeuw," p. 103.
5. Clare Le Corbeiller, *China Trade Porcelain: Patterns of Exchange; Additions to the Helena Woolworth McCann Collection in The Metropolitan Museum of Art* (New York: The Metropolitan Museum of Art, 1974), p. 1.
6. Robert Finlay, "The Pilgrim Art: The Culture of Porcelain in World History," *Journal of World History* 9, no. 2 (Fall 1998), p. 168.
7. Jos Gommans, "Merchants among Kings: Dutch Diplomatic Encounters in Asia," in *Asia in Amsterdam: The Culture of Luxury in the Golden Age*, ed. Karina H. Corrigan, Jan van Campen, and Femke Diercks, exh. cat. (Salem, MA: Peabody Essex Museum, 2015), p. 32.
8. David S. Howard, *The Choice of the Private Trader: The Private Market in Chinese Export Porcelain; Illustrated from the Hodroff Collection* (London: Zwemmer, 1994), p. 13.
9. Quoted in Anne Gerritsen and Stephen McDowall, "Material Culture and the Other: European Encounters with Chinese Porcelain, ca. 1650–1800," in "Global China," special issue, *Journal of World History* 23, no. 1 (March 2012), p. 92.

10. Quoted in Gerritsen and McDowall, "Material Culture and the Other," p. 92.
11. Farrington, *Trading Places*, p. 13.
12. Le Corbeiller, *China Trade Porcelain*, p. 14.
13. On the probable shape of the ewer, see Le Corbeiller, *China Trade Porcelain*, pp. 12–14. See also Ronda Kasl, "Empires and Emporia: The Manila Galleon Trade and the Spanish Invention of China," *Arts of Asia* 50, no. 2 (March–April 2020), pp. 92–102.
14. Quoted in Gerritsen and McDowall, "Material Culture and the Other," p. 93.
15. Quoted in Benjamin Schmidt, "The Rearing Horse and the Kneeling Camel: Continental Ceramics and Europe's Race to Modernity," in *Bodies and Maps: Early Modern Personifications of the Continents*, ed. Maryanne Cline Horowitz and Louise Arizzoli, Intersections 73 (Leiden: Brill, 2020), p. 322.
16. On the Manila galleons, see Kasl, "Empires and Emporia." On the global culture of porcelain, see Finlay, "Pilgrim Art."
17. W. H. Moreland, ed. and trans., *Peter Floris: His Voyage to the East Indies in the Globe, 1611–1615* (London: Hakluyt Society, 1934), p. 108.
18. Finlay, "Pilgrim Art," p. 162.
19. Matthew Dimmock, *Elizabethan Globalism: England, China and the Rainbow Portrait* (London: Paul Mellon Centre for Studies in British Art, 2019), p. 132.
20. Clare Le Corbeiller, "A Medici Porcelain Pilgrim Flask," *J. Paul Getty Museum Journal* 16 (1988), p. 122.
21. Le Corbeiller, "Medici Porcelain Pilgrim Flask," p. 122.
22. See Jan Hogendorn and Marion Johnson, *The Shell Money of the Slave Trade*, African Studies Series 49 (1986; repr., Cambridge: Cambridge University Press, 2003), p. 15.
23. Edmund de Waal, *The White Road: Journey into an Obsession* (New York: Picador, 2016), p. 8.
24. See Jen Liu, interview by Xiaowei Wang, *Bomb*, March 4, 2024, https://bombmagazine.org /articles/2024/03/04/jen-liu-by -xiaowei-wang/.
25. On Robert Cecil's obsession with China, see Dimmock, *Elizabethan Globalism*, pp. 129–52.
26. On this decoration technique, see Jorge Welsh, *Kinrande: Porcelain Dressed in Gold* (London: Jorge Welsh Research and Publishing, 2020).
27. On mounted porcelain as status symbol, see C. Louise Avery, "Chinese Porcelain in English Mounts," *The Metropolitan Museum of Art Bulletin*, n.s., 2, no. 9 (May 1944), p. 268. On Elizabeth and the politics of gender, see Louis Montrose, *The Subject of Elizabeth: Authority, Gender, and Representation* (Chicago: University of Chicago Press, 2006).
28. See Elizabeth Cleland, "England, Europe, and the World: Art as Policy," in Elizabeth Cleland and Adam Eaker, *The Tudors: Art and Majesty in Renaissance England*, exh. cat. (New York: The Metropolitan Museum of Art, 2022), pp. 20–101.
29. See Avery, "Chinese Porcelain," p. 266. Avery attributed the mounts on the bowl, purchased from J. Pierpont Morgan with the four porcelain vessels from Burghley House, to the same silversmith.
30. See Montrose, *Subject of Elizabeth*, pp. 144–66.
31. On the fashioning of Elizabeth's images, see Sarah Bochicchio, "Iterations of Elizabeth," in Cleland and Eaker, *Tudors*, pp. 286–93.
32. Kristen G. Brookes, "A Feminine 'Writing That Conquers': Elizabethan Encounters with the New World," *Criticism* 48, no. 2 (Spring 2006), pp. 240–41.
33. Wilfred P. Mustard, "Siren-Mermaid," *Modern Language Notes* 23, no. 1 (January 1908), p. 21.
34. This may have been due to the fact that the ancient Greek word *pterughion* meant both wing and fin. See Meri Lao, *Sirens: Symbols of Seduction* (Rochester, VT: Park Street, 1998), p. 82.
35. Mustard, "Siren-Mermaid," p. 23.
36. Tara E. Pedersen, *Mermaids and the Production of Knowledge in Early Modern England* (Farnham: Ashgate, 2015), p. 13.
37. For the English, Circe and Medea symbolized fears about race and encounters in the New World. See Brookes, "Feminine 'Writing That Conquers,'" pp. 227–62.
38. Monique Roffey, *The Mermaid of Black Conch* (New York: Vintage Books, 2020), p. 30.
39. On Batavia, see Jan van Campen, "The Hybrid World of Batavia," in Corrigan, Van Campen, and Diercks, *Asia in Amsterdam*, pp. 40–49.
40. See Ann Laura Stoler, *Carnal Knowledge and Imperial Power: Race and the Intimate in Colonial Rule* (Berkeley: University of California Press, 2010), p. 11.
41. Jean Gelman Taylor, "Meditations on a Portrait from Seventeenth-Century Batavia," *Journal of Southeast Asian Studies* 37, no. 1 (February 2006), p. 27.
42. Taylor, "Meditations on a Portrait," p. 35.
43. Taylor, "Meditations on a Portrait," p. 33.
44. Taylor, "Meditations on a Portrait," p. 39.
45. On the Portuguese ruins in Macao and the politics of European and Chinese memory, see Jonathan Porter, "'The Past Is Present': The Construction of Macau's Historical Legacy," *History and Memory* 21, no. 1 (Spring–Summer 2009), pp. 63–100.
46. Heidi Lau, interview by the author, April 4, 2024.
47. Lau, interview by the author, April 4, 2024.

SURROGATE BODIES: MARY II, SUCCESSION, AND PORCELAIN OBSESSIONS

1. Daniel Defoe, *A Tour thro' the whole island of Great Britain, divided into circuits or journies* [. . .] (1724; repr., London: Peter Davies, 1927), p. 175.
2. Defoe, *Tour*, p. 166.
3. Defoe, *Tour*, p. 166.
4. Accounts suggest that it was in fact Catherine of Braganza, the Portuguese bride of Charles II, who introduced the fashion for porcelain. See Edward Corp, "Catherine of Braganza and Cultural Politics," in *Queenship in Britain, 1660–1837: Royal Patronage, Court Culture, and Dynastic Politics*, ed. Clarissa Campbell Orr (Manchester: Manchester University Press, 2002), p. 65.
5. On porcelain collectors in England, see Stella Beddoe,

"'Prodigous Charming Pots': British Chinoiserie Ceramics," in *Chinese Whispers: Chinoiserie in Britain, 1650–1930*, ed. David Beevers, exh. cat. (Brighton: Royal Pavilion and Museums, 2008), pp. 27–37; and Eric Weichel, "'Every Other Place It Could Be Placed with Advantage': Ladies-in-Waiting at the British Court and the 'Excessive' Display of Ceramics as Art Objects, 1689–1740," in *The Uses of Excess in Visual and Material Culture, 1600–2010*, ed. Julia Skelly (2014; repr., London: Routledge, 2018), pp. 41–61.

6. See Patricia F. Ferguson, "Ambassadeur voor Nederland: Delfts aardewerk in Engeland," in *Koninklijk blauw: Het mooiste Delfts aardewerk van Willem en Mary*, ed. Suzanne Lambooy, exh. cat. (Zwolle: Waanders, 2020), pp. 133–63.

7. See David Porter, *The Chinese Taste in Eighteenth-Century England* (Cambridge: Cambridge University Press, 2010), p. 63. On the display of women on porcelain, see Sarah E. Fraser, Yue Sun, and Hua Wang, "Introduction: Women on Display: Narration and Cross Media Spaces in Seventeenth- and Eighteenth-Century Porcelain," in *Women Cross Media: East Asian Photography, Prints, and Porcelain from the Staatliche Kunstsammlungen Dresden*, ed. Sarah Fraser, Mio Wakita, and Lianming Wang (Heidelberg: arthistoricum.net, 2022), pp. 48–130.

8. Meredith Martin, *Dairy Queens: The Politics of Pastoral Architecture from Catherine de' Medici to Marie-Antoinette* (Cambridge, MA: Harvard University Press, 2011), p. 48.

9. Catriona Murray, *Imaging Stuart Family Politics: Dynastic Crisis and Continuity* (New York: Routledge, 2017), pp. 130–32.

10. Murray, *Imaging Stuart Family Politics*, p. 117.

11. On the Exclusion crisis, see Tim Harris, *Politics under the Later Stuarts: Party Conflict in a Divided Society, 1660–1715* (New York: Routledge, 1993), pp. 80–108.

12. See Lois G. Schwoerer, "Images of Queen Mary II, 1689–95,"

Renaissance Quarterly 42, no. 4 (Winter 1989), p. 729.

13. On the gendered nature of needlework, see Kathleen Staples, "Embroidered Furnishings: Questions of Production and Usage," in *English Embroidery from The Metropolitan Museum of Art, 1580–1700: 'Twixt Art and Nature*, ed. Andrew Morrall and Melinda Watt, exh. cat. (New York: Bard Graduate Center for Studies in the Decorative Arts, Design, and Culture, 2008), pp. 23–37.

14. See Morrall and Watt, *English Embroidery*, pp. 216–21, cat. 56, "Mirror with Jael and Barak."

15. Amy Lim, "World of Interiors: Mary II, the Decorative Arts, and Cultural Transfer," in *Later Stuart Queens, 1660–1735: Religion, Political Culture, and Patronage*, ed. Eilish Gregory and Michael C. Questier (Cham: Palgrave Macmillan, 2023), p. 175.

16. Ralph Hyde, "Romeyn de Hooghe and the Funeral of the People's Queen," *Print Quarterly* 15, no. 2 (June 1998), p. 150.

17. Lim, "World of Interiors," p. 175.

18. Quoted in Linda Shulsky, "Queen Mary's Collection of Porcelain and Delft and Its Display at Kensington Palace: Based upon an Analysis of the Inventory Taken in 1697" (master's thesis, Cooper-Hewitt Museum, Smithsonian Institution; Parsons School of Design, 1985), p. 9.

19. See Virginia Treanor, "'Une abondance extra ordinaire': The Porcelain Collection of Amalia van Solms," *Early Modern Women* 9, no. 1 (Fall 2014), pp. 141–54.

20. Treanor, "'Abondance extra ordinaire,'" p. 148.

21. See Jan van Campen, "'Reduced to a Heap of Monstrous Shivers and Splinters': Some Notes on Coromandel Lacquer in Europe in the 17th and 18th Centuries," *Rijksmuseum Bulletin* 57, no. 2 (2009), pp. 137–38.

22. Van Campen, "'Reduced to a Heap,'" pp. 38–39.

23. Susan Broomhall and Jacqueline Van Gent, *Dynastic Colonialism: Gender, Materiality and the Early Modern House of Orange-Nassau* (New York: Routledge, 2016), p. 93.

24. Quoted in Lim, "World of Interiors," p. 176.

25. Schwoerer, "Images of Queen Mary II," p. 727.

26. Schwoerer, "Images of Queen Mary II," p. 727.

27. Schwoerer, "Images of Queen Mary II," p. 730.

28. Melinda S. Zook, "The Shocking Death of Mary II: Gender and Political Crisis in Late Stuart England," in "Britain and the World," special issue, *British Scholar* 1, no. 1 (September 2008), p. 22.

29. Schwoerer, "Images of Queen Mary II," p. 734.

30. Sebastian Edwards, "The Building and Decoration of William and Mary's Kensington House," in *Kensington Palace and the Porcelain of Queen Mary II*, ed. Mark Hinton and Oliver Impey, exh. cat. (London: Christie's, 1998), p. 14.

31. Richard Doebner, ed., *Memoirs of Mary, Queen of England (1689–1693): Together with Her Letters and Those of James II and William III to the Electress Sophia of Hanover* (Leipzig: Veit, 1886), p. 17.

32. Theodoor Herman Lunsingh Scheurleer, "Documents on the Furnishing of Kensington House," *Walpole Society* 38 (1960–62), p. 19.

33. Linda Shulsky, "Queen Mary's Collection of Porcelain and Its Display at Kensington Palace," in Hinton and Impey, *Kensington Palace*, p. 38.

34. Shulsky, "Queen Mary's Collection," p. 38.

35. Shulsky, "Porcelain and Delft," p. 69.

36. Simon Thurley, *Hampton Court: A Social and Architectural History* (New Haven: Yale University Press, 2003), p. 172.

37. Defoe, *Tour*, p. 175.

38. Defoe, *Tour*, p. 175.

39. Defoe, *Tour*, p. 175.

40. Jérémie Benoît, "Le Trianon de Porcelaine côté cour," in *La Chine à Versailles: Art et diplomatie au XVIIIe siècle*, ed. Marie-Laure de Rochebrune, exh. cat. (Paris: Somogy éditions d'art, 2014), p. 30.

41. Quoted in Christopher Stevens, "Koningin Mary II en de Water Gallery van Hampton Court Palace," in Lambooy, *Koninklijk blauw*, p. 112.

42. Stevens, "Koningin Mary II," p. 113.
43. Quoted in Stevens, "Koningin Mary II," p. 113.
44. On De Vere, see Brett Dolan, *Beauty, Sex and Power: A Story of Debauchery and Decadent Art at the Late Stuart Court, 1660–1714*, exh. cat. (London: Historic Royal Palaces, 2012), pp. 125–26.
45. The original commission was probably assembled at Saint James's Palace and is mentioned in the duke's (later James II's) 1674 inventory; see Dolan, *Beauty, Sex and Power*, p. 24.
46. Dolan, *Beauty, Sex and Power*, p. 122.
47. Martin, *Dairy Queens*, p. 29.
48. Martin, *Dairy Queens*, p. 31.
49. On milk and fertility in the context of Fontainebleau and the French Renaissance, see Rebecca Zorach, *Blood, Milk, Ink, Gold: Abundance and Excess in the French Renaissance* (Chicago: University of Chicago Press, 2005), esp. chapter 3.
50. Quoted in Mary Fissel, "Remaking the Maternal Body in England, 1680–1730," *Journal of the History of Sexuality* 26, no. 1 (January 2017), p. 120.
51. On Melanie Klein's work in contemporary art, see Mignon Nixon, "Bad Enough Mother," in "Feminist Issues," special issue, *October* 71 (Winter 1995), pp. 70–92.

SPILLING TEA: PERFORMING POLITENESS AND DOMESTICITY

1. Edward Corp, "Catherine of Braganza and Cultural Politics," in *Queenship in Britain, 1660–1837: Royal Patronage, Court Culture, and Dynastic Politics*, ed. Clarissa Campbell Orr (Manchester: Manchester University Press, 2002), p. 64.
2. Peter B. Brown, *In Praise of Hot Liquors: The Study of Chocolate, Coffee and Tea-Drinking, 1600–1850*, exh. cat. (York: York Civic Trust, 1995), p. 52.
3. Corp, "Catherine of Braganza," p. 64.
4. David Porter, *The Chinese Taste in Eighteenth-Century England* (Cambridge: Cambridge University Press, 2010), p. 139.
5. Oliver Impey, "Japanese Porcelain at Burghley House: The Inventory of 1688 and the Sale of 1888," in "Essays in Honor of Clare Le Corbeiller," special issue, *Metropolitan Museum Journal* 37 (2002), p. 118.
6. See Amanda Vickery, *The Gentleman's Daughter: Women's Lives in Georgian England* (1998; repr., New Haven: Yale University Press, 2003), p. 161.
7. Quoted in Vickery, *Gentleman's Daughter*, p. 209.
8. I am grateful to Edward Town of the Yale Center for British Art for sharing his research on the painting and its ties to the Carter family.
9. Elizabeth Kowaleski-Wallace, *Consuming Subjects: Women, Shopping, and Business in the Eighteenth Century* (New York: Columbia University Press, 1997), p. 25.
10. The policing of gender and sexuality was not limited to women. For an account of eighteenth-century fops and macaronis, see Peter McNeil, *Pretty Gentlemen: Macaroni Men and the Eighteenth-Century Fashion World* (New Haven: Yale University Press, 2018). On glass and notions of polish, see Christopher L. Maxwell, ed., *In Sparkling Company: Reflections on Glass in the Eighteenth-Century British World*, exh. cat. (Corning, NY: Corning Museum of Glass, 2020).
11. Steven Goss, *British Tea and Coffee Cups, 1745–1940* (Oxford: Shire, 2002), p. 5.
12. On women painters, see Roger Massey, "Independent China Painters in 18th-Century London," *English Ceramics Circle Transactions* 19, no. 1 (2005), p. 158. The china painter William Billingsley, who worked at Derby China Factory, complained about hiring women, saying, "From the many injuries done to the trade by employing Women in Painting of China, &c., Particularly not being employ'd in London in any Painting or Gilding Shop whatsoever, we hope you will not withstand Granting us the favour of their not being employ'd here." Quoted in Llewellynn Frederick William Jewitt, *The History of Ceramic Art in Great Britain: From Prehistoric Times Down Through Each Successive Period to the Present Day* (New York: Scribner, Welford, and Armstrong, 1878), vol. 2, p. 102. I thank Patricia F. Ferguson for these references.
13. Quoted in Porter, *Chinese Taste*, p. 100.
14. Stacey Sloboda, "Porcelain Bodies: Gender, Acquisitiveness, and Taste in Eighteenth-Century England," in *Material Cultures, 1740–1920: The Meanings and Pleasures of Collecting*, ed. John Potvin and Alla Myzelev (Farnham: Ashgate, 2009), p. 20.
15. Porter, *Chinese Taste*, p. 91.
16. On the Allegories of the Continents, see Michael Wintle, "Gender and Race in the Personification of the Continents in the Early Modern Period: Building Eurocentrism," in *Bodies and Maps: Early Modern Personifications of the Continents*, ed. Maryanne Cline Horowitz and Louise Arizzoli, Intersections 73 (Leiden: Brill, 2020), pp. 39–66.
17. On the blackamoor figure in European porcelain, see Adrienne L. Childs, "Sugar Boxes and Blackamoors: Ornamental Blackness in Early Meissen Porcelain," in *The Cultural Aesthetics of Eighteenth-Century Porcelain*, ed. Alden Cavanaugh and Michael E. Yonan (Farnham: Ashgate, 2010), pp. 159–77.
18. Porter, *Chinese Taste*, p. 137.
19. See Eddy de Jongh, "A Bird's-Eye View of Erotica: Double Entendre in a Series of Seventeenth-Century Genre Scenes," in Eddy de Jongh, *Questions of Meaning: Theme and Motif in Dutch Seventeenth-Century Painting*, trans. Michael Hoyle (Leiden: Primavera Pers, 1995), pp. 22–58.
20. Porter, *Chinese Taste*, p. 141.
21. Quoted in Porter, *Chinese Taste*, p. 141.
22. Abbé Le Blanc quoted in Iris Moon, "Of Pastels and Porcelain," in Francesca Whitlum-Cooper, *Discover Liotard and "The Lavergne Family Breakfast,"* exh. cat. (London: National Gallery, 2023), p. 98. The painting by Jean-Etienne

Liotard is *Still Life: Tea Set*, ca. 1781–83. Oil on canvas mounted on board. J. Paul Getty Museum, Los Angeles (84.PA.57).

23. Porter, *Chinese Taste*, pp. 144–45.

24. Candice Lin, "The Land of Milk and Blood," in *Saturation: Race, Art, and the Circulation of Value*, ed. C. Riley Snorton and Hentyle Yapp (Cambridge, MA: MIT Press, 2020), p. 55.

25. Lin, "Land of Milk and Blood," p. 56.

ARTIFICIAL MOTHERS: FIGURINES AND FANTASIES OF THE FEMALE SUBJECT

1. On the nude, see Lynda Nead, *The Female Nude: Art, Obscenity, and Sexuality* (London: Routledge, 1992).

2. On the Pygmalion myth and the complexities of embodiment and race, see Angela Rosenthal, "Visceral Culture: Blushing and the Legibility of Whiteness in Eighteenth-Century British Portraiture," *Art History* 27, no. 4 (September 2004), pp. 563–92.

3. See Jorge Welsh and Luísa Vinhais, eds., *Porcelain People: Figures from the Qing Dynasty*, exh. cat. (London: Jorge Welsh Research and Publishing, 2021), p. 18.

4. Robert H. Blumenfield, *Blanc de Chine: The Great Porcelain of Dehua* (Berkeley: Ten Speed, 2002), p. 62; and Welsh and Vinhais, *Porcelain People*, p. 50. On the changing image of Guanyin, see Yuhang Li, *Becoming Guanyin: Artistic Devotion of Buddhist Women in Late Imperial China* (New York: Columbia University Press, 2019).

5. Blumenfield, *Blanc de Chine*, p. 62.

6. Blumenfield, *Blanc de Chine*, p. 62.

7. Quoted in Welsh and Vinhais, *Porcelain People*, p. 50.

8. Oliver Impey, "Japanese Porcelain at Burghley House: The Inventory of 1688 and the Sale of 1888," in "Essays in Honor of Clare Le Corbeiller," special issue, *Metropolitan Museum Journal* 37 (2002), pp. 118–22.

9. Quoted in Christiane Hertel,

Siting China in Germany: Eighteenth-Century Chinoiserie and Its Modern Legacy (University Park: Pennsylvania State University Press, 2019), p. 19.

10. Benjamin Schmidt, "The Rearing Horse and the Kneeling Camel: Continental Ceramics and Europe's Race to Modernity," in *Bodies and Maps: Early Modern Personifications of the Continents*, ed. Maryanne Cline Horowitz and Louise Arizzoli, Intersections 73 (Leiden: Brill, 2020), p. 331.

11. Schmidt, "Rearing Horse," p. 333.

12. Schmidt, "Rearing Horse," p. 334.

13. Vanessa Sigalas and Meredith Chilton, eds., *All Walks of Life: A Journey with the Alan Shimmerman Collection; Meissen Porcelain Figures of the Eighteenth Century* (Stuttgart: Arnoldsche, 2022), pp. 66–67.

14. Sigalas and Chilton, *All Walks of Life*, pp. 57–58.

15. Sigalas and Chilton, *All Walks of Life*, p. 61.

16. Hertel, *Siting China*, p. 23.

17. Hertel, *Siting China*, p. 45.

18. See, for example, Wolf Burchard, *Inspiring Walt Disney: The Animation of French Decorative Arts*, exh. cat. (New York: The Metropolitan Museum of Art, 2021), pp. 47–63. For a different take on questions of animation as tied to the posthuman condition, see Lynn Festa, *Fiction Without Humanity: Person, Animal, Thing in Early Enlightenment Literature and Culture* (Philadelphia: University of Pennsylvania Press, 2019).

19. Quoted in David Pullins, "L'introuvable peinture chinoise de François Boucher ou la question de la caricature," in *Une des provinces du rococo: La Chine rêvée de François Boucher*, ed. Virginie Frelin, exh. cat. (Paris: In Fine éditions d'art, 2019), p. 127. On colonial mimicry, see Homi Bhabha, "Of Mimicry and Man: The Ambivalence of Colonial Discourse," in "Discipleship: A Special Issue on Psychoanalysis," *October* 28 (Spring 1984), pp. 124–33.

20. On Watteau, see Katie Scott, "Playing Games with Otherness: Watteau's Chinese Cabinet at the

Château de la Muette," *Journal of the Warburg and Courtauld Institutes* 66 (2003), pp. 189–248. See also Perrin Stein, "François Boucher, la gravure et l'entreprise de chinoiseries," in Frelin, *Provinces du rococo*, pp. 224–26.

21. See Marie-Laure de Rochebrune, "L'echo des inventions chinoises de François Boucher dans les arts décoratifs au XVIIIe siècle," in Frelin, *Provinces du rococo*, pp. 239–40. On the Chinoiserie models of Kändler, see Sigalas and Chilton, *All Walks of Life*.

22. Stein, "François Boucher," p. 231.

23. Yohan Rimaud, "Les couleurs célestes de la terre: La collection d'objets orientaux de François Boucher," in Frelin, *Provinces du rococo*, p. 64.

24. Rimaud, "Couleurs célestes," p. 66.

25. See James Cahill, *Pictures for Use and Pleasure: Vernacular Painting in High Qing China* (Berkeley: University of California Press, 2010), p. 20.

26. See Françoise Vergès, *Monsters and Revolutionaries: Colonial Family Romance and Métissage* (Durham, NC: Duke University Press, 1999).

27. On the Chinese source, see Richard E. Strassberg, "War and Peace: Four Intercultural Landscapes," in *China on Paper: European and Chinese Works from the Late Sixteenth to the Early Nineteenth Century*, ed. Marcia Reed and Paola Demattè, exh. cat. (Los Angeles: Getty Research Institute, 2007), pp. 89–96. The prints and vases were also the focus of a 2004 exhibition at the Getty Museum organized by Jeffrey Weaver, *Imagining the Orient*. See also Juliet Carey, "Circumventing the Orient: The Getty Museum's 'Dudley Vases' and Sèvres Chinoiseries," in "Reframing Eighteenth-Century European Ceramics," ed. Patricia F. Ferguson, Diana Davis, and John Whitehead, special issue, *French Porcelain Society Journal* 9 (2022), pp. 243–77.

28. Chi-ming Yang, "Elephantine Chinoiserie and Asian Whiteness: Views on a Pair of Sèvres Vases," *Journal of the Walters Art Museum* 75, https://journal.thewalters.org/volume/75

/essay/elephantine-chinoiserie
-and-asian-whiteness-views-on
-a-pair-of-sevres-vases/.

29. See the now classic take in Chantal Thomas, *The Wicked Queen: The Origins of the Myth of Marie-Antoinette* (New York: Zone Books, 1999).

30. On the iterative, see Scott, "Playing Games with Otherness," pp. 206–7.

31. See *Cohen & Cohen. 50 Years of Chinese Export Porcelain*, sale cat. (Bonhams, New York, January 24, 2023), lot 54, https://www.bonhams.com /auction/28289/lot/54 /a-pair-of-extremely-rare-famille -rose-reclining-ladies-each -viewing-a-painting-album -qianlong-period-circa-1750-2/.

32. I thank Marlise Brown for first introducing me to the margravine of Bayreuth through her exceptional research.

33. Marie Theres Stauffer, "Mirrors and Memories: The Chinese Mirror Cabinet at the Hermitage near Bayreuth," in *Solitudo: Spaces, Places, and Times of Solitude in Late Medieval and Early Modern Cultures*, ed. Karl A. E. Enenkel and Christine Göttler, Intersections 56 (Leiden: Brill, 2018), pp. 481–83.

34. Stauffer, "Mirrors and Memories," p. 504.

35. On reverse-painted mirrors, see Thierry Audric, *Chinese Reverse Glass Painting, 1720– 1820: An Artistic Meeting Between China and the West* (Bern: Peter Lang, 2020). See also Francine Giese et al., eds., *China and the West: Reconsidering Chinese Reverse Glass Painting* (Berlin: De Gruyter, 2023).

36. Quoted in Audric, *Chinese Reverse Glass Painting*, p. 26.

AFTERLIVES OF CHINOISERIE

1. See Lenore Metrick-Chen, *Collecting Objects / Excluding People: Chinese Subjects and American Visual Culture, 1830–1900* (Albany: State University of New York Press, 2012), pp. 13–15.

2. On the Rococo style, see Katie Scott and Melissa Lee Hyde, eds., *Rococo Echo: Art, History and Historiography from Cochin

to Coppola* (Oxford: Voltaire Foundation, 2014).

3. Gordon H. Chang, *Fateful Ties: A History of America's Preoccupation with China* (Cambridge, MA: Harvard University Press, 2015), p. 17. On the early American fascina- tion with China, see Alfred Owen Aldridge, *The Dragon and the Eagle: The Presence of China in the American Enlightenment* (Detroit: Wayne State University Press, 1993). I thank Agnes Hsu-Tang for the reference.

4. Jonathan Goldstein, "Cantonese Artifacts, Chinoiserie, and Early American Idealization of China," in *America Views China: American Images of China Then and Now*, ed. Jonathan Goldstein, Jerry Israel, and Hilary Conroy (London: Associated University Presses, 1991), p. 46.

5. This story is recounted in Amitav Ghosh, *Smoke and Ashes: Opium's Hidden Histories* (New York: Farrar, Straus and Giroux, 2024).

6. Chang, *Fateful Ties*, p. 30.

7. For a new take on foot-binding, see Dorothy Ko, *Cinderella's Sisters: A Revisionist History of Footbinding* (Berkeley: University of California Press, 2007).

8. See Emily Apter, *Feminizing the Fetish: Psychoanalysis and Narrative Obsession in Turn-of- the-Century France* (Ithaca, NY: Cornell University Press, 1991), p. 43.

9. Linda Merrill, "Whistler and the 'Lange Lijzen,'" *Burlington Magazine* 136, no. 1099 (October 1994), p. 683.

10. Jean-Paul Desroches, "Les collections provenant de la campagne de Chine," in *Le Musée chinois de l'impératrice Eugénie*, ed. Colombe Samoyault-Verlet et al., exh. cat. (Paris: Réunion des musées nationaux, 1994), p. 29.

11. On prints of the palace, see Richard E. Strassberg, "War and Peace: Four Intercultural Landscapes," in *China on Paper: European and Chinese Works from the Late Sixteenth to the Early Nineteenth Century*, ed. Marcia Reed and Paola Demattè, exh. cat. (Los Angeles: Getty Research Institute, 2007), pp. 104–20.

12. Sally Wen Mao, "On Porcelain," in *The Kingdom of Surfaces: Poems* (Minneapolis: Graywolf,

2023), p. 29.

13. "John Luther Long, Playwright, Dead," *New York Times*, November 1, 1927.

14. See, for example, Manu Karuka, *Empire's Tracks: Indigenous Nations, Chinese Workers, and the Transcontinental Railroad* (Berkeley: University of California Press, 2019).

15. Quoted in Metrick-Chen, *Collecting Objects / Excluding People*, p. 22.

16. Metrick-Chen, *Collecting Objects / Excluding People*, p. 24.

17. Anne Anlin Cheng, *Ornamen- talism* (New York: Oxford University Press, 2019), pp. 5–6.

18. Cheng, *Ornamentalism*, pp. 28–30.

19. Cheng, *Ornamentalism*, p. 33.

20. Metrick-Chen, *Collecting Objects / Excluding People*, p. 126.

21. Ying-chen Peng, *Artful Subversion: Empress Dowager Cixi's Image Making* (New Haven: Yale University Press, 2023), p. 58.

22. Peng, *Artful Subversion*, p. 7.

23. Luke Gartlan, "Stillfried's Hand-Colored Portraits," in *Power and Perspective: Early Photography in China*, ed. Stephanie H. Tung and Karina H. Corrigan, exh. cat. (Salem, MA: Peabody Essex Museum, 2022), pp. 291–93.

24. See Catherine Yeh, *Shanghai Love: Courtesans, Intellectuals, and Entertainment Culture, 1850–1910* (Seattle: University of Washington Press, 2006), pp. 143–46.

25. See Yeh, *Shanghai Love*, chapter 3.

26. Peng, *Artful Subversion*, p. 31.

27. Peng, *Artful Subversion*, p. 34.

28. Mei Mei Rado, "The Court," in *China's Hidden Century, 1792– 1912*, ed. Jessica Harrison-Hall and Julia Lovell, exh. cat. (London: British Museum, 2023), p. 79.

29. Peng, *Artful Subversion*, pp. 81–82.

30. See also Rado, "Court," pp. 76–79.

31. See Cindy Kang's essay in this catalogue.

32. Yunte Huang, *Daughter of the Dragon: Anna May Wong's Rendezvous with American History* (New York: Liveright, 2023), p. 70.

33. On the ties between Wong,

race, and color in film, see Homay King, "Anna May Wong and the Color Image," in "Blackness," special issue, *Liquid Blackness: Journal of Aesthetics and Black Studies* 5, no. 2 (October 2021), pp. 59–73.

34. Quoted in Graham Russell Gao Hodges, *Anna May Wong: From Laundryman's Daughter to Hollywood Legend*, 3rd ed. (Chicago: Chicago Review Press, 2023), p. 70. See also Huang, *Daughter of the Dragon*, pp. 112–15.

35. Huang, *Daughter of the Dragon*, p. 130.

36. Cheng, *Ornamentalism*, p. 69.

37. Cheng, *Ornamentalism*, p. 70.

OBJECT ENCOUNTERS

THE STRANDED BEAUTY OF YEESOOKYUNG

1. Charles Dickens, "Pottery and Porcelain," *Household Words* 4 (1851), p. 33.

2. "Can the Following Facts Be Tolerated?," in 34th Congress, 1st Session, House Executive Document No. 105, on the "Slave and Coolie Trade," p. 78.

3. Karl Marx, correspondence published in the *New York Daily Tribune*, June 2, 1857, accessed June 13, 2024, https://www.marxists.org/archive/marx/works/1857/06/02.htm.

4. Alden Cavanaugh and Michael E. Yonan, eds., *The Cultural Aesthetics of Eighteenth-Century Porcelain* (Farnham: Ashgate, 2010), p. 125.

5. Marco Polo, *The Travels of Marco Polo: The Complete Yule-Cordier Edition* (New York: Dover, 2012), vol. 2, p. 160.

6. Christopher Clarey, "Atlanta: Day 3 – Gymnastics; Miller Gives United States High Hopes for Gold," *New York Times*, July 22, 1996, https://www.nytimes.com/1996/07/22/sports/atlanta-day-3-gymnastics-miller-gives-united-states-high-hopes-for-a-gold.html.

7. "How to Achieve K-Pop Idol's Clear, Glass Skin: R.E.A.L. Beauty Tips," posted by krystallee August 25, 2023, YouTube video, https://www.youtube.com/watch?v=Vd1iu6LJOCU.

8. Koichi Kato, "Statement by Chief Cabinet Secretary Koichi Kato on the Issue of the So-Called 'Wartime Comfort Women' from the Korean Peninsula," Ministry of Foreign Affairs of Japan, July 6, 1992, https://www.mofa.go.jp/a_o/rp/page25e_000346.html.

9. Nina Azzarello, "Interview with Korean Artist Yeesookyung on Emphasizing Flaws with Gold at Massimo de Carlo," *designboom*, October 8, 2020, https://www.designboom.com/art/interview-yeesookyung-kintsugi-massimo-de-carlo-10-08-2020/.

INTERIOR OF A CHINESE SHOP

1. Elmer Kolfin, "*Omphalos mundi*: The Pictorial Tradition of the Theme of Amsterdam and the Four Continents, circa 1600–1665," in *Aemulatio: Imitation, Emulation and Invention in Netherlandish Art from 1500 to 1800; Essays in Honor of Eric Jan Sluijter*, ed. Anton W. A. Boschloo et al. (Zwolle: Waanders, 2011), pp. 384–85; Karina H. Corrigan, "Asia on the Herengracht: Furnishing Amsterdam with Asian imports," in *Asia in Amsterdam: The Culture of Luxury in the Golden Age*, ed. Karina Corrigan, Jan van Campen, and Femke Diercks, exh. cat. (Salem, MA: Peabody Essex Museum, 2015), pp. 124–27; Jaap van der Veen, "East Indies Shops in Amsterdam," in Corrigan, Van Campen, and Diercks, *Asia in Amsterdam*, p. 137; Suet May Lam, "Fantasies of the East: 'Shopping' in Early Modern Eurasia," in *The Mercantile Effect: Art and Exchange in the Islamicate World during the 17th and 18th Centuries*, ed. Sussan Babaie and Melanie Gibson (London: Gingko Library, 2017), p. 16; and Suet May Lam, "From Ephemeral to Eternal: Unfolding Early Modern 'Fashion' for Asia," in *European Fans in the 17th and 18th Centuries: Images, Accessories, and Instruments of Gesture*, ed. Miriam Volmert and Danijela Bucher (Berlin: De Gruyter, 2020), p. 260.

2. David Porter, *The Chinese Taste in Eighteenth-Century England* (Cambridge: Cambridge University Press, 2010).

3. Lam, "Fantasies of the East," p. 15; and Lam, "Ephemeral to Eternal," pp. 250–52, 257.

4. Lam, "Ephemeral to Eternal," p. 258.

5. Lam, "Ephemeral to Eternal," p. 255.

6. Lam, "Fantasies of the East," p. 21; and Lam, "Ephemeral to Eternal," pp. 253, 256.

7. David Porter, "Monstrous Beauty: Eighteenth-Century Fashion and the Aesthetics of the Chinese Taste," in "Aesthetics and the Disciplines," special issue, *Eighteenth-Century Studies* 35, no. 3 (Spring 2002), pp. 395–411; and Ewa Lajer-Burcharth, *The Painter's Touch: Boucher, Chardin, Fragonard* (Princeton: Princeton University Press, 2022), pp. 53–62.

DRAGOON VASE

1. Ulrich Pietsch, Anette Loesch, and Eva Ströber, *The Dresden Porcelain Collection: China, Japan, Meissen* (Munich: Deutscher Kunstverlag, 2006), p. 5. The term "dragoon vase" first appeared in print in 1873, and the legend was then promoted as part of the glorious cultural past of Saxony. See Feng Schöneweiß, "Provenance and Monumentality: Chinese Porcelain, German Curators, and the Shaping of Museological Art History in Dresden" (PhD diss., Ruprecht-Karls-Universität Heidelberg, 2023), pp. 103–15.

2. A recent study recorded a total of twenty-four pieces of this design known in public and private collections and dated them to around 1690; these include Staatliche Kunstsammlungen, Dresden (13 pieces: 1 on loan to Military History Museum, Dresden, and 1 on loan to Oranienburg Palace, Berlin), Oranienburg Palace, Berlin (1 piece), RA Collection, Lisbon (4 pieces), Royal Collection at Windsor Castle (2 pieces), Petworth House, England (2 pieces), Peabody Essex Museum, Salem, Massachusetts (1 piece), and The Met (1 piece). See Schöneweiß, "Provenance and Monumentality," pp. 32–34; 216–19.

3. Patricia F. Ferguson, *Ceramics: 400 Years of British Collecting in 100 Masterpieces* (London: Philip Wilson, 2016), p. 34.
4. John Ayers, *Chinese and Japanese Works of Art in the Collection of Her Majesty the Queen* (London: Royal Collection Trust, 2016), pp. 352–53.
5. *Porzellan: Meissen, China, Japan, Elfenbeinskulpturen, Gemälde, und Waffen aus den Sächsischen Staatssammlungen in Dresden*, sale cat. (Rudolph Lepke's Kunst-Auctions-Haus, Berlin, October 12, 1920), lot 760.
6. William R. Sargent, *Treasures of Chinese Export Ceramics from the Peabody Essex Museum* (Salem, MA: Peabody Essex Museum, 2012), pp. 120–22.
7. Direct proof would be a painted or incised number (known as a "palace number") from Augustus's 1721 inventory of his porcelain collection, such as the one in the Peabody Essex Museum with the mark "N.327"; see Sargent, *Chinese Export Ceramics*, p. 120. However, some works in the Dresden collection have lost their painted numbers over time. The vase in The Met does not bear a palace number, and it is difficult to trace its provenance earlier than the collection of Mary Clark Thompson.
8. Large porcelain was notoriously difficult to make even for the imperial factory before the late seventeenth century. The imperial orders to create large dragon jars (H. 80 cm, Diam. 112 cm) in 1654 and architectural barriers (H. 96 cm, W. 80 cm) in 1659 both failed and were called off in 1660; see Pu Lan, *The Potteries of China*, trans. Geoffrey R. Sayer (London: Routledge and Kegan Paul, 1951), p. 11. In his second letter (dated January 25, 1722) of his famous accounts of Chinese porcelain manufacture, French missionary Père François-Xavier d'Entrecolles observed in Jingdezhen some large urns three feet high that were made exclusively for the merchant trade with Europe, but only eight out of eighty were successful; see William Burton, *Porcelain: A Sketch of Its Nature, Art and Manufacture* (London: Cassell, 1906), pp. 115–16.

CHINOISERIE AND THE MEXICAN GARDEN

1. William Lytle Schurz, *The Manila Galleon* (New York: E. P. Dutton, 1939), p. 27.
2. Enrique A. Cervantes, *Loza blanca y azulejo de Puebla* (Mexico City: self-pub., 1939), vol. 1, p. 29.
3. Leonor Cortina, "Polvos azules de oriente," in "La talavera de Puebla," special issue, *Artes de México*, n.s., 3 (2002), p. 48; and Efraín Castro Morales, "Loceros poblanos, su gremio, ordenanzas y hermandad," *Boletin de monumentos históricos*, 3rd ser., 1 (2004), pp. 55–56.
4. Agustín de Vetancurt, "Tratado de la ciudad de Mexico y las grandezas que la ilustran despues que la fundaron españoles" [1698], in *La ciudad de México en el siglo XVIII (1690–1780): Tres crónicas*, ed. Antonio Rubial García (Mexico City: Consejo Nacional para la Cultura y las Artes, 1990), pp. 45–46.
5. Manuel Romero de Terreros, *Los jardines de la Nueva España* (Mexico City: Ediciones México Moderno, 1919), p. 14.
6. Patrizia Granziera, "The Art of Gardening in New Spain: Spanish Heritage in Mexican Gardens," *Garden History* 42, no. 2 (Winter 2014), p. 193.
7. Frances Calderón de la Barca, *Life in Mexico* (1843; Berkeley: University of California Press, 1982), p. 171.
8. On the Spanish garden as *locus amoenus*, see Alexander Samson, "Outdoor Pursuits: Spanish Gardens, the *Huerto* and Lope de Vega's *Novelas a Marcia Leonarda*," in "Gardens and Horticulture in Early Modern Europe," special issue, *Renaissance Studies* 25, no. 1 (February 2011), pp. 124–50.

TOILETTE OF THE PRINCESS TAPESTRIES FOR THE PRIVY CHAMBER OF THE QUEEN

1. Wendy Hefford, "'Bread, Brushes, and Brooms': Aspects of Tapestry Restoration in England, 1660–1760," in *Acts of the Tapestry Symposium, November 1976*, ed. Anna G. Bennett (San Francisco: Fine Arts Museums of San Francisco, 1979), p. 70; and Edith Standen, "English Tapestries 'After the Indian Manner,'" *Metropolitan Museum Journal* 15 (1980), p. 119.
2. F. H. W. Sheppard, ed., "Appendix 1: The Soho Tapestry Makers," in *Survey of London*, vol. 34, *The Parish of St. Anne, Soho* (London: Athlone, 1966), pp. 515–16.
3. Hefford, "'Bread, Brushes, and Brooms,'" p. 70.
4. Margaret Swain, "Chinoiserie Tapestries in Scotland," *Bulletin du Centre international d'étude des textiles anciens* 69 (1991), p. 85.
5. For examples, see Candace J. Adelson, *European Tapestry in the Minneapolis Institute of Arts* (Minneapolis: Minneapolis Institute of Arts, 1994), pp. 105–15; Elizabeth Cleland, cat. 5, "A Falconer with Two Ladies and a Foot Soldier," in *European Tapestries in the Art Institute of Chicago*, ed. Koenraad Brosens and Christa C. Mayer Thurman (Chicago: Art Institute of Chicago, 2008), pp. 56–61; and Elizabeth Cleland, cat. 68, "Birds and Beasts in a Landscape with a Millefleurs Ground," in Elizabeth Cleland and Lorraine Karafel, *Tapestries from the Burrell Collection* (London: Philip Wilson, 2017), pp. 303–13.
6. Theodoor Herman Lunsingh Scheurleer, "Documents on the Furnishing of Kensington House," *Walpole Society* 38 (1960–62), pp. 21 (1697 inventory), 50 (1699 inventory).
7. Victoria and Albert Museum, London, T.1601-2017.
8. Standen, "English Tapestries," pp. 137–38; cited and discussed in Jan van Campen, "'Reduced to a Heap of Monstrous Shivers and Splinters': Some Notes on Coromandel Lacquer in Europe in the 17th and 18th Centuries," *Rijksmuseum Bulletin* 57, no. 2 (2009), pp. 141–42.
9. For contextual discussion of Mary and William's Dutch projects, see Theodoor Herman Lunsingh Scheurleer, "Stadhouderlijke lakkabinette," in *Opstellen voor H. van de Waal*, ed. L. D. Couprie et al. (Amsterdam: Scheltema and Holkema, 1970), pp. 164–73.

10. For examples, see Daniëlle Kisluk-Grosheide, "The (Ab)Use of Export Lacquer in Europe," in *Ostasiatische und europäische Lacktechniken*, ed. Michael Kühlenthal (Munich: Lipp, 2000), pp. 27–42; for documents and sources, see Van Campen, "'Reduced to a Heap,'" pp. 137–40.

11. Standen, "English Tapestries," pp. 127–31, 135–39; repeated in Mette Bruun, "The Chinoiserie of the 17th- to 18th-Century Soho Tapestry Makers," in *Global Textile Encounters*, ed. Marie-Louise Nosch, Zhao Feng, and Lotika Varadarajan (Philadelphia: Oxbow Books, 2015), pp. 171–76; and Isabelle Tillerot, *East Asian Aesthetics and the Space of Painting in Eighteenth-Century Europe*, trans. Chris Miller (Los Angeles: Getty Research Institute, 2024), pp. 217–18.

12. Swain, "Chinoiserie Tapestries," pp. 85, 87; and Koenraad Brosens, "The Duke of Arenberg's Brussels Chinoiserie Tapestries by Judocus de Vos," *Filoforme* 9 (2004), p. 4.

13. The Metropolitan Museum of Art, New York, 2014.567.

14. For Lady Mary, see Geoffrey W. Beard, "Tapestries by John Vanderbank," *Country Life*, August 31, 1951, pp. 653–54; for Yale, see Romita Ray, "Going Global, Staying Local: Elihu Yale the Art Collector," *Yale University Art Gallery Bulletin* (2012), pp. 44–45.

15. For Carlisle, see Standen, "English Tapestries," pp. 120–21; for Chute, see Maurice Howard, *The Vyne, Hampshire* (London: National Trust, 1998), p. 12. Vanderbank also supplied "3 pieces of Blue & Gold hangings" for the 5th Earl of Exeter's bedchamber at Burghley House (Lincolnshire) in 1688; as noted in James Rothwell and Annabel Westman, "The Ghost of a Royal Visit: The Furnishing of the State Apartment at Lyme Park in the Mid-1670s," *Furniture History* 47 (2011), p. 15, n. 9. This might conceivably have been an edition of the "after the Indian manner" set, although the date is very early and the description is too vague to be certain.

16. See Standen, "English Tapestries," pp. 119–26,

131–34, 139–42; the most current analyses of documented and surviving examples are Brosens, cat. 58, "The Tent from an Indo-Chinese or Indian Series," in Brosens and Mayer Thurman, *European Tapestries*, pp. 345–51; and Wendy Hefford, cat. 81, in Guy Delmarcel, Nicole de Reyniès, and Wendy Hefford, *The Toms Collection: Tapestries of the Sixteenth to Nineteenth Centuries* (Lausanne: Fondation Toms Pauli, 2010).

17. One Brussels weaver, Judocus de Vos, did create at least three editions of these black-ground, multi-scene verdures, published by Brosens, "Brussels Chinoiserie Tapestries," pp. 3–6. For the French tapestry series, see Edith Standen, "The Story of the Emperor of China: A Beauvais Tapestry Series," *Metropolitan Museum Journal* 11 (1976), pp. 103–17; and Tillerot, *East Asian Aesthetics*, pp. 214–16.

FAUX-DAIRYING FOR PLEASURE

1. A 1705 diary entry by William III, cited in Meredith Martin, "Interiors and Interiority in the Ornamental Dairy Tradition," *Eighteenth-Century Fiction* 20, no. 3 (Spring 2008), pp. 357–58.

2. A. M. L. Erkelens, *"Delffs porcelijn" van Koningin Mary II: Ceramiek op Het Loo uit de tijd van Willem III en Mary II = Queen Mary's "Delft Porcelain": Ceramics at Het Loo from the Time of William and Mary* (Zwolle: Waanders, 1996), p. 24. At Het Loo, Mary may have performed her dairying in her bathing quarters next door to the cellar kitchen.

3. In the late eighteenth century, many obsolete ornamental dairies were used to store porcelain collections; see, for example, Arlene Leis, "'A Little Old-China Mad': Lady Dorothea Banks (1758–1828) and Her Dairy at Spring Grove," *Journal for Eighteenth-Century Studies* 40, no. 2 (June 2017), p. 199.

4. Caroline Stanford, "James Wyatt's Ornamental Dairy at Cobham Hall, Kent," *Georgian Group Journal* 28 (2020), p. 131.

5. Simon Thurley, *Hampton Court: A Social and Architectural History* (New Haven: Yale University Press, 2003), p. 172.

6. For evidence of Villiers as a collector, see Carolyn Sargentson, *Merchants and Luxury, Markets: The Marchands Merciers of Eighteenth-Century Paris* (London: Victoria and Albert Museum, 1996), p. 66.

7. Compare with the design for three panels by Marot in the Rijksmuseum, Amsterdam, RP-P-1964-3175.

8. See Victoria and Albert Museum, London, C.57-1948 and C.90-1950; Historic Royal Palaces, London, 3003306.1-2; and *Ceramics*, sale cat. (Christie's, London, April 17, 2000), lot 73. Four print sources are in the Rijksmuseum, Amsterdam: RP-P-1889-A-14959; RP-P-OB-2569; RP-P-1889-A-14948; and RP-P-OB-2564. The drawings for the plates were first identified in Christopher Stevens, "Koningin Mary II en de Water Gallery van Hampton Court Palace," in *Koninklijk blauw: Het mooiste Delfts aardewerk van Willem en Mary*, ed. Suzanne Lambooy, exh. cat. (Zwolle: Waanders, 2020), p. 126, figs. 119–20.

9. See a mezzotint, ca. 1690, identified as "The African Queen," in the British Museum, London, 1870,0514.2767. The figure may represent an actor in the role of Semernia in Aphra Benn's *The Widow Ranter* (1688).

10. Rijksmuseum, Amsterdam, RP-P-1964-3174. This source was first identified by Arthur Lane, "Daniel Marot: Designer of Delft Vases and of Gardens at Hampton Court," *The Connoisseur* 123, no. 511 (March 1949), p. 23.

11. Peter Fuhring, *Ornament Prints in the Rijksmuseum II: The Seventeenth Century*, Studies in Prints and Printmaking 5 (Amsterdam: Rijksmuseum; Rotterdam: Sound and Vision, 2004), vol. 1, p. 395, cat. 2323. The costumes may have been fashion plates showing Eastern peoples by Nicolas Bonnart I, British Museum, London, 1871,0812.4688.

NOT THE METAPHOR OF THE EYES, BUT THE CORPOREALITY OF THE MOUTH

1. Ian Miller, *A History of Force Feeding: Hunger Strikes, Prisons and Medical Ethics, 1909–1974* (New York: Palgrave Macmillan, 2016), p. 2.
2. George Bataille's "Story of the Eye" (1928), referenced in Roland Barthes, "Metaphor of the Eye," in *Critical Essays*, trans. Richard Howard (Evanston, IL: Northwestern University Press, 1972), p. 239 (my emphasis).

WOMEN INSIDE AND OUTDOORS

1. Lydia H. Liu, "Robinson Crusoe's Earthenware Pot," *Critical Inquiry* 25, no. 4 (Summer 1999), p. 749.
2. Elizabeth Kowaleski-Wallace, *Consuming Subjects: Women, Shopping, and Business in the Eighteenth Century* (New York: Columbia University Press, 1997), pp. 19–36.
3. Michael A. Salmon, *The Aurelian Legacy: British Butterflies and Their Collectors* (Berkeley: University of California Press, 2001). See also Elizabeth Kowaleski Wallace, "'Character Resolved into Clay': The Toby Jug, Eighteenth-Century English Ceramics, and the Rise of Consumer Culture," in "Material Fictions," ed. Eugenia Zuroski and Michael Yonan, special issue, *Eighteenth-Century Fiction* 31, no. 1 (Fall 2018), pp. 19–44.

PATTY CHANG

1. In the reviews of Chang's 1999 debut at Jack Tilton Gallery, critics for *Artforum*, *Art in America*, and the *New York Times* only talked about her work in the lineage of (post-)feminist and endurance-based performances without considering her Asian identity in their analysis.
2. See Jerry Saltz and Rachel Corbett, "How Identity Politics Conquered the Art World: An Oral History," *New York Magazine*, April 18, 2016, www
.vulture.com/2016/04/identity
-politics-that-forever-changed
-art.html. However, the article focused primarily on art and events created by Black, queer, and women artists, only mentioning Asian American artists once.
3. For instance, *Splendors of Imperial China: Treasures from the National Palace Museum, Taipei* (The Met, 1997) and *China: 5,000 Years; Innovation and Transformation in the Arts* (Solomon R. Guggenheim Museum, 1998).
4. Eve Oishi, "Passionate Interaction: Interview with Patty Chang," *X-TRA* 5, no. 4 (Summer 2003), p. 17.

RECLAIMING THE DEITY

1. See Kenson Kwok, "A Note on the Construction of Dehua Figures," in Rose Kerr and John Ayers, *Blanc de Chine: Porcelain from Dehua*, exh. cat. (Richmond, Surrey: Curzon, 2002), p. 45; and the discussion of the clay's unique properties in Ching-Ling Wang, "Blanc de Chine," in *Royal East Asian Porcelain*, ed. Christiaan J. A. Jörg and Cora Würmell, a catalogue of the Royal Dresden Porcelain Collection project, doi.org/10.58749/skd.ps.2024
.rpc.c1.a270 (accessed February 5, 2024).
2. The other pieces of Dehua porcelain at Hampton Court were incense burners.
3. "A Pair of Chinese Blanc de Chine Figures of Guanyin," Burghley House, accessed March 20, 2024, https://
collections.burghley.co.uk
/collection/a-pair-of-blanc-de
-chine-figures-of-guanyin-late
-17th-century-2/.
4. Jeffrey Munger, *European Porcelain in The Metropolitan Museum of Art* (New York: The Metropolitan Museum of Art, 2018), pp. 46–48.
5. See, for instance, the provenance information for PO 8550, in Jörg and Würmell, *Royal East Asian Porcelain*, accessed February 5, 2024, https://
royalporcelaincollection.skd
.museum/unique/object/132350.
Further examples can be found in the 1721 inventory of the Dresden Residenzschloss,
Porzellansammlung, Staatliche Kunstsammlungen Dresden, 324, pp. 207–18; the manuscript has been digitized and paginated as part of the Royal Dresden Porcelain Collection project, accessed February 5, 2004, doi.org/10.58749/skd.ps.2024
.rpc.c2.in0001.
6. The authoritative study on this phenomenon remains Chün-fang Yü, *Kuan-yin: The Chinese Transformation of Avalokiteśvara* (New York: Columbia University Press, 2001).
7. For an illuminating study on laywomen's Guanyin worship and their material practices, see Yuhuang Li, *Becoming Guanyin: Artistic Devotion of Buddhist Women in Late Imperial China* (New York: Columbia University Press, 2019), esp. pp. 107–41.

THE QUEER TOUCH OF THE ELEPHANT IN A PAIR OF SÈVRES VASES

1. Georges-Louis Leclerc Buffon, *Buffon's natural history. Containing a theory of the earth, a general history of man, of the brute creation, and of vegetables* [. . .] (London: J. S. Barr, 1792), vol. 7, p. 291 (my emphasis).
2. Buffon, *Natural history*, vol. 7, pp. 267, 306. See also vol. 9, p. 137, on "the voluntary or forced intermixture of the Negresses with the apes."
3. Jeffrey Munger, *European Porcelain in The Metropolitan Museum of Art* (New York: The Metropolitan Museum of Art, 2018), pp. 189–92, cat. 60A–C. See also Iris Moon, "The Sèvres Elephant Garniture and the Politics of Dispersal during the French Revolution," *Metropolitan Museum Journal* 56 (2021), pp. 81–97.
4. Claude Nicolas Le Cat, *A physical essay on the senses* [. . .]. (London: R. Griffiths, 1750), p. 9.
5. Jonathan Hay, *Sensuous Surfaces: The Decorative Object in Early Modern China* (London: Reaktion Books, 2010), p. 81.
6. Anne Anlin Cheng, *Ornamentalism* (New York: Oxford University Press, 2019), p. ix.

LAOTIAN GODDESS KI MAO SAO AND WORSHIPPERS

1. Between 1708 and 1716, artists Antoine Watteau and Claude Audran III collaborated to decorate a Chinoiserie-themed cabinet inside Château de la Muette in Paris. However, the cabinet was remodeled again in the 1730s. Most of Watteau's Chinoiserie-themed paintings at Muette would have been completely lost had not Jean de Jullienne, an avid Watteau collector, commissioned artists Michel Aubert, François Boucher, and Edme Jeaurat to produce prints after Watteau's paintings. The original title of Aubert's print after Watteau was *Idole de la Déesse Ki Mâo dans le Royaume de Mang au pays des Laos* (*The Idol of the Goddess Ki Mao in the Mang Kingdom of the Country of the Laotians*). This title was probably bestowed upon the print during the time of Jean de Jullienne's commission. Katie Scott revises earlier notions that these titles were original to the conception of the Chinese cabinet at Château de la Muette, arguing that no other painted decorative scheme by Audran or Watteau utilized text or titles. Scott believes that the titles were added later by the publisher of *Recueil Jullienne*, a tactic that appealed to the print market. Katie Scott, "Playing Games with Otherness: Watteau's Chinese Cabinet at the Château de la Muette," *Journal of the Warburg and Courtauld Institutes* 66 (2003), p. 199.
2. Yushu Chen and Bing Huang, "Images of Chinese Women in Seventeenth- and Eighteenth-Century European Exotic Knowledge Books," *Women's History Review* 32, no. 5 (2023), pp. 653–54.
3. Scott, "Playing Games with Otherness," pp. 207–10, 228–31.
4. Stacey Sloboda, *Chinoiserie: Commerce and Critical Ornament in Eighteenth-Century Britain* (Manchester: Manchester University Press, 2014), 67. For more information regarding the harm that Chinoiserie has perpetuated in the twentieth

and twenty-first centuries, see Anne Anlin Cheng, "Ornamentalism: A Feminist Theory for the Yellow Woman," *Critical Inquiry* 44, no. 3 (Spring 2018), pp. 415–46.

ASIA AND AFRICA

1. The pairing of Asia and Africa exists well outside the context of ceramics as part of what Ella Shohat calls the "outside of history" created to support "the exotic reverse image of Western Reason"; Ella Shohat, "The Specter of the Blackamoor: Figuring Africa and the Orient," *The Comparatist* 42 (October 2018), p. 160. The pendant work is *Europe and America*, with Europe reclining languorously against a horse, and America unclothed like Africa with only a headdress and what appears to be a girdle of feathers.
2. For the Asia-Africa dynamic in eighteenth-century German porcelain, see Christiane Hertel, *Siting China in Germany: Eighteenth-Century Chinoiserie and Its Modern Legacy* (University Park: Pennsylvania State University Press, 2019), pp. 111–20.
3. A prominent case in point is *Allegorical Figure Depicting Putti as "Asia" and "Africa,"* made by the Meissen porcelain manufactory and modeled by Friedrich Elias Meyer, now in the Cooper Hewitt, Smithsonian Design Museum, New York, 1960-1-36.
4. Anne Betty Weinshenker, "Chinoiserie Sculpture," in "Orientales," ed. Roland Bonnel, special issue, *Dalhousie French Studies* 43 (Summer 1998), p. 46.
5. The Metropolitan Museum of Art, New York, 1977.1.3.
6. Anton Wilhelm Amo, "Die Apatheia der menschlichen Seele" (PhD diss., Martin-Luther-Universität Halle-Wittenberg, 1734; repr. 1968), p. 72.
7. Amo was recorded as a "Moor" in the church register in Wolfenbüttel. His master's thesis may have been the first defense of African rights in Europe in the German

Enlightenment; Anton Wilhelm Amo, "Dissertatio Inauguralis de Jure Maurorum in Europa" (master's thesis, Martin-Luther-Universität Halle-Wittenberg, 1729). The thesis is presumed lost but was summarized in the university's annals, where Amo argued that the slave trade violated the rights of African rulers who were vassals, not slaves, of Rome, as well as of Roman citizens living in Africa. See Edwin Bikundo, "Enslavement as a Crime against Humanity: Some Doctrinal, Historical, and Theoretical Considerations," in *Oxford Handbook of International Criminal Law*, ed. Darryl Robinson et al. (Oxford: Oxford University Press, 2020), p. 375.

EXEMPLARY WOMEN BY CAO ZHENXIU AND GAI QI

1. Translation adapted from Ju-hsi Chou, *Journeys on Paper and Silk: The Roy and Marilyn Papp Collection of Chinese Painting*, exh. cat. (Phoenix: Phoenix Art Museum, 1998), p. 144. The full names for the figures referred to in the poem are Zhong You, Wang Xizhi, Yu Shinan, and Chu Suiliang.
2. Cao's title for the album is not recorded; the current title was given to the work in the twentieth century by the artist and collector Wu Hufan.
3. Recent scholarship notes that the earliest *lienü* collections did include examples of women as active agents in intellectual life. In the millennia leading to the time of Cao Zhenxiu, however, these instances were deemphasized in favor of faithful wives and chaste widows. In this sense, Cao's collection is as much a revival as an attempt at innovation. See Lisa Raphals, *Sharing the Light: Representations of Women and Virtue in Early China* (Albany: State University of New York Press, 1998); and Anne Behnke Kinney, ed. and trans., *Exemplary Women of Early China: The "Lienü zhuan" of Liu Xiang* (New York: Columbia University Press, 2014).

4. On the rise of companionate marriage as one aspect of shifting social norms in Ming and Qing China, see Dorothy Ko, *Teachers of the Inner Chambers: Women and Culture in Seventeenth-Century China* (Stanford: Stanford University Press, 1994), pp. 179–218.

ANNA MAY WONG: GLAMOUR AS RESISTANCE

1. On how Anna May Wong used fashion to construct her image, see Graham Russell Gao Hodges, *Anna May Wong: From Laundryman's Daughter to Hollywood Legend* (New York: Palgrave Macmillan, 2004), pp. 129–31; Karen J. Leong, *The China Mystique: Pearl S. Buck, Anna May Wong, Mayling Soong, and the Transformation of American Orientalism* (Berkeley: University of California Press, 2005), pp. 85–87; Sean Metzger, *Chinese Looks: Fashion, Performance, Race* (Bloomington: Indiana University Press, 2014), pp. 109–24; and Shirley Jennifer Lim, *Anna May Wong: Performing the Modern* (Philadelphia: Temple University Press, 2019), pp. 77–79, 101–7, 115–52.

2. Two versions of this dress were made—one in velvet, which Wong wore in the film, and the silk charmeuse version in The Met, which she wore in publicity images. The dragon on the velvet version has paws with five claws (the number of claws traditionally reserved for imperial objects), while the one in The Met has no paws. On the different purposes and types of film stills and publicity images, see Douglas Gomery, "The Images in Our Minds: Film Stills and Cinema History," *Princeton University Library Chronicle* 65, no. 3 (Spring 2004), pp. 502–9.

3. For example, The Metropolitan Museum of Art, New York, 18.56.60.

4. Yunte Huang, *Daughter of the Dragon: Anna May Wong's Rendezvous with American History* (New York: Liveright, 2023), pp. 154–58. See also Cynthia W. Liu, "When Dragon Ladies Die, Do They Come Back as Butterflies? Re-Imagining Anna May Wong," in *Countervisions: Asian American Film Criticism*, ed. Darrell Y. Hamamoto and Sandra Liu (Philadelphia: Temple University Press, 2000), pp. 23–40.

5. On the conflation of Chinese female bodies and porcelain, see Anne Anlin Cheng, *Ornamentalism* (New York: Oxford University Press, 2019), pp. 93–96.

6. Anna May Wong, "I Protest," interview by Doris Mackie, *Film Weekly*, August 18, 1933, p. 11.

7. Wong was voted best-dressed woman in the world by the Mayfair Mannequin Society in New York in 1934, the same year *Limehouse Blues* came out.

8. I am grateful to Iris Moon for suggesting this interpretation.

9. Cheng, *Ornamentalism*, pp. 75–77. See also Carol Dyhouse, *Glamour: Women, History, Feminism* (London: Zed Books, 2010), pp. 9–47.

10. Cheng, *Ornamentalism*, p. 73.

PORCELAIN CYBORG / CYBORG PORCELAIN

1. "A Feeling About Freedom: Lee Bul in Conversation with Stephanie Rosenthal," in *Lee Bul*, ed. Stephanie Rosenthal (London: Hayward Gallery Publishing, 2018), p. 84.

2. "Feeling About Freedom," p. 87.

3. "Feeling About Freedom," p. 87.

4. "Feeling About Freedom," p. 87.

5. "Feeling About Freedom," p. 88.

6. Lee Bul, Sunjung Kim, and Hans-Ulrich Obrist, *Lee Bul*, exh. cat. (Seoul: Art Sonje Center, 1998), n.p.

7. Lee, Kim, and Obrist, *Lee Bul*, n.p.

8. Lee, Kim, and Obrist, *Lee Bul*, n.p.

9. Soyoung Lee, *Art of the Korean Renaissance, 1400–1600*, exh. cat. (New York: The Metropolitan Museum of Art, 2009), pp. 41–45.

10. Lee, Kim, and Obrist, *Lee Bul*, n.p.

11. For a discussion of cyborgs, ornamentalism, and Asiatic femininity, see Anne Anlin Cheng, *Ornamentalism* (New York: Oxford University Press, 2019), esp. pp. 127–51.

12. Lee, Kim, and Obrist, *Lee Bul*, n.p.

BIBLIOGRAPHY

Adelson, Candace J. *European Tapestry in the Minneapolis Institute of Arts*. Minneapolis: Minneapolis Institute of Arts, 1994.

Aldridge, Alfred Owen. *The Dragon and the Eagle: The Presence of China in the American Enlightenment*. Detroit: Wayne State University Press, 1993.

Amo, Anton Wilhelm. "Dissertatio Inauguralis de Jure Maurorum in Europa." Master's thesis, Martin-Luther-Universität Halle-Wittenberg, 1729.

Amo, Anton Wilhelm. "Die Apatheia der menschlichen Seele." PhD diss., Martin-Luther-Universität Halle-Wittenberg, 1734. Reprint, 1968.

Apter, Emily. *Feminizing the Fetish: Psychoanalysis and Narrative Obsession in Turn-of-the-Century France*. Ithaca, NY: Cornell University Press, 1991.

Audric, Thierry. *Chinese Reverse Glass Painting, 1720–1820: An Artistic Meeting Between China and the West*. Bern: Peter Lang, 2020.

Avery, C. Louise. "Chinese Porcelain in English Mounts." *The Metropolitan Museum of Art Bulletin*, n.s., 2, no. 9 (May 1944), pp. 266–72.

Ayers, John. *Chinese and Japanese Works of Art in the Collection of Her Majesty the Queen*. London: Royal Collection Trust, 2016.

Azzarello, Nina. "Interview with Korean Artist Yeesookyung on Emphasizing Flaws with Gold at Massimo de Carlo." *designboom*, October 8, 2020. https://www.designboom.com/art/interview-yeesookyung-kintsugi-massimo-de-carlo-10-08-2020/.

Babaie, Sussan, and Melanie Gibson, eds. *The Mercantile Effect: Art and Exchange in the Islamicate World during the 17th and 18th Centuries*. London: Gingko Library, 2017.

Barthes, Roland. *Critical Essays*. Translated by Richard Howard. Evanston, IL: Northwestern University Press, 1972.

Beard, Geoffrey W. "Tapestries by John Vanderbank." *Country Life*, August 31, 1951, pp. 653–54.

Beevers, David, ed. *Chinese Whispers: Chinoiserie in Britain, 1650–1930*. Exh. cat. Brighton: Royal Pavilion and Museums, 2008.

Bennett, Anna G., ed. *Acts of the Tapestry Symposium, November 1976*. San Francisco: Fine Arts Museums of San Francisco, 1979.

Bhabha, Homi. "Of Mimicry and Man: The Ambivalence of Colonial Discourse." In "Discipleship: A Special Issue on Psychoanalysis," *October* 28 (Spring 1984), pp. 124–33.

Blumenfield, Robert H. *Blanc de Chine: The Great Porcelain of Dehua*. Berkeley: Ten Speed, 2002.

Bonnel, Roland, ed. "Orientales." Special issue, *Dalhousie French Studies* 43 (Summer 1998).

Boschloo, Anton W. A., Jacquelyn N. Coutré, Stephanie S. Dickey, and Nicolette C. Sluijter-Seijffert, eds. *Aemulatio: Imitation, Emulation and Invention in Netherlandish Art from 1500 to 1800; Essays in Honor of Eric Jan Sluijter*. Zwolle: Waanders, 2011.

Brookes, Kristen G. "A Feminine 'Writing That Conquers': Elizabethan Encounters with the New World." *Criticism* 48, no. 2 (Spring 2006), pp. 227–62.

Broomhall, Susan, and Jacqueline Van Gent. *Dynastic Colonialism: Gender, Materiality and the Early Modern House of Orange-Nassau*. New York: Routledge, 2016.

Brosens, Koenraad. "The Duke of Arenberg's Brussels Chinoiserie Tapestries by Judocus de Vos." *Filoforme* 9 (2004), pp. 3–6.

Brosens, Koenraad, and Christa C. Mayer Thurman, eds. *European Tapestries in the Art Institute of Chicago*. Chicago: Art Institute of Chicago, 2008.

Brown, Peter B. *In Praise of Hot Liquors: The Study of Chocolate, Coffee and Tea-Drinking, 1600–1850*. Exh. cat. York: York Civic Trust, 1995.

Buffon, Georges-Louis Leclerc. *Buffon's natural history. Containing a theory of the earth, a general history of man, of the brute creation, and of vegetables [. . .]*. 10 vols. London: J. S. Barr, 1792.

Burchard, Wolf. *Inspiring Walt Disney: The Animation of French Decorative Arts*. Exh. cat. New York: The Metropolitan Museum of Art, 2021.

Burghley House. "A Pair of Chinese Blanc de Chine Figures of Guanyin." Accessed March 20, 2024. https://collections.burghley.co.uk/collection/a-pair-of-blanc-de-chine-figures-of-guanyin-late-17th-century-2/.

Burton, William. *Porcelain: A Sketch of Its Nature, Art and Manufacture*. London: Cassell, 1906.

Cahill, James. *Pictures for Use and Pleasure: Vernacular Painting in High Qing China*. Berkeley: University of California Press, 2010.

Cahill, James, ed. *Beauty Revealed: Images of Women in Qing Dynasty Chinese Painting*. Exh. cat. Berkeley: University of California, Berkeley Art Museum and Pacific Film Archive, 2013.

Calderón de la Barca, Frances. *Life in Mexico*. London: Chapman and Hall, 1843. Reprint, Berkeley: University of California Press, 1982.

"Can the Following Facts Be Tolerated?" 34th Congress, 1st Session, House Executive Document No. 105, on the "Slave and Coolie Trade."

Castro Morales, Efraín. "Loceros poblanos, su gremio, ordenanzas y hermandad." *Boletin de monumentos históricos*, 3rd ser., 1 (2004), pp. 51–67.

Cavanaugh, Alden, and Michael E. Yonan, eds. *The Cultural Aesthetics of Eighteenth-Century Porcelain*. Farnham: Ashgate, 2010.

Ceramics. Sale cat. Christie's, London, April 17, 2000.

Cervantes, Enrique A. *Loza blanca y azulejo de Puebla*. 2 vols. Mexico City: self-pub., 1939.

Chang, Gordon H. *Fateful Ties: A History of America's Preoccupation with China*. Cambridge, MA: Harvard University Press, 2015.

Chen, Yushu, and Bing Huang. "Images of Chinese Women in Seventeenth- and Eighteenth-Century European Exotic Knowledge Books." *Women's History Review* 32, no. 5 (2023), pp. 651–77.

Cheng, Anne Anlin. "Ornamentalism: A Feminist Theory for the Yellow Woman." *Critical Inquiry* 44, no. 3 (Spring 2018), pp. 415–46.

Cheng, Anne Anlin. *Ornamentalism*. New York: Oxford University Press, 2019.

Chou, Ju-hsi. *Journeys on Paper and Silk: The Roy and Marilyn Papp Collection of Chinese Painting*. Exh. cat. Phoenix: Phoenix Art Museum, 1998.

Clarey, Christopher. "Atlanta: Day 3 – Gymnastics; Miller Gives United States High Hopes for Gold." *New York Times*, July 22, 1996. https://www.nytimes.com/1996/07/22/sports/atlanta-day-3-gymnastics-miller-gives-united-states-high-hopes-for-a-gold.html.

Cleland, Elizabeth, and Lorraine Karafel. *Tapestries from the Burrell Collection*. London: Philip Wilson, 2017.

Cleland, Elizabeth, and Adam Eaker. *The Tudors: Art and Majesty in Renaissance England*. Exh. cat. New York: The Metropolitan Museum of Art, 2022.

Cohen & Cohen: 50 Years of Chinese Export Porcelain. Sale cat. Bonhams, New York, January 24, 2023.

Corrigan, Karina H., Jan van Campen, and Femke Diercks, eds. *Asia in Amsterdam: The Culture of Luxury in the Golden Age*. Exh. cat. Salem, MA: Peabody Essex Museum, 2015.

Cortina, Leonor. "Polvos azules de oriente." In "La talavera de Puebla," special issue, *Artes de México*, n.s., 3 (2002), pp. 44–55.

Couprie, L. D., R. H. Fuchs, H. J. Mühl, A. W. Reinink, and E. Tholen, eds. *Opstellen over H. van de Waal*. Amsterdam: Scheltema and Holkema, 1970.

de Bruijn, Emile. *Chinese Wallpaper in Britain and Ireland*. London: Philip Wilson, 2017.

de Jongh, Eddy. *Questions of Meaning: Theme and Motif in Dutch Seventeenth-Century Painting*. Translated by Michael Hoyle. Leiden: Primavera Pers, 1995.

de Waal, Edmund. *The White Road: Journey into an Obsession*. New York: Picador, 2016.

Defoe, Daniel. *A Tour thro' the whole island of Great Britain, divided into circuits or journeys [. . .]*. London: G. Strahan, 1724. Reprint, London: Peter Davies, 1927.

Delmarcel, Guy, Nicole de Reyniès, and Wendy Hefford. *The Toms Collection: Tapestries of the Sixteenth to Nineteenth Centuries*. Lausanne: Fondation Toms Pauli, 2010.

Dickens, Charles. "Pottery and Porcelain." *Household Words* 4 (1851), pp. 32–37.

Dimmock, Matthew. *Elizabethan Globalism: England, China and the Rainbow Portrait*. London: Paul Mellon Centre for Studies in British Art, 2019.

Doebner, Richard, ed. *Memoirs of Mary, Queen of England (1689–1693): Together with Her Letters and Those of James II and William III to the Electress Sophia of Hanover*. Leipzig: Veit, 1886.

Dolan, Brett. *Beauty, Sex and Power: A Story of Debauchery and Decadent Art at the Late Stuart Court, 1660–1714*. Exh. cat. London: Historic Royal Palaces, 2012.

Dyhouse, Carol. *Glamour: Women, History, Feminism*. London: Zed Books, 2010.

Enenkel, Karl A. E., and Christine Göttler, eds. *Solitudo: Spaces, Places, and Times of Solitude in Late Medieval and Early Modern Cultures*. Intersections 56. Leiden: Brill, 2018.

Erkelens, A. M. L. "Delffs porcelijn" van Koningin Mary II: Ceramiek op Het Loo uit de tijd van Willem III en Mary II = Queen Mary's "Delft Porcelain": Ceramics at Het Loo from the Time of William and Mary. Zwolle: Waanders, 1996.

Farrington, Anthony. *Trading Places: The East India Company and Asia, 1600–1834*. Exh. cat. London: British Library, 2002.

Ferguson, Patricia F. *Ceramics: 400 Years of British Collecting in 100 Masterpieces*. London: Philip Wilson, 2016.

Ferguson, Patricia F., Diana Davis, and John Whitehead, eds. "Reframing Eighteenth-Century European Ceramics." Special issue, *French Porcelain Society Journal* 9 (2022).

Festa, Lynn. *Fiction Without Humanity: Person, Animal, Thing in Early Enlightenment Literature and Culture*. Philadelphia: University of Pennsylvania Press, 2019.

Finlay, Robert. "The Pilgrim Art: The Culture of Porcelain in World History." *Journal of World History* 9, no. 2 (Fall 1998), pp. 141–87.

Fissel, Mary. "Remaking the Maternal Body in England, 1680–1730." *Journal of the History of Sexuality* 26, no. 1 (January 2017), pp. 114–39.

Fraser, Sarah, Mio Wakita, and Lianming Wang, eds. *Women Cross Media: East Asian Photography, Prints, and Porcelain from the Staatliche Kunstsammlungen Dresden*. Heidelberg: arthistoricum.net, 2022.

Frelin, Virginie, ed. *Une des provinces du rococo: La Chine rêvée de François Boucher*. Exh. cat. Paris: In Fine éditions d'art, 2019.

Fuhring, Peter. *Ornament Prints in the Rijksmuseum II: The Seventeenth Century*. 3 vols. Studies in Prints and Printmaking 5. Amsterdam: Rijksmuseum; Rotterdam: Sound and Vision, 2004.

Fuller, Thomas, and Jill Cowan. "8 Dead in Atlanta Spa Shootings, with Fears of Anti-Asian Bias." *New York Times*, updated March 26, 2021. https://www.nytimes.com/live/2021/03/17/us/shooting-atlanta-acworth.

Gaillard, Karin, and Eline van den Berg, eds. *Gezonken schatten: Vondsten uit scheepswrakken van de maritieme zijderoute, 800–1900 = Sunken Treasures: Discoveries in Shipwrecks from the Maritime Silk*

Road, 800–1900. Exh. cat. Zwolle: Waanders & De Kunst, 2019.

Gerritsen, Anne, and Stephen McDowall. "Material Culture and the Other: European Encounters with Chinese Porcelain, ca. 1650–1800." In "Global China," special issue, Journal of World History 23, no. 1 (March 2012), pp. 87–113.

Ghosh, Amitav. Smoke and Ashes: Opium's Hidden Histories. New York: Farrar, Straus and Giroux, 2024.

Giese, Francine, Hans Bjarne Thomsen, Elisa Ambrosio, and Alina Martimyanova, eds. China and the West: Reconsidering Chinese Reverse Glass Painting. Berlin: De Gruyter, 2023.

Goldstein, Jonathan, Jerry Israel, and Hilary Conroy, eds. America Views China: American Images of China Then and Now. London: Associated University Presses, 1991.

Gomery, Douglas. "The Images in Our Minds: Film Stills and Cinema History." Princeton University Library Chronicle 65, no. 3 (Spring 2004), pp. 502–20.

Goss, Steven. British Tea and Coffee Cups, 1745–1940. Oxford: Shire, 2002.

Granziera, Patrizia. "The Art of Gardening in New Spain: Spanish Heritage in Mexican Gardens." Garden History 42, no. 2 (Winter 2014), pp. 178–200.

Gregory, Eilish, and Michael C. Questier, eds. Later Stuart Queens, 1660–1735: Religion, Political Culture, and Patronage. Cham: Palgrave Macmillan, 2023.

Grossberg, Lawrence, Cary Nelson, and Paula Treichler, eds. Cultural Studies. New York: Routledge, 1992.

Hallinger, Johannes Franz. Das Ende der Chinoiserie: Die Auflösung eines Phänomens der Kunst in der Zeit der Aufklärung. Munich: Scaneg, 1996.

Hamamoto, Darrell Y., and Sandra Liu, eds. Countervisions: Asian American Film Criticism. Philadelphia: Temple University Press, 2000.

Harris, Tim. Politics under the Later Stuarts: Party Conflict in a Divided Society, 1660–1715. New York: Routledge, 1993.

Harrison-Hall, Jessica, and Julia Lovell, eds. China's Hidden Century, 1792–1912. Exh. cat. London: British Museum, 2023.

Hay, Jonathan. Sensuous Surfaces: The Decorative Object in Early Modern China. London: Reaktion Books, 2010.

Hertel, Christiane. Siting China in Germany: Eighteenth-Century Chinoiserie and Its Modern Legacy. University Park: Pennsylvania State University Press, 2019.

Hevia, James L. Cherishing Men from Afar: Qing Guest Ritual and the Macartney Embassy of 1793. Durham, NC: Duke University Press, 1995.

Hinton, Mark, and Oliver Impey, eds. Kensington Palace and the Porcelain of Queen Mary II. Exh. cat. London: Christie's, 1998.

Hodges, Graham Russell Gao. Anna May Wong: From Laundryman's Daughter to Hollywood Legend. New York: Palgrave Macmillan, 2004. 3rd ed., Chicago: Chicago Review Press, 2023.

Hogendorn, Jan, and Marion Johnson. The Shell Money of the Slave Trade. African Studies Series 49. Cambridge: Cambridge University Press, 1986. Reprint, 2003.

Honour, Hugh. Chinoiserie: The Vision of Cathay. London: John Murray, 1961.

Horowitz, Maryanne Cline, and Louise Arizzoli, eds. Bodies and Maps: Early Modern Personifications of the Continents. Intersections 73. Leiden: Brill, 2020.

"How to Achieve K-Pop Idol's Clear, Glass Skin: R.E.A.L. Beauty Tips." Posted by krystallee on August 25, 2023. YouTube video, 00:06:58. https://www.youtube.com/watch?v=Vd1iu6LJOCU.

Howard, David S. The Choice of the Private Trader: The Private Market in Chinese Export Porcelain; Illustrated from the Hodroff Collection. London: Zwemmer, 1994.

Howard, Maurice. The Vyne, Hampshire. London: National Trust, 1998.

Huang, Yunte. Daughter of the Dragon: Anna May Wong's Rendezvous with American History. New York: Liveright, 2023.

Hyde, Ralph. "Romeyn de Hooghe and the Funeral of the People's Queen." Print Quarterly 15, no. 2 (June 1998), pp. 150–72.

Impey, Oliver. "Japanese Porcelain at Burghley House: The Inventory of

1688 and the Sale of 1888." In "Essays in Honor of Clare Le Corbeiller," special issue, Metropolitan Museum Journal 37 (2002), pp. 117–32.

Jewitt, Llewellynn Frederick William. The History of Ceramic Art in Great Britain: From Prehistoric Times Down Through Each Successive Period to the Present Day. 2 vols. New York: Scribner, Welford, and Armstrong, 1878.

"John Luther Long, Playwright, Dead." New York Times, November 1, 1927.

Kasl, Ronda. "Empires and Emporia: The Manila Galleon Trade and the Spanish Invention of China." Arts of Asia 50, no. 2 (March–April 2020), pp. 92–102.

Kato, Koichi. "Statement by Chief Cabinet Secretary Koichi Kato on the Issue of the So-Called 'Wartime Comfort Women' from the Korean Peninsula." Ministry of Foreign Affairs of Japan, July 6, 1992. https://www.mofa.go.jp/a_o/rp/page25e_000346.html.

Kerr, Rose, and John Ayers. Blanc de Chine: Porcelain from Dehua. Exh. cat. Richmond, Surrey: Curzon, 2002.

King, Homay. "Anna May Wong and the Color Image." In "Blackness," special issue, Liquid Blackness: Journal of Aesthetics and Black Studies 5, no. 2 (October 2021), pp. 59–73.

Kingston, Maxine Hong. The Woman Warrior: Memoirs of a Girlhood among Ghosts. New York: Vintage International, 1989.

Kinney, Anne Behnke, ed. and trans. Exemplary Women of Early China: The "Lienü zhuan" of Liu Xiang. New York: Columbia University Press, 2014.

Ko, Dorothy. Teachers of the Inner Chambers: Women and Culture in Seventeenth-Century China. Stanford: Stanford University Press, 1994.

Ko, Dorothy. Cinderella's Sisters: A Revisionist History of Footbinding. Berkeley: University of California Press, 2007.

Kowaleski-Wallace, Elizabeth. Consuming Subjects: Women, Shopping, and Business in the Eighteenth Century. New York: Columbia University Press, 1997.

Kroeber, A. L., ed. Anthropology Today: An Encyclopedic Inventory. Chicago: University of Chicago Press, 1953.

Kühlenthal, Michael, ed. *Ostasiatische und europäische Lacktechniken*. Munich: Lipp, 2000.

Kwun, Aileen. "It's Time to Rethink Chinoiserie." *Elle Décor*, May 27, 2021. https://www.elledecor.com /life-culture/a36548998/time-to -rethink-chinoiserie/.

Lajer-Burcharth, Ewa. *The Painter's Touch: Boucher, Chardin, Fragonard*. Princeton: Princeton University Press, 2022.

Lambooy, Suzanne, ed. *Koninklijk blauw: Het mooiste Delfts aardewerk van Willem en Mary*. Exh. cat. Zwolle: Waanders, 2020.

Lane, Arthur. "Daniel Marot: Designer of Delft Vases and of Gardens at Hampton Court." *The Connoisseur* 123, no. 511 (March 1949), pp. 19–24.

Lao, Meri. *Sirens: Symbols of Seduction*. Rochester, VT: Park Street, 1998.

Le Cat, Claude Nicolas. *A physical essay on the senses* [. . .]. London: R. Griffiths, 1750.

Le Corbeiller, Clare. "China into Delft: A Note on Visual Translation." In "Art Forgery," special issue, *The Metro-politan Museum of Art Bulletin* 26, no. 6 (February 1968), pp. 269–76.

Le Corbeiller, Clare. *China Trade Porcelain: Patterns of Exchange; Additions to the Helena Woolworth McCann Collection in The Metropolitan Museum of Art*. New York: The Metropolitan Museum of Art, 1974.

Le Corbeiller, Clare. "A Medici Porcelain Pilgrim Flask." *J. Paul Getty Museum Journal* 16 (1988), pp. 119–26.

Lee, Soyoung. *Art of the Korean Renaissance, 1400–1600*. Exh. cat. New York: The Metropolitan Museum of Art, 2009.

Lee Bul, Sunjung Kim, and Hans-Ulrich Obrist. *Lee Bul*. Exh. cat. Seoul: Art Sonje Center, 1998.

Leis, Arlene. "'A Little Old-China Mad': Lady Dorothea Banks (1758–1828) and Her Dairy at Spring Grove." *Journal for Eighteenth-Century Studies* 40, no. 2 (June 2017), pp. 199–221.

Leong, Karen J. *The China Mystique: Pearl S. Buck, Anna May Wong, Mayling Soong, and the Transformation of American Orientalism*. Berkeley: University of California Press, 2005.

Li, Yuhang. *Becoming Guanyin: Artistic Devotion of Buddhist Women in Late Imperial China*. New York: Columbia University Press, 2019.

Lim, Shirley Jennifer. *Anna May Wong: Performing the Modern*. Philadelphia: Temple University Press, 2019.

Liu, Jen. Interview by Xiaowei Wang. *Bomb*, March 4, 2024. https:// bombmagazine.org/articles/2024 /03/04/jen-liu-by-xiaowei-wang/.

Liu, Lydia H. "Robinson Crusoe's Earthenware Pot." *Critical Inquiry* 25, no. 4 (Summer 1999), pp. 728–57.

Lunsingh Scheurleer, Theodoor Herman. "Documents on the Furnishing of Kensington House." *Walpole Society* 38 (1960–62), pp. 15–58.

Mao, Sally Wen. *The Kingdom of Surfaces: Poems*. Minneapolis: Graywolf, 2023.

Martin, Meredith. "Interiors and Interiority in the Ornamental Dairy Tradition." *Eighteenth-Century Fiction* 20, no. 3 (Spring 2008), pp. 357–84.

Martin, Meredith. *Dairy Queens: The Politics of Pastoral Architecture from Catherine de' Medici to Marie-Antoinette*. Cambridge, MA: Harvard University Press, 2011.

Marx, Karl. Transcription of correspondence published in the *New York Daily Tribune*, June 2, 1857. Accessed June 13, 2024. https://www.marxists.org/archive /marx/works/1857/06/02.htm.

Massey, Roger. "Independent China Painters in 18th-Century London." *English Ceramics Circle Transactions* 19, no. 1 (2005), pp. 153–89.

Maxwell, Christopher L., ed. *In Sparkling Company: Reflections on Glass in the Eighteenth-Century British World*. Exh. cat. Corning, NY: Corning Museum of Glass, 2020.

McNeil, Peter. *Pretty Gentlemen: Macaroni Men and the Eighteenth-Century Fashion World*. New Haven: Yale University Press, 2018.

Merrill, Linda. "Whistler and the 'Lange Lijzen.'" *Burlington Magazine* 136, no. 1099 (October 1994), pp. 683–90.

Metrick-Chen, Lenore. *Collecting Objects / Excluding People: Chinese Subjects and American Visual Culture, 1830–1900*. Albany: State University of New York Press, 2012.

Metzger, Sean. *Chinese Looks: Fashion, Performance, Race*. Bloomington: Indiana University Press, 2014.

Miller, Ian. *A History of Force Feeding: Hunger Strikes, Prisons and Medical Ethics, 1909–1974*. New York: Palgrave Macmillan, 2016.

Montrose, Louis. *The Subject of Elizabeth: Authority, Gender, and Representation*. Chicago: University of Chicago Press, 2006.

Moon, Iris. "The Sèvres Elephant Garniture and the Politics of Dispersal during the French Revolution." *Metropolitan Museum Journal* 56 (2021), pp. 81–97.

Moreland, W. H., ed. and trans. *Peter Floris: His Voyage to the East Indies in the Globe, 1611–1615*. London: Hakluyt Society, 1934.

Morrall, Andrew, and Melinda Watt, eds. *English Embroidery from The Metropolitan Museum of Art, 1580–1700: 'Twixt Art and Nature*. Exh. cat. New York: Bard Graduate Center for Studies in the Decorative Arts, Design, and Culture, 2008.

Munger, Jeffrey. *European Porcelain in The Metropolitan Museum of Art*. New York: The Metropolitan Museum of Art, 2018.

Murray, Catriona. *Imaging Stuart Family Politics: Dynastic Crisis and Continuity*. New York: Routledge, 2017.

Mustard, Wilfred P. "Siren-Mermaid." *Modern Language Notes* 23, no. 1 (January 1908), pp. 21–24.

Nead, Lynda. *The Female Nude: Art, Obscenity, and Sexuality*. London: Routledge, 1992.

Nixon, Mignon. "Bad Enough Mother." In "Feminist Issues," special issue, *October* 71 (Winter 1995), pp. 70–92.

Nosch, Marie-Louise, Zhao Feng, and Lotika Varadarajan, eds. *Global Textile Encounters*. Philadelphia: Oxbow Books, 2015.

Oishi, Eve. "Passionate Interaction: Interview with Patty Chang." *X-TRA* 5, no. 4 (Summer 2003), pp. 14–17.

Orr, Clarissa Campbell, ed. *Queenship in Britain, 1660–1837: Royal Patronage, Court Culture, and*

Dynastic Politics. Manchester: Manchester University Press, 2002.

Pedersen, Tara E. *Mermaids and the Production of Knowledge in Early Modern England*. Farnham: Ashgate, 2015.

Peng, Ying-chen. *Artful Subversion: Empress Dowager Cixi's Image Making*. New Haven: Yale University Press, 2023.

Pietsch, Ulrich, Anette Loesch, and Eva Ströber. *The Dresden Porcelain Collection: China, Japan, Meissen*. Munich: Deutscher Kunstverlag, 2006.

Polo, Marco. *The Travels of Marco Polo: The Complete Yule-Cordier Edition*. 2 vols. New York: Dover, 1993–2012.

Porter, David. "Monstrous Beauty: Eighteenth-Century Fashion and the Aesthetics of the Chinese Taste." In "Aesthetics and the Disciplines," special issue, *Eighteenth-Century Studies* 35, no. 3 (Spring 2002), pp. 395–411.

Porter, David. *The Chinese Taste in Eighteenth-Century England*. Cambridge: Cambridge University Press, 2010.

Porter, Jonathan. "'The Past Is Present': The Construction of Macau's Historical Legacy." *History and Memory* 21, no. 1 (Spring–Summer 2009), pp. 63–100.

Porzellan: Meissen, China, Japan, Elfenbeinskulpturen, Gemälde, und Waffen aus den Sächsischen Staatssammlungen in Dresden. Sale cat. Rudolph Lepke's Kunst-Auctions-Haus, Berlin, October 12, 1920.

Potvin, John, and Alla Myzelev, eds. *Material Cultures, 1740–1920: The Meanings and Pleasures of Collecting*. Farnham: Ashgate, 2009.

Pu Lan. *The Potteries of China*. Translated by Geoffrey R. Sayer. London: Routledge and Kegan Paul, 1951.

Raphals, Lisa. *Sharing the Light: Representations of Women and Virtue in Early China*. Albany: State University of New York Press, 1998.

Ray, Romita. "Going Global, Staying Local: Elihu Yale the Art Collector." *Yale University Art Gallery Bulletin* (2012), pp. 34–51.

Reed, Marcia, and Paola Demattè, eds. *China on Paper: European and Chinese Works from the Late Sixteenth to the Early Nineteenth Century*. Exh. cat. Los Angeles: Getty Research Institute, 2007.

Robinson, Darryl, Frédéric Mégret, Jens David Ohlin, Kevin Jon Heller, and Sarah M. H. Nouwen, eds. *Oxford Handbook of International Criminal Law*. Oxford: Oxford University Press, 2020.

Rochebrune, Marie-Laure de, ed. *La Chine à Versailles: Art et diplomatie au XVIIIᵉ siècle*. Exh. cat. Paris: Somogy éditions d'art, 2014.

Roffey, Monique. *The Mermaid of Black Conch*. New York: Vintage Books, 2020.

Romero de Terreros, Manuel. *Los jardines de la Nueva España*. Mexico City: Ediciones México Moderno, 1919.

Rosenthal, Angela. "Visceral Culture: Blushing and the Legibility of Whiteness in Eighteenth-Century British Portraiture." *Art History* 27, no. 4 (September 2004), pp. 563–92.

Rosenthal, Stephanie, ed. *Lee Bul*. London: Hayward Gallery Publishing, 2018.

Rothwell, James, and Annabel Westman. "The Ghost of a Royal Visit: The Furnishing of the State Apartment at Lyme Park in the Mid-1670s." *Furniture History* 47 (2011), pp. 1–17.

The Royal Dresden Porcelain Collection. Dresden: Staatliche Kunstsammlungen, 2014–24. doi .org/10.58749/skd.ps.2024.rpc.

Rubial García, Antonio, ed. *La ciudad de México en el siglo XVIII (1690–1780): Tres crónicas*. Mexico City: Consejo Nacional para la Cultura y las Artes, 1990.

Salmon, Michael A. *The Aurelian Legacy: British Butterflies and Their Collectors*. Berkeley: University of California Press, 2001.

Saltz, Jerry, and Rachel Corbett, "How Identity Politics Conquered the Art World: An Oral History." *New York Magazine*, April 18, 2016. www.vulture.com/2016/04 /identity-politics-that-forever -changed-art.html.

Samoyault-Verlet, Colombe, Jean-Paul Desroches, Gilles Béguin, and Albert Le Bonheur, eds. *Le Musée chinois de l'impératrice Eugénie*. Exh. cat. Paris: Réunion des musées nationaux, 1994.

Samson, Alexander. "Outdoor Pursuits: Spanish Gardens, the *Huerto* and Lope de Vega's *Novelas a Marcia Leonarda*." In "Gardens and Horticulture in Early Modern Europe," special issue, *Renaissance Studies* 25, no. 1 (February 2011), pp. 124–50.

Sargent, William R. *Treasures of Chinese Export Ceramics from the Peabody Essex Museum*. Salem, MA: Peabody Essex Museum, 2012.

Sargentson, Carolyn. *Merchants and Luxury Markets: The Marchands Merciers of Eighteenth-Century Paris*. London: Victoria and Albert Museum, 1996.

Schöneweiß, Feng. "Provenance and Monumentality: Chinese Porcelain, German Curators, and the Shaping of Museological Art History in Dresden." PhD diss., Ruprecht-Karls-Universität Heidelberg, 2023.

Schurz, William Lytle. *The Manila Galleon*. New York: E. P. Dutton, 1939.

Schwoerer, Lois G. "Images of Queen Mary II, 1689–95." *Renaissance Quarterly* 42, no. 4 (Winter 1989), pp. 717–48.

Scott, Katie. "Playing Games with Otherness: Watteau's Chinese Cabinet at the Château de la Muette." *Journal of the Warburg and Courtauld Institutes* 66 (2003), pp. 189–248.

Scott, Katie, and Melissa Lee Hyde, eds. *Rococo Echo: Art, History and Historiography from Cochin to Coppola*. Oxford: Voltaire Foundation, 2014.

Shohat, Ella. "The Specter of the Blackamoor: Figuring Africa and the Orient." *The Comparatist* 42 (October 2018), pp. 158–88.

Shulsky, Linda. "Queen Mary's Collection of Porcelain and Delft and Its Display at Kensington Palace: Based upon an Analysis of the Inventory Taken in 1697." Master's thesis, Cooper-Hewitt Museum, Smithsonian Institution; Parsons School of Design, 1985.

Sigalas, Vanessa, and Meredith Chilton, eds. *All Walks of Life: A Journey with the Alan Shimmerman Collection; Meissen Porcelain Figures of the Eighteenth Century*. Stuttgart: Arnoldsche, 2022.

Skelly, Julia, ed. *The Uses of Excess in Visual and Material Culture, 1600–2010*. Burlington, VT: Ashgate, 2014; London: Routledge, 2018.

Sloboda, Stacey. *Chinoiserie:*

Commerce and Critical Ornament in Eighteenth-Century Britain. Manchester: Manchester University Press, 2014.

Snorton, C. Riley, and Hentyle Yapp, eds. Saturation: Race, Art, and the Circulation of Value. Cambridge, MA: MIT Press, 2020.

Standen, Edith. "The Story of the Emperor of China: A Beauvais Tapestry Series." Metropolitan Museum Journal 11 (1976), pp. 103–17.

Standen, Edith. "English Tapestries 'After the Indian Manner.'" Metropolitan Museum Journal 15 (1980), pp. 119–42.

Stanford, Caroline. "James Wyatt's Ornamental Dairy at Cobham Hall, Kent." Georgian Group Journal 28 (2020), pp. 127–56.

Stoler, Ann Laura. Carnal Knowledge and Imperial Power: Race and the Intimate in Colonial Rule. Berkeley: University of California Press, 2010.

Survey of London. Vol. 34, The Parish of St. Anne, Soho, edited by F. H. W. Sheppard. London: Athlone, 1966.

Swain, Margaret. "Chinoiserie Tapestries in Scotland." Bulletin du Centre international d'étude des textiles anciens 69 (1991), pp. 85–92.

Taylor, Jean Gelman. "Meditations on a Portrait from Seventeenth-Century Batavia." Journal of Southeast Asian Studies 37, no. 1 (February 2006), pp. 23–41.

Thomas, Chantal. The Wicked Queen: The Origins of the Myth of Marie-Antoinette. New York: Zone Books, 1999.

Thurley, Simon. Hampton Court: A Social and Architectural History. New Haven: Yale University Press, 2003.

Tillerot, Isabelle. East Asian Aesthetics and the Space of Painting in Eighteenth-Century Europe. Translated by Chris Miller. Los Angeles: Getty Research Institute, 2024.

Treanor, Virginia. "'Une abondance extra ordinaire': The Porcelain Collection of Amalia van Solms." Early Modern Women 9, no. 1 (Fall 2014), pp. 141–54.
Tung, Stephanie H., and Karina

H. Corrigan, eds. Power and Perspective: Early Photography in China. Exh. cat. Salem, MA: Peabody Essex Museum, 2022.

Van Campen, Jan. "'Reduced to a Heap of Monstrous Shivers and Splinters': Some Notes on Coromandel Lacquer in Europe in the 17th and 18th Centuries." Rijksmuseum Bulletin 57, no. 2 (2009), pp. 136–49.

Vergès, Françoise. Monsters and Revolutionaries: Colonial Family Romance and Métissage. Durham, NC: Duke University Press, 1999.

Vickery, Amanda. The Gentleman's Daughter: Women's Lives in Georgian England. New Haven: Yale University Press, 1998. Reprint, 2003.

Volmert, Miriam, and Danijela Bucher, eds. European Fans in the 17th and 18th Centuries: Images, Accessories, and Instruments of Gesture. Berlin: De Gruyter, 2020.

Welsh, Jorge. Kinrande: Porcelain Dressed in Gold. London: Jorge Welsh Research and Publishing, 2020.

Welsh, Jorge, and Luísa Vinhais, eds. Porcelain People: Figures from the Qing Dynasty. Exh. cat. London: Jorge Welsh Research and Publishing, 2021.

Whitlum-Cooper, Francesca. Discover Liotard and "The Lavergne Family Breakfast." Exh. cat. London: National Gallery, 2023.

Wong, Anna May. "I Protest." Interview by Doris Mackie. Film Weekly, August 18, 1933, p. 11.

Wu Hung. The Double Screen: Medium and Representation in Chinese Painting. Chicago: University of Chicago Press, 1996.

Yang, Chi-ming. Performing China: Virtue, Commerce, and Orientalism in Eighteenth-Century England, 1660–1760. Baltimore: Johns Hopkins University Press, 2011.

Yang, Chi-ming. "Elephantine Chinoiserie and Asian Whiteness: Views on a Pair of Sèvres Vases." Journal of the Walters Art Museum 75. https://journal.thewalters.org /volume/75/essay/elephantine -chinoiserie-and-asian-whiteness -views-on-a-pair-of-sevres-vases/.

Yeh, Catherine. Shanghai Love: Courtesans, Intellectuals, and Entertainment Culture, 1850–1910.

Seattle: University of Washington Press, 2006.

Yü, Chün-fang. Kuan-yin: The Chinese Transformation of Avalokiteśvara. New York: Columbia University Press, 2001.

Zook, Melinda S. "The Shocking Death of Mary II: Gender and Political Crisis in Late Stuart England." In "Britain and the World," special issue, British Scholar 1, no. 1 (September 2008), pp. 21–36.

Zorach, Rebecca. Blood, Milk, Ink, Gold: Abundance and Excess in the French Renaissance. Chicago: University of Chicago Press, 2005.

Zuroski, Eugenia, and Michael Yonan, eds. "Material Fictions." Special issue, Eighteenth-Century Fiction 31, no. 1 (Fall 2018).

CHECKLIST

17
Meissen porcelain manufactory
(German, 1710–present)
Vase with cover
ca. 1725
Hard-paste porcelain,
16 15/16 × 5 3/4 × 5 3/4 in.
(43 × 14.6 × 14.6 cm)
The Metropolitan Museum of Art,
New York, Bequest of Henry H.
Arnhold, 2018 (2019.139.2a, b)

18
Vase with women enjoying scholarly
pursuits
China, Qing dynasty (1644–1911),
Kangxi period (1662–1722),
late 17th–18th century
Porcelain with colored enamels
over transparent glaze, and gilded
(Jingdezhen ware), H. 16 15/16 in.
(43 cm)
The Metropolitan Museum of Art,
New York, Bequest of John D.
Rockefeller Jr., 1960 (61.200.67)

19
Willem Wissing (Dutch, 1656–1687)
Mary II When Princess of Orange
ca. 1686–87
Oil on canvas, 49 1/2 × 40 1/4 in.
(125.8 × 102.3 cm)
Royal Collection Trust, London
(RCIN 405643)

20
Written and published by John
Stalker and George Parker (British,
17th century)
*A Treatise of Japanning and
Varnishing . . .*
ca. 1688
Illustrations: etching and engraving,
14 3/4 × 9 5/8 × 11/16 in.
(37.5 × 24.5 × 1.8 cm)
The Metropolitan Museum of Art,
New York, Harris Brisbane Dick
Fund, 1932 (32.80.2)

21
Mirror with Jael and Barak
British, 1672
Satin worked with silk and metal-
wrapped thread, beads, purl, mica,
seed pearls; detached buttonhole
variations, long-and-short, satin,
couching, and straight stitches;
wood frame, celluloid imitation
tortoiseshell, mirror glass, silk plush,
28 3/4 × 23 3/4 in. (73 × 60.3 cm)
The Metropolitan Museum of Art,
Purchase, Mrs. Thomas J. Watson
Gift, 1939 (39.13.2a)

22
Charger with double portrait of
William III and Mary II
Delft, The Netherlands, 1690
Tin-glazed earthenware,
2 1/8 × 13 5/8 × 13 5/8 in.
(5.4 × 34.6 × 34.6 cm)
The Metropolitan Museum of Art,
New York, Robert A. Ellison Jr.
Collection, Gift of Robert A Ellison Jr.,
2014 (2014.712.3)

23
Daniel Marot (French, 1661–1752)
Published by Pierre Husson (Dutch,
1678–1733)
Chimneypiece with various porcelain
vases, from *Nouvelles cheminées
faittes en plusieur en droits de la
hollande et autres prouinces*, part of
Oeuvres du Sr. D. Marot
published 1703 or 1712
Etching, sheet: 13 9/16 × 8 1/4 in.
(34.4 × 21 cm), plate: 9 3/4 × 7 13/16 in.
(24.8 × 19.8 cm)
The Metropolitan Museum of Art,
New York, Harris Brisbane Dick Fund,
1930 (30.4[43])

24
Mirror with Coromandel lacquer frame
England, ca. 1680
Softwood, carved and veneered
with Chinese Coromandel lacquer,
60 × 39 in. (152.4 × 99.1 cm)
Victoria and Albert Museum, London
(W.39-1950)

25
Grinling Gibbons (British, 1648–1721)
Design for a chimneypiece with
displays of porcelain on the
overmantel and above the fire
surround, and with draped upholstery
across the overmantel
ca. 1689–94
Pen and brown ink over graphite
underdrawing, with gray-brown,
yellow ochre and pink wash; on laid
paper, 184 1/4 × 111 13/16 in.
(468 × 284 cm)
Sir John Soane's Museum, London
(SM, volume 110/23)

26
Hexagonal jars with flower and bird
decoration (a pair)
Japan, late 17th century, Edo period
(1615–1868)
Porcelain with overglaze enamels
(Arita ware, Kakiemon type),
H. 12 1/4 in. (31.1 cm), Diam. 7 1/2 in.
(19.1 cm)
The Metropolitan Museum of Art,
New York, Dr. and Mrs. Roger G. Gerry
Collection, Bequest of Dr. and Mrs,
Roger G. Gerry, 2000
(2002.447.63a, b)

27
Greek A factory (Dutch, 1658–1722)
Proprietor Adrianus Kocx (Dutch,
act. 1689–1694; d. 1701)
Ewer and stand (one of a pair)
ca. 1694
Tin-glazed earthenware,
H. 46 1/16 in. (117 cm)
Royal Collection Trust, London
(RCIN 1083)

28
Sir Godfrey Kneller (German-British,
1646–1723)
Diana de Vere, Duchess of Saint Albans
ca. 1691
Oil on canvas, 92 × 45 1/4 in.
(233.6 × 115 cm)
Royal Collection Trust, London
(RCIN 404722)

29
Greek A factory (Dutch, 1658–1722)
Proprietor Adrianus Kocx (Dutch,
act. 1689–1694; d. 1701)
Based on a print by Daniel Marot
French, 1661–1752)
Milk pan
ca. 1689–94
Tin-glazed earthenware with painted
in-glaze decoration and enamel
colors and gilding, Diam. 20 in. (50 cm)
Victoria and Albert Museum, London
(C.57-1948)

30
Jennifer Ling Datchuk (American,
b. 1980)
Pretty Sister, Ugly Sister
2014
Porcelain and hair, 6 5/8 × 1 5/8 × 8 7/8 in.
(16.8 × 4.1 × 22.5 cm)
McKay Otto and Keith Coffee

31
Toilet set in original leather case
Fourteen identified German (Augsburg) goldsmiths and other German artisans; Japanese porcelain maker, ca. 1743–45
Gilt silver, hard-paste porcelain, cut glass, walnut, carved and partially gilt coniferous wood, leather, textiles, moiré paper, hog's bristle, case: H. 16 ½ in. (41.9 cm); D. 28 in. (71.1 cm); silver-gilt mirror: H. 29 ½ in. × W 23 ½ in. (74.9 × 59.7 cm)
The Metropolitan Museum of Art, New York, Purchase, Anna-Maria and Stephen Kellen Foundation Gift, in memory of Stephen M. Kellen, 2005 (2005.364.1a–f-.48)

32
Unknown artist (British)
A Family Being Served with Tea, Possibly the Carter family
ca. 1745
Oil on canvas, 42 × 55 in. (106.7 × 139.7 cm)
Yale Center for British Art, Paul Mellon Collection (B1981.25.271)

33
Paul de Lamerie (British, 1688–1751)
Teapot
1743–44
Silver and wood, 5 ½ × 8 ½ in. (14 × 21.6 cm)
The Metropolitan Museum of Art, New York, Gift of Mrs. Charles C. Paterson, in memory of Mrs. John A. Stewart, 1946 (46.66)

34
After a design by Thomas Chippendale (British, 1718–1779)
China table
ca. 1755
Mahogany, 28 ¼ × 37 ¾ × 26 ½ in. (71.8 × 95.9 × 67.3 cm)
The Metropolitan Museum of Art, New York, Gift of Irwin Untermyer, 1964 (64.101.1099)

35
Decorated by Ignaz Preissler (German, 1676–1741)
Saucer
ca. 1730
Hard-paste porcelain, Diam. 5 ¼ in. (13.3 cm)
The Metropolitan Museum of Art, New York, Gift of R. Thornton Wilson, in memory of Florence Ellsworth Wilson, 1950 (50.211.250)

36
Possibly decorated by Ignaz Preissler (German, 1676–1741)
Tumbler
ca. 1720
Glass, 3 ¾ × 2 ¾ in. (9.5 × 7 cm)
The Metropolitan Museum of Art, New York, Rogers Fund, 1915 (15.34.1)

37
Jean Pillement (French 1728–1808)
Published by Robert Sayer (British 1725–1794)
Ladies' Amusement: Or, The Whole Art of Japanning Made Easy
1760
Illustrations: etching and engraving, hand-colored, 7 ⅞ × 12 ⁵⁄₁₆ × 1 ³⁄₁₆ in. (20 × 31.2 × 3 cm)
The Metropolitan Museum of Art, New York, Harris Brisbane Dick Fund, 1933 (33.24)

38
Worcester factory (British, 1751–2008)
Milk jug
ca. 1753
Soft-paste porcelain, 3 ⅜ × 3 ¼ × 2 ³⁄₁₆ in. (8.5 × 8.3 × 5.5 cm)
The Metropolitan Museum of Art, New York, Gift of Mrs. Constance D. Stieglitz, in memory of her husband, Marcel H. Stieglitz, 1964 (64.142.73)

39
Worcester factory (British, 1751–2008)
Teabowl and saucer
ca. 1755
Soft-paste porcelain, cup: 1 ⅞ × 2 ⅞ in. (4.8 × 7.3 cm); saucer: 1 × 4 ⅞ in. (2.5 × 12.4 cm)
The Metropolitan Museum of Art, New York, Gift of Mrs. Constance D. Stieglitz, in memory of her husband, Marcel H. Stieglitz, 1964 (64.142.23, .24)

40
Samuel Phillips (British, act. 1797–1808)
After William Hogarth (British, 1697–1764)
Taste in High Life
May 1, 1798
Engraving and aquatint; second state
Sheet (trimmed to plate line): 15 ¹⁄₁₆ × 18 ⅛ in. (38.2 × 46 cm)
The Metropolitan Museum of Art, New York, Harris Brisbane Dick Fund, 1932 (32.35 [51])

41
I. M. P. (French, Jurisdiction of Lille)
Teapot
French, mid-18th century
Silver, ebony, H. 7 ⁵⁄₁₆ in. (18.6 cm)
The Metropolitan Museum of Art, New York, Gift of James Hazen Hyde, 1956 (56.176)

42
Union porcelain works (American, 1863–1922)
Partial tea set (teapot, sugar bowl, cream pitcher, slop bowl)
1876
Porcelain; allover blue ground with delicate gilded and enamel decoration, teapot with lid: H. 6 ¾ in. (17.1 cm)
The Metropolitan Museum of Art, New York, Gift of Emma and Jay A. Lewis, 2021 (2021.238.2.1a, b –.4)

43
Bernard Lens II (British, 1659–1725)
Woman Drinking Tea
ca. before 1725
Mezzotint on medium, moderately textured, beige laid paper, 5 ½ × 4 ½ in. (14 × 11.4 cm)
Yale Center for British Art, Paul Mellon Fund, New Haven (B1970.3.1019)

44
Birdcage
Delft, The Netherlands, first half of the 18th century
Tin-glazed earthenware, 16 ½ × 11 in. (41.9 × 27.9 cm)
The Metropolitan Museum of Art, New York, Gift of Henry G. Marquand, 1894 (94.4.103)

45
Tea set: teapot with portrait of a woman, creamer with cover, two cups, two saucers, and bowl
Chinese, made for the European market
1750–70
Hard-paste porcelain with enamel decoration and gilding, various dimensions
The Metropolitan Museum of Art, New York, Helena Woolworth McCann Collection, Gift of Winfield Foundation, 1951 (51.86.285a, b; .286a, b; .287; 288; .289; .290; .291)

46
Cup with two figures and birdcage
Chinese, made for the European market
ca. 1750
Porcelain, H. 2 ½ in. (6.4 cm)
The Belvedere Collection

47
Cup and saucer with woman
trimming toenails
Chinese, made for the European market
ça. 1740
Porcelain, H. 1 ½ in. (⅝ cm); Diam.
of saucer 4 ¾ in. (12.1 cm)
The Belvedere Collection

48
Pair of saucers with Dutch maid
Chinese, made for the European market
ca. 1750
Porcelain, Diam. 4 ¾ in. (12.1 cm)
The Belvedere Collection

49
William Hogarth (British, 1697–
1764)
A Harlot's Progress, Plate 2
Before April 1732
Etching and engraving; first state
of four
Sheet 12 ⁷⁄₁₆ × 14 ¹⁵⁄₁₆ in.
(31.6 × 37.9 cm)
The Metropolitan Museum of Art,
New York, Harris Brisbane Dick
Fund, 1932 (32.35 [3])

50
John Bowles (British, act. 1743),
printseller
The Tea-Table
ca. 1766
Print on laid paper, etching, sheet:
8 ⅛ × 6 ¼ in. (20.8 × 15.8 cm)
Lewis Walpole Library, Yale
University, Farmington
(766.00.00.37 Impression 2)

51
Candice Lin (American, b. 1979)
The Tea Table
2016
Etching on Japanese Kozo paper,
24.4 × 29.5 in. (62 × 75 cm)
Lewis Walpole Library, Yale
University, Farmington

52
Chelsea porcelain manufactory
(British, 1744–1784, Red Anchor
period, ca. 1753–1766)
Joseph Willems (Flemish, 1716–
1766), modeler
Chinese Musicians
ca. 1755
Soft-paste porcelain,
14 ½ × 14 ½ × 14 ⅝ in.
(36.8 × 36.8 × 37.1 cm)
The Metropolitan Museum of Art,
New York, Gift of Irwin Untermyer,
1964 (64.101.474)

53
Bodhisattva Guanyin seated on a rock
China, Qing dynasty (1644–1911),
18th–19th centuries
Porcelain with ivory glaze (Dehua
ware), 9 ¹⁄₁₆ × 4 ¹⁄₁₆ × 2 ⅝ in.
(23 × 10.3 × 6.7 cm)
The Metropolitan Museum of Art,
New York, Bequest of Helen W. D.
Mileham, 1954 (55.111.84)

54
Figure of a standing beauty
Japan, Edo period (1615–1868),
1670–90
Porcelain with overglaze polychrome
enamels (Arita ware, Kakiemon type),
15 ⅝ × 5 ⅜ × 4 ⅞ in.
(39.7 × 13.7 × 12.4 cm)
The Metropolitan Museum of Art,
New York, The Harry G. C. Packard
Collection of Asian Art, Gift of
Harry G. C. Packard, and Purchase,
Fletcher, Rogers, Harris Brisbane
Dick, and Louis V. Bell Funds, Joseph
Pulitzer Bequest, and The Annenberg
Fund Inc. Gift, 1975 (1975.268.528)

55
Martin Engelbrecht
(German, 1684–1756), engraver
After Johann Friedrich Eosander von
Göthe (German, 1669–1728), architect
*Design for the Porcelein Cabinet at
the Charlottenburg Palace*
ca. 1711–56
Etching, sheet: 13 ⅜ × 16 ¹⁵⁄₁₆ in.
(34 × 43 cm)
The Metropolitan Museum of Art,
New York, The Elisha Whittelsey
Collection, The Elisha Whittelsey
Fund, 1966 (66.559.140)

56
Meissen porcelain manufactory
(German, 1710–present)
Johann Joachim Kändler (German,
1706–1775), modeler
Johann Friedrich Eberlein (German,
1695–1749), modeler
Peter Reinicke (1715–1768),
modeler
Asia (one of a pair)
ca. 1745–55
Hard-paste porcelain with French
gilt-bronze mounts,
22 × 20 ¼ × 9 ⅛ in.
(55.9 × 51.4 × 23.2 cm)
The Metropolitan Museum of Art,
New York, Gift of Mrs. Douglas Dillon,
2009 (2009.437.1)

57
Published by Johann Christian
Leopold (German, 1699–1755)
*Accurate Representation . . . Des
Herrlichen Festins Welches . . .
Francisca Sibylla Augusta,
Marggräffin zu Baaden und
Hochberg. In Schloss Ettlingen
Anno 1729 . . . gegeben*
ca. 1730
Engraving, hand-colored in watercolor,
7 ¹⁵⁄₁₆ × 12 × ⅜ in. (20.2 × 30.5 × 1 cm)
The Metropolitan Museum of Art,
New York, The Elisha Whittelsey
Collection, The Elisha Whittelsey
Fund, 1954 (54.648.1)

58
Meissen porcelain manufactory
(German, 1710–present)
Based on a design by François
Boucher (French, 1703–1770)
Johann Joachim Kändler (German,
1706-1775), modeler
Peter Reinicke (1715–1768), modeler
Asian woman with children
ca. 1750
Hard-paste porcelain with enamel,
6 ⅛ in. (15.5 cm)
Victoria and Albert Museum, London
1978 (C.7-1978)

59
John Ingram (British, act. 1721–
1763)
After François Boucher (French,
1703–1770)
The Master Gardener
ca. 1741–63
Etching and engraving, 8 ¹¹⁄₁₆ × 5
¹¹⁄₁₆ in. (22 × 14.5 cm)
The Metropolitan Museum of Art,
New York, Harris Brisbane Dick
Fund, 1953 (53.600.1020[5])

60
Probably Chelsea porcelain
manufactory (British, 1744–1784)
Based on a design by François
Boucher
Chinoiserie figure
ca. 1750
Soft-paste porcelain
Pamela Klaber Roditi, London

61
Interior with woman, child, and nurse
China, Qing dynasty (1644–1911),
late 18th-early 19th century
Hanging scroll; ink and color on silk,
image: 71 ¼ × 47 ½ in.
(181 × 120.7 cm), overall with
mounting: 92 ⅜ × 50 ⅜ in.
(234.6 × 128 cm), overall with knobs:
92 ⅜ × 54 ⅜ in. (234.6 × 138.1 cm)
The Metropolitan Museum of Art,
New York, Gift of Mathias Komor,
1944 (44.121)

62
Inkstand
Chinese, made for the European
market
1750–70
Hard-paste porcelain, overall (stand
and cover): 3 ½ × 4 ½ × 8 in.
(8.9 × 11.4 × 20.3 cm); H. (sand
shaker) 2 ¹¹⁄₁₆ in. (6.8 cm);
H. (ink bottle). 2 ¹¹⁄₁₆ in. (6.8 cm)
The Metropolitan Museum of Art,
New York, Helena Woolworth McCann
Collection, Gift of Winfield Foundation,
1951 (51.86.365a–d)

63
Sèvres manufactory
(French, 1756–present)
Pair of potpourri vases
ca. 1760
Soft-paste porcelain, bleu lapis, blue,
pink and green ground colors,
polychrome enamel decoration, and
gilding, (each) 11 ¾ × 6 ½ × 5 ¾ in.
(29.8 × 16.5 × 14.6 cm)
J. Paul Getty Museum, Los Angeles
(78.DE.358)

64
Vienna manufactory (Austrian,
1718–present)
Factory director Claudius Innocentius
du Paquier period (1718–1744)
Manticore
ca. 1735
Hard-paste porcelain, 4 ¹³⁄₁₆ × 5 ⅜ in.
(12.2 × 13.7 cm)
The Metropolitan Museum of Art,
New York, The Hans Syz Collection,
Gift of Stephan B. Syz and John D.
Syz, 1995 (1995.268.310)

65
Vienna manufactory (Austrian,
1718–present)
Factory director Claudius Innocentius
du Paquier period (1718–1744)
Vase with coiling dragon
ca. 1725
Hard-paste porcelain with raised
decoration painted with colored
enamels over transparent glaze,
H. 6 ½ in. (16.5 cm)
The Metropolitan Museum of Art,
New York, The Hans Syz Collection,
Gift of Stephan B. Syz and John D.
Syz, 1995 (1995.268.275)

66
Caricature of Marie Antoinette as
a leopard
French, late 18th century
Etching, sheet: 4 ⅝ × 3 ⅞ in.
(11.8 × 9.8 cm)
The Metropolitan Museum of Art,
New York, The Elisha Whittelsey
Collection, The Elisha Whittelsey
Fund, 1962 (62.520.16)

67
Chelsea porcelain manufactory
(British, 1744–1784)
Joseph Willems (Flemish, 1716–
1766), modeler
Lady with a child and a cat playing
with a string toy
ca. 1750–52
Soft-paste porcelain,
9 ¼ × 5 ⅞ × 4 ¾ in.
(23.5 × 15 × 12 cm)
Museum of Fine Arts, Boston, Jessie
and Sigmund Katz Collection
(1988.804)

68
Chelsea porcelain manufactory
(British, 1744–1784)
Based on a print by François
Boucher (French, 1703–1770)
Joseph Willems (Flemish, 1716–
1766), modeler
Possibly enameled in the workshop
of William Duesbury (1725–1786)
Mother and child, based on the print
Le mérite de tout pais
ca. 1749–50
Soft-paste porcelain with polychrome
enamel decoration, 8 ⅞ × 6 × 4 ⅝ in.
(22.5 × 15.2 × 11.7 cm)
The Metropolitan Museum of Art,
New York, Purchase, Larry and Ann
Burns Gift, in honor of Austin B.
Chinn, 2023 (2023.433)

69
Two figurines of possibly pregnant
ladies in repose
Chinese, made for the European market
Qianlong period (1736–1795),
ca. 1750
Porcelain, W. 9 in. (22.9 cm)
Private collection

70
Mrs. and Miss Revell on a Veranda
Chinese, made for the European market
ca. 1768–87
Reverse painting on glass,
18 ⅜ × 16 ⅛ in. (46.7 × 41 cm)
Peabody Essex Museum, Salem,
Museum purchase, made possible by
an anonymous donor (AE85763)

71
Woman and scholar
China, Qing dynasty (1644–1911),
Qianlong period (1736–95),
18th century
Gold, wood, and reverse painting on
glass, 44 ¾ × 25 ¼ × 1 ¾ in.
(113.7 × 64.1 × 4.5 cm)
Peabody Essex Museum, Salem,
Museum purchase with funds
donated in part by the Asian Export
Art Visiting committee

72
Portrait of Elizabeth Graham
China, Qing dynasty (1644–1911),
Qianlong period (1736–95), 1785
Probably in pernilla oil paint,
executed on framed and imported
European (probably French) mirror
glass, Chinese frames made of
lacquered and gold-painted wood,
British frames of gilded wood
embellished with carton-pierre
decoration, 51 ³⁄₁₆ × 35 ¹⁄₁₆ in.
(130 × 89 cm)
Toledo Museum of Art, Purchased
with funds from the Libbey
Endowment, Gift of Edward
Drummond Libbey (2010.50)

73
Portrait of Christian Graham
China, Qing dynasty (1644–1911),
Qianlong period (1736–95), 1785
Probably in pernilla oil paint,
executed on framed and imported
European (probably French) mirror
glass, Chinese frames made of
lacquered and gold-painted wood,
British frames of gilded wood
embellished with carton-pierre
decoration, 51 ³⁄₁₆ × 35 ¹⁄₁₆ in.
(130 × 89 cm)
Toledo Museum of Art, Purchased
with funds from the Libbey
Endowment, Gift of Edward
Drummond Libbey (2010.51)

74
Woman with a pipe
Chinese, made for the European
market
ca. 1760–80
Reverse-painted crown glass,
imitation lacquer frame, with frame:
20 ½ × 15 ⅝ × 1 ⅛ in.
(52.1 × 39.7 × 2.9 cm)
The Metropolitan Museum of Art,
New York, Purchase, Larry and Ann
Burns Gift, in honor of Austin B.
Chinn, 2022 (2022.52)

75
Sèvres manufactory
(French, 1740–present)
Hyacinthe Régnier (French, act.
1825–1863), designer
Coffee and tea service (*déjeuner
chinois réticiulé*)
ca. 1855–61
Hard-paste porcelain, tray:
H. 8 ⅜ in. (21.3 cm), Diam. 19 ⅝ in.
(49.8 cm), coffee pot with cover:
H. 4 ¹⁵⁄₁₆ in. (12.5 cm), sugar bowl
with cover: H. 4 ⁹⁄₁₆ in. (11.6 cm),
bowl and dish: H. 2 ⅛ in. (5.4 cm),
milk jug: H. 4 ¾ in. (12.1 cm),
Diam. 2 ¹³⁄₁₆ in. (7.1 cm), saucers:
Diam. 4 ¾ in. (12.1 cm),
saucer: Diam. 4 ¹³⁄₁₆ in. (12.2)
The Metropolitan Museum of Art,
New York, Gift of Helen Boehm, in
memory of her late husband, Edward
Marshall Boehm, 1969 (69.193.1–.11)

76
Tureen with cover
Chinese, made for the American market
early 19th century
Hard-paste porcelain,
10 ¾ × 9 ¾ × 14 in.
(27.3 × 24.8 × 35.6 cm)
The Metropolitan Museum of Art,
New York, Helena Woolworth McCann
Collection, Gift of Winfield Foundation,
1951 (51.86.334a, b)

77
Liberty
Chinese, made for the American
market
ca. 1800
Oil on glass, 22 ¾ × 16 ¼ in.
(57.8 × 41.3 cm)
The Metropolitan Museum of Art,
New York, Rogers Fund, 1939
(39.58)

78
Burning of the "Factories" in Canton
Chinese, made for the American market
19th century
Oil on copper, 4 ¾ × 6 ⅜ in.
(12.1 × 16.2 cm)
The Metropolitan Museum of Art,
New York, Rogers Fund, 1956
(56.143)

79
Lacquer box and shoes
Chinese, made for the American market
ca. 1852
Silk, cotton, wood, leather, lacquer,
gilt, 3 ¾ × 6 ⅛ × 4 ¼ in.
(9.5 × 15.6 × 10.8 cm)
South Street Seaport Museum, New
York, Gift of Grace A. Barker

80
Lee Bul (South Korean, 1964–present)
Untitled (Cyborg Leg)
2000
Porcelain, 21 × 9 × 14 in.
(53.3 × 22.9 × 35.6 cm)
The Metropolitan Museum of Art,
New York, Gift of Thaddaeus Ropac,
2023 (2023.285.1)

81
James McNeill Whistler (American,
1834–1903)
*Purple and Rose: The Lange Leizen
of the Six Marks*
1864
Oil on canvas, 36 ¾ × 24 ⅛ in.
(93.3 × 61.3 cm)
Philadelphia Museum of Art, John G.
Johnson Collection, 1917 (Cat. 1112)

82
Worcester factory (British, 1751–
2008)
James Hadley (British, 19th century),
modeler
Figure of a Japanese woman
ca. 1879
Bone china ("ivory porcelain") with
enamel decoration and gilding,
15 ½ × 7 ½ × 6 ⅝ in.
(39.4 × 19.1 × 16.8 cm)
The Metropolitan Museum of Art,
New York, Gift of Helene Fortunoff
and Robert Grossman, 2017
(2018.62.99)

83
Decorated by Joseph S. Potter
(American, 1822–1904)
Vase (*Old World*) (one of a pair)
ca. 1886–89
Porcelain with enameled and gilded
decoration, H. 22 ½ in. (57.2 cm)
The Metropolitan Museum of Art,
New York, Purchase, Ronald S. Kane
Bequest, in memory of Berry B.
Tracy, 2018 (2018.648.1a, b)

84
Yu Xunling (Chinese, 1074–1043)
Empress Dowager Cixi, after 1903
Hand-tinted silver print from
negative plate, 4 ½ × 3 in.
(11.3 × 7.62 cm)
Loewentheil China Photography
Collection

85
Nail guard
China, Qing Dynasty (1644–1911),
18th–19th century
Silver, 3 ⅜ × ⁹⁄₁₆ in. (8.5 × 1.5 cm)
Philadelphia Museum of Art, Gift of
Mrs. Rudolph Blankenburg, 1918
(1918-159)

86
Raimund von Stillfried (Austrian,
1839–1911)
Fille de Shanghai
1870s
Albumen silver print from glass
negative with applied color,
9 ⁵⁄₁₆ × 7 ⁹⁄₁₆ in. (23.7 × 19.2 cm)
The Metropolitan Museum of Art,
New York, Gilman Collection, Museum
Purchase, 2005 (2005.100.505.1 [8a])

87
Woman's sleeveless jacket with
bamboo and rock design
China, Qing dynasty (1644–1911),
Guangxu period (1875–1908),
late 19th century
Silk and metallic thread tapestry
(*kesi*), 28 ½ × 36 in. (72.4 × 91.4 cm)
The Metropolitan Museum of Art,
New York, Gift of Florance Waterbury,
1945 (45.125.13)

88
Bowl
China, Qing dynasty (1644–1911),
Guangxu period (1875–1908),
1874–76
Porcelain painted in overglaze
enamels and gilt, H. 2 ¼ in. (5.7 cm),
Diam. 4 ⅛ in. (10.5 cm), Diam. of
foot 1 ¾ in. (4.4 cm)
The Metropolitan Museum of Art,
New York, Gift of Mrs. Harry L.
Toplitt Jr., in memory of Harry L.
Toplitt Jr., 1984 (1984.286)

89
Anna May Wong
(American, 1905–1961)
Manuscript for "I'm Anna May Wong"
Sheet music
Houghton Library, Harvard University,
Cambridge, Massachusetts,
Purchase, Daniel Oliver Gallery,
2021 October 29, Ruth Neils and
John M. Ward Fund (2022MT-29)

90
Augusto, Ltd. (British)
Evening coat
ca. 1934
Silk, paper, metallic thread
The Metropolitan Museum of Art,
Brooklyn Museum Costume
Collection at The Metropolitan
Museum of Art, New York, Gift of
the Brooklyn Museum, 2009; Gift of
Anna May Wong, 1956
(2009.300.6986)

91
Marianne Brandt
(German, 1893–1983)
Untitled (With Anna May Wong)
1929
Photomontage, photograph,
26 ³⁄₈ × 19 ¹¹⁄₁₆ in. (67 × 50 cm)
Harvard Art Museums/Busch-
Reisinger Museum, Cambridge,
Massachusetts, Purchase through
the generosity of the Friends of the
Busch-Reisinger Museum and their
Acquisitions Committee, Richard and
Priscilla Hunt, Elizabeth C. Lyman,
Mildred Rendl-Marcus, and Sylvia de
Cuevas (2006.25)

92
Lee Bul (South Korean, b. 1964)
Monster: Black
ca. 2011 (reconstruction of
1998 work)
Fabric, fiberfill, stainless-steel
frame, sequins, acrylic paint, dried
flower, glass beads, aluminum,
crystal, metal chain,
85 ⁷⁄₁₆ × 73 ⁵⁄₈ × 67 ⁵⁄₁₆ in.
(217 × 187 × 171 cm)
Leeum Museum of Art, Seoul, Purchase

93
Yeesookyung (South Korean, b. 1963)
Translated Vase,
begun ca. 2002, ongoing
Ceramic shards, stainless steel,
aluminum, epoxy, 24K gold leaf,
192 × 78 ³⁄₄ × 74 ¹³⁄₁₆ in.
(487.7 × 200 × 190 cm)
Collection of the artist

94
Unknown artist (The Netherlands)
Interior of a Chinese Shop (fan leaf),
1680–1700
Gouache on paper, mounted onto a
wooden panel, paper:
10 ³⁄₈ × 17 ¹⁄₈ in. (26.3 × 43.6 cm),
panel: 13 ³⁄₄ × 20 ¹⁄₈ × 1 ⁵⁄₈ in.
(35 × 51 × 4 cm)
Victoria and Albert Museum, London
(P.35-1926)

95
Jar with dragons and floral designs
China, Qing dynasty (1644–1911),
Kangxi period (1662–1722),
late 17th–early 18th century
Porcelain painted with cobalt blue
under a transparent glaze
(Jingdezhen ware), H. 40 ¹⁄₂ in.
(102.9 cm); Diam. 18 ¹⁄₂ in. (47 cm)
The Metropolitan Museum of Art,
New York, Bequest of Mary Clark
Thompson, 1923 (24.80.150a, b)

96
New Spain (present-day Mexico)
Barrel-shaped planter with Chinese
figures
ca. 1760
Tin-glazed earthenware,
H. 18 in. (45.7 cm)
The Metropolitan Museum of Art,
New York, Gift of Mrs. Robert W.
de Forest, 1911 (11.87.41)

97
Probably workshop of John
Vanderbank (Flemish, 1683–1717)
or Sarah Vanderbank (Flemish,
d. 1739)
Probably woven by Great Wardrobe
(London)
Tapestry "After the Indian Manner,"
called *Toilette of the Princess* (from
a pair), after 1690
Wool, silk, 121 ³⁄₄ × 156 in.
(309.2 × 396.2 cm)
The Metropolitan Museum of Art,
New York, Gift of Mrs. George F. Baker,
1953 (53.165.2)

98
Greek A factory (Dutch, 1658–1722)
Daniel Marot (French, 1660–1752),
designer
Proprietor Adrianus Kocx (Dutch,
act. 1689–1694; d. 1701)
Milk pan
ca. 1689–94
Tin-glazed earthenware painted in
blue, H. 4 ¹⁄₂ in. (11.3 cm);
Diam. 18 ⁵⁄₈ in. (47.4 cm)
Victoria and Albert Museum, London
(C.384-1926)

99
Greek A factory (Dutch, 1658–1722)
De Metaale Pot Factory (Dutch,
1670–1771/75)
Flower pyramid (one of a pair)
ca. 1695
Tin-glazed earthenware painted in
cobalt blue, 63 × 13 ¹⁄₄ × 14 ¹⁄₈ in.
(160 × 33.7 × 36 cm)
Victoria and Albert Museum, London
(C.96 to J-1981)

100
Jemima Lupton (British, 1743–1837)
Teapot
Inscribed *Miss Iemj Lupton of
Allfraton*
British, manufactured May 1, 1762
Lead-glazed earthenware (creamware),
H. 4 ¹⁄₂ in. (11.4 cm), Diam. 7 ¹⁄₄ in.
(18.4 cm); Diam. at base: 2 ⁵⁄₈ in.
(6.7 cm)
Museum of Fine Arts, Boston, The
Lloyd and Vivian Hawes Collection
(2000.704a–b)

101
Worcester factory
(British, 1751–2008)
Teapot
ca. 1768–78
Soft-paste porcelain with enamel
decoration, 5 × 7 ¹⁄₄ × 4 ³⁄₈ in.
(12.7 × 18.4 × 11.1 cm)
The Metropolitan Museum of Art,
New York, Gift of Mrs. Constance D.
Stieglitz, in memory of her husband,
Marcel H. Stieglitz, 1964
(64.142.69a, b)

102
Patty Chang (American, b. 1972)
Melons (At a Loss)
1998
Single-channel video (color, sound),
duration 3 mins., 47 sec.
Collection of the artist

103
Patty Chang (American, b. 1972)
Fountain
1999
Single-channel video (color, sound),
duration 5 mins., 30 sec.
Collection of the artist

104
Meissen porcelain manufactory
(German, 1710–present)
Figure of Guanyin
1710–13
Red stoneware with gilding,
14 ¾ × 4 × 4 ⅛ in.
(37.5 × 10.2 × 10.5 cm)
The Metropolitan Museum of Art,
New York, The Lesley and Emma
Sheafer Collection, Bequest of
Emma A. Sheafer, 1973
(1974.356.319)

105
Bodhisattva Guanyin seated on a rock
China, Qing dynasty (1644–1911),
Dehua, 18th century
Porcelain, 7 ½ in. (19.1 cm)
The Metropolitan Museum of Art,
New York, Bequest of Benjamin
Altman, 1913 (14.40.201)

106
Sèvres manufactory
(French, 1756–present)
Charles Nicolas Dodin (French,
1734–1803), decorator
Elephant vases
ca. 1761
Soft-paste porcelain with enamels
and gilding, 12 ¼ in. (31.1 cm)
The Walters Art Museum, Baltimore,
purchase, 1941 (48.1796, 48.1797)

107
Bow porcelain manufactory
(British, 1747–1776)
After an engraving by Michel Aubert
(French, 1700–1757)
After a design by Antoine Watteau
(French, 1684–1721)
*The Laotian Goddess Ki Mao Sao
and Worshippers*
ca. 1750–52
Soft-paste porcelain, 6 ¾ × 11 in.
(17.1 × 27.9 cm)
The Metropolitan Museum of Art,
New York, Gift of Irwin Untermyer,
1964 (64.101.694)

108
Vincennes manufactory
(French, ca. 1740–1756)
Asia and Africa
ca. 1752
Soft-paste porcelain,
11 ³⁄₁₆ × 10 ⅜ × 7 ⅛ in.
(28.4 × 26.4 × 18.1 cm)
The Metropolitan Museum of Art,
New York, Purchase, Friends of
European Sculpture and Decorative
Arts Gifts and Marilyn and Lawrence
Friedland Gift, 2012 (2012.507)

109, 110
Gai Qi (Chinese, 1773–1828)
Calligraphy by Cao Zhenxiu (Chinese,
1762–1822)
Wei Shuo Practicing Calligraphy and
*The Lady in the Red Sleeves Combs
Her Hair* from *Exemplary Women*
China, Qing dynasty (1644–1911),
dated 1799
Album of sixteen double leaves, ink
on paper, image (each): 9 ¾ × 6 ⅝ in.
(24.8 × 16.8 cm), double-page leaf
(each): 12 ⅜ × 16 in. (31.4 × 40.6 cm)
The Metropolitan Museum of Art,
New York, Purchase, Bequests of
Edna H. Sachs and Flora E. Whiting,
by exchange; Fletcher Fund, by
exchange; Gifts of Mrs. Harry Payne
Bingham and Mrs. Henry J. Bernheim,
by exchange; and funds from various
donors, by exchange, 2016
(2016.362a–t)

111
Travis Banton (American, 1894–1958)
Evening dress
ca. 1934
Black silk charmeuse embroidered
with gold and silver sequins
Brooklyn Museum Costume
Collection at The Metropolitan
Museum of Art, Gift of the Brooklyn
Museum, 2009; Gift of Anna May
Wong, 1956 (2009.300.1507)

112
Lee Bul (South Korean, b. 1964)
Untitled (Cyborg Pelvis)
2000
Porcelain, 14 × 12 × 14 in.
(35.6 × 30.5 × 35.6 cm)
The Metropolitan Museum of Art,
New York, Gift of Thaddaeus Ropac,
2023 (2023.285.2)

**EXHIBITION WORKS
NOT ILLUSTRATED**

Patty Chang (American, b. 1972)
Abyssal
2024
Glazed and unglazed vitreous
porcelain, 28 ¾ x 26 ½ x 74 ½ in.
(75.6 x 67.3 x 189.2 cm)
Collection of Patty Chang

Jug with Portuguese arms
Chinese, made for the Portuguese
market
1520–40
Hard-paste porcelain with cobalt
blue under transparent glaze
(Jingdezhen ware), H. 7 ⅜ in. (18.7 cm)
The Metropolitan Museum of Art,
New York, Helena Woolworth McCann
Collection, Purchase, Winfield
Foundation Gift, 1961 (61.196)

Ewer in the form of a conch shell
Japanese porcelain, ca. 1700,
French mounts, ca. 1750
Hard-paste porcelain, gilt-bronze,
11 ⅝ × 7 ⁹⁄₁₆ × 5 ⅜ in.
(29.5 × 19.2 × 13.7 cm)
The Metropolitan Museum of Art,
New York, Gift of Mrs. Charles
Wrightsman, 2013 (2013.238.1)

Dish with initials of the V.O.C.
(Verenigde Oostindische Compagnie)
Japanese, made for the Dutch market
1670–1700
Hard-paste porcelain (Arita ware),
2 ⅜ × 14 ¼ in. (6 × 36.2 cm)
The Metropolitan Museum of Art,
New York, Helena Woolworth McCann
Collection, Purchase, Winfield
Foundation Gift, 1968 (68.86)

Yeesookyung (Korean, b. 1963)
Translated Vase_2023 TVG 1
2023
Ceramic shards, epoxy, 24K gold leaf,
6 ½ in. × 7 ¹⁄₁₆ in. × 5 ¹¹⁄₁₆ in.
(16.5 × 18 × 14.5 cm)
Collection of the artist

Vienna manufactory (Austrian,
1718–present)
Factory director Claudius Innocentius
du Paquier period (1718–44)
Tulip vase from a garniture
ca. 1725
Hard-paste porcelain,
H. 6 ⁷⁄₁₆ × 8 ⅜ × 6 ⁹⁄₁₆ in.
(16.4 × 21.3 × 16.7 cm)
The Metropolitan Museum of Art,
New York, Gift of R. Thornton Wilson,
in memory of Florence Ellsworth
Wilson, 1954 (54.147.94)

Covered ewer
China, Qing dynasty (1644–1911),
Kangxi period (1662–1722),
early 18th century
Porcelain with a clear glaze, Dehua
ware (blanc de chine), H. 4 ½ in.
(11.4 cm)
The Metropolitan Museum of Art,
New York, Purchase by subscription,
1879 (79.2.486a, b)

Jar with female rider
China, Ming dynasty (1368–1644),
mid-17th century
Porcelain painted with cobalt blue
under a transparent glaze
(Jingdezhen ware), H. (with cover)
2 ¼ in. (5.7 cm)
The Metropolitan Museum of Art,
New York, Purchase by subscription,
1879 (79.2.237a, b)

Cup with women and flowers
China, Qing dynasty (1644–1911)
Porcelain painted in underglaze blue,
H. 2 in. (5.1 cm), Diam. 3 ½ in. (8.9 cm)
The Metropolitan Museum of Art,
New York, Purchase by subscription,
1879 (79.2.271)

Saucer with women and flowers
China, Qing dynasty (1644–1911)
Porcelain painted in underglaze blue,
Diam. 5 in. (12.7 cm)
The Metropolitan Museum of Art,
New York, Purchase by subscription,
1879 (79.2.272)

Winepot with cover
China, Qing dynasty (1644–1911),
Kangxi period (1662–1722), late
17th–early 18th century
Porcelain painted in enamels on the
biscuit, 5 ½ × 5 ⅛ × 3 ⅛ in.
(14 × 13 × 7.9 cm)
The Metropolitan Museum of Art,
New York, Gift of Edwin C. Vogel,
1964 (64.279.7)

Cup
China, Qing dynasty (1644–1911),
Kangxi period (1662–1722)
Porcelain painted in polychrome
enamels, H. 1 ¾ in. (4.4 cm),
Diam. 3 ¼ in. (8.3 cm)
The Metropolitan Museum of Art,
New York, Gift of Edwin C. Vogel,
1964 (64.279.12)

Saucer
China, Qing dynasty (1644–1911),
Kangxi period (1662–1722)
Porcelain painted in polychrome
enamels, H. ¾ in. (1.9 cm),
Diam. 5 in. (12.7 cm)
The Metropolitan Museum of Art,
New York, Gift of Edwin C. Vogel,
1964 (64.279.13)

Vase with magnolias
China, Qing dynasty (1644–1911),
Kangxi period (1662–1722), late
17th century
Porcelain with relief decoration,
painted with cobalt blue under a
clear glaze (Jingdezhen ware),
H. 17 ⅜ in. (44.1 cm);
Diam. 8 ¾ in. (22.2 cm)
The Metropolitan Museum of Art,
New York, H. O. Havemeyer
Collection, Bequest of Mrs. H. O.
Havemeyer, 1929 (29.100.308)

Figure of a horse
China, Qing dynasty (1644–1911),
Kangxi period (1662–1722),
late 17th–early 18th century
Porcelain painted in famille-verte
enamels on the biscuit,
4 ⅝ × 5 ¼ × 2 ⅝ in.
(11.7 × 13.3 × 6.7 cm)
The Metropolitan Museum of Art,
New York, Gift of Edwin C. Vogel,
1963 (63.213.3)

Figure of a horse
China, Qing dynasty (1644–1911),
Kangxi period (1662–1722),
late 17th–early 18th century
Porcelain painted in famille-verte
enamels on the biscuit,
4 ¼ × 5 ½ × 2 ¾ in.
(10.8 × 14 × 7 cm)
The Metropolitan Museum of Art,
New York, Gift of Edwin C. Vogel,
1963 (63.213.4)

Incense burner (koro)
Japanese, made for the European
market
late 17th century
Hard-paste porcelain painted with
cobalt blue under and colored
enamels over transparent glaze
(Hizen ware; Kakiemon type),
H. 4 ⅛ in. (10.5 cm)
The Metropolitan Museum of Art,
New York, The Hans Syz Collection,
Gift of Stephan B. Syz and John D.
Syz, 1995 (1995.268.114a, b)

Covered jar with large finial
Japan, made for the export market
1725–50
Porcelain, 24 ¹¹⁄₁₆ × 13 ⁵⁄₁₆ × 13 ⁵⁄₁₆ in.
(62.7 × 33.8 × 33.8 cm)
The Metropolitan Museum of Art,
New York, Gift of Jane Hardesty
Poole, 2014 (2014.207a, b)

Beaker vase (part of an assembled
garniture)
Japanese, made for the export
market (Hizen ware, Imari type)
1690–1720
Hard-paste porcelain with underglaze
blue and overglaze enamel and
gilding, 23 ⅜ × 11 × 11 in.
(59.4 × 27.9 × 27.9 cm),
W. at base: 6 in. (15.2 cm)
The Metropolitan Museum of Art,
New York, Gift of Jane Hardesty
Poole, 2019 (2019.257.10)

Beaker vase (part of an assembled
garniture)
Japanese, made for the export
market (Hizen ware, Imari type)
1690–1720
Hard-paste porcelain with underglaze
blue and overglaze enamel and
gilding (Hizen ware, Imari type),
15 ¾ × 7 ¼ × 7 ¼ in.
(40 × 18.4 × 18.4 cm),
W. at base: 4 ½ in. (11.4 cm)
The Metropolitan Museum of Art,
New York, Gift of Jane Hardesty
Poole, 2019 (2019.257.13)

Bodhisattva Guanyin
China, Ming dynasty (1368–1644),
16th century
Ivory, H. 9 ¾ in. (24.8 cm);
H. incl. base 10 ¼ (26 cm);
W. 3 in. (5.1 cm)
The Metropolitan Museum of Art,
New York, Rogers Fund, 1913
(12.219.1)

Teapot in melon shape
Japan, late 17th century, Edo period
(1615–1868), with later mounts by
Thome, New York (rim and hinge)
Porcelain painted with cobalt blue
under and colored enamels over
transparent glaze (Hizen ware,
Kakiemon type), American mount,
H. 5 ⅞ in. (14.9 cm),
Diam. 5 ½ in. (14 cm)
The Metropolitan Museum of Art,
New York, Dr. and Mrs. Roger G. Gerry
Collection, Bequest of Dr. and Mrs,
Roger G. Gerry, 2000
(2002.447.60a, b)

William Fowle (British, 1658–1684)
Mirror with cresting (part of a
toilet service)
ca. 1683–84
Silver gilt, overall assembled:
22 ⁷⁄₁₆ × 20 ¼ in. (57 × 51.4 cm),
overall mirror: 16 ⁷⁄₁₆ × 20 ¼
(41.8 × 51.4 cm), overall cresting:
6 × 20 ¼ in. (15.2 × 51.4 cm)
The Metropolitan Museum of Art,
New York, Fletcher Fund, 1963
(63.70.1a, b)

William Fowle (British, 1658–1684)
Box with cover (one of a pair, part of
a toilet service)
ca. 1683–84
Silver gilt, 2 ⁹⁄₁₆ × 5 × 5 in.
(6.5 × 12.7 × 12.7 cm)
The Metropolitan Museum of Art,
New York, Fletcher Fund, 1963
(63.70.3a, b)

William Fowle (British, 1658–1684)
Pair of boxes with covers
(part of a toilet service)
ca. 1683–84
Silver gilt, 2 × 3 ½ × 3 ½ in.
(5.1 × 8.9 × 8.9 cm)
The Metropolitan Museum of Art,
New York, Fletcher Fund, 1963
(63.70.5a, b, .6a, b)

William Fowle (British, 1658–1684)
Pair of bowls with covers
(part of a toilet service)
ca. 1683–84
Silver gilt, 2 ¾ × 5 ½ × 4 ½ in.
(7 × 14 × 11.4 cm)
The Metropolitan Museum of Art,
New York, Fletcher Fund, 1963
(63.70.9a, b, .10a, b)

William Fowle (British, 1658–1684)
Pair of salvers (part of a toilet service)
ca. 1683–84
Silver gilt, salver on foot:
3 ⅜ × 9 ¼ × 9 ¼ in.
(8.6 × 23.5 × 23.5 cm)
The Metropolitan Museum of Art,
New York, Fletcher Fund, 1963
(63.70.11, .12)

Unknown artist with mark "D." (London)
Pair of scent bottles (part of a toilet
service)
ca. 1687–88
Silver gilt, 5 ⅝ × 3 ½ × 3 ½ in.
(14.3 × 8.9 × 8.9 cm)
The Metropolitan Museum of Art,
New York, Fletcher Fund, 1963
(63.70.13a, b, .14a, b)

Unknown artist with mark "D." (London)
Pin cushion (part of a toilet service)
1687–88
Silver gilt, 1 ¹³⁄₁₆ × 7 ¼ × 5 ¼ in.
(4.6 × 18.4 × 13.3 cm)
The Metropolitan Museum of Art,
New York, Fletcher Fund, 1963
(63.70.15)

Probably by Thomas Jenkins (British,
act. 1668–1708)
Pair of pomade pots (part of a
toilet service)
ca. 1684
Silver gilt, 2 ³⁄₁₆ × 2 × 2 in.
(5.6 × 5.1 × 5.1 cm)
The Metropolitan Museum of Art,
New York, Fletcher Fund, 1963
(63.70.18a, b, .19a, b)

Saint-Cloud factory (French,
mid-1690s–1766)
Toilet jar with cover
ca. 1720–40
Soft-paste porcelain, 2 ½ in. (6.4 cm)
The Metropolitan Museum of Art,
New York, Gift of R. Thornton Wilson,
in memory of Florence Ellsworth
Wilson, 1950 (50.211.137a, b)

Greek A factory (Dutch, 1658–1722)
Based on a print by Daniel Marot
(French, 1661–1752)
Proprietor Adrianus Kocx (Dutch,
act. 1689–1694; d. 1701)
Vase
ca. 1690
Tin-glazed earthenware (Delftware),
28 ½ in. (72.4 cm)
The Metropolitan Museum of Art,
New York, Purchase, Bequest of
Helen Hay Whitney and Gift of
George D. Widener, by exchange,
1994 (1994.218a–c)

Greek A factory (Dutch, 1658–1722)
Proprietor Adrianus Kocx (Dutch,
act. 1689–1694; d. 1701)
Base for a tulip vase
ca. 1690
Tin-glazed earthenware (Delftware)
National Museums Liverpool, Lady
Lever Art Gallery (L.1995.53)

Greek A factory (Dutch, 1658–1722)
Based on a print by Daniel Marot
(French, 1661–1752)
Proprietor Adrianus Kocx (Dutch,
act. 1689–1694; d. 1701)
Tile with a bust of William III
ca. 1694
Tin-glazed earthenware (Delftware),
27 ¼ × 27 ¼ in. (69.2 × 69.2 cm)
The Metropolitan Museum of Art,
New York, Gift of Irwin Untermyer,
1964 (64.101.389)

Greek A factory (Dutch, 1658–1722)
Proprietor Adrianus Kocx (Dutch,
act. 1689–1694; d. 1701)
Tulip vase (one of a pair)
commissioned by Queen Mary II prior
to her death in 1694
Tin-glazed earthenware, 38 ⅜ in.
(97.5 cm)
Royal Collection Trust, London
(RCIN 1084)

Saint-Cloud factory (French,
mid-1690s–1766)
Spice box with cover (poivrière)
ca. 1710–30
Soft-paste porcelain, H. 3 ⅜ in.
(8.6 cm)
The Metropolitan Museum of Art,
New York, Gift of R. Thornton Wilson,
in memory of Florence Ellsworth
Wilson, 1950 (50.211.134a, b)

Bodhisattva Guanyin seated on a rock
China, Qing dynasty (1644–1911),
18th–19th century
Porcelain with ivory glaze
(Dehua ware), (without stand):
6 ⅛ × 4 ⅛ × 3 ⅛ in.
(15.6 × 10.5 × 7.9 cm)
The Metropolitan Museum of Art,
New York, Bequest of Flora E.
Whiting, 1971 (1971.180.245)

Louisa Courtauld
(British, 1729–1807)
Hot water urn
ca. 1765–66
Silver, ivory, 21 ⅝ × 11 ⅝ × 11 ⅝ in.
(55 × 29.5 × 29.5 cm), base at ball
and claw feet: 6 ¾ × 6 ¾ in.
(17.1 × 17.1 cm)
The Metropolitan Museum of Art,
New York, Gift of Madame Lilliana
Teruzzi, 1966 (66.192.1a–c)

Hester Bateman
(British, act. 1761–1790)
Sugar tongs
ca. 1774–76
Silver, L. 5 ⅜ in. (13.7 cm)
The Metropolitan Museum of Art,
New York, Rogers Fund, 1913
(13.42.76)

Elizabeth Tookey
(British, act. beginning ca. 1773)
Strainer spoon
ca. 18th century
Silver, 5 ½ in. (14 cm)
The Metropolitan Museum of Art,
New York, Rogers Fund, 1913
(13.42.80f)

Decorated by Ignaz Preissler
(German, 1676–1741)
Vase (one of a pair)
ca. 1729–32
Hard-paste porcelain (Jingdezhen
ware) with Bohemian decoration,
H. 10 ¹¹⁄₁₆ in. (27.1 cm);
Diam. 4 ⅛ in. (10.5 cm)
The Metropolitan Museum of Art,
New York, Gift of R. Thornton Wilson,
in memory of Florence Ellsworth
Wilson, 1954 (54.147.96)

Meissen porcelain manufactory
(German, 1710–present)
Decorated by Ignaz Preissler
(German, 1676–1741)
Dish in the form of a leaf
ca. 1725–32
Hard-paste porcelain, 1 ¾ × 3 × 4 in.
(4.4 × 7.6 × 10.2 cm)
The Metropolitan Museum of Art,
New York, Gift of R. Thornton Wilson,
in memory of Florence Ellsworth
Wilson, 1950 (50.211.25)

Meissen porcelain manufactory
(German, 1710–present)
Decoration attributed to Johann
Gregor Höroldt (German, 1696–1775)
Bowl
ca. 1724
Hard-paste porcelain, 3 ½ × 6 ¹⁵⁄₁₆ in.
(8.9 × 17.6 cm)
The Metropolitan Museum of Art,
New York, Rogers Fund, 1927
(27.190)

Meissen porcelain manufactory
(German, 1710–present)
Decoration attributed to Johann
Gregor Höroldt (German, 1696–1775)
Caddy (part of a set)
Hard-paste porcelain, H. 5 in. (12.7 cm)
The Metropolitan Museum of Art,
New York, The George B. McClellan
Collection, Gift of Mrs. George B.
McClellan, 1941 (42.205.74a, b)

Meissen porcelain manufactory
(German, 1710–present)
Teapot
ca. 1735–40
Hard-paste porcelain, H. (with cover)
4 ⁷⁄₁₆ in. (11.3 cm)
The Metropolitan Museum of Art,
New York, Gift of Estate of James
Hazen Hyde, 1959 (59.208.27a, b)

Cup and saucer with ladies
China, Qing dynasty (1644–1911),
Kangxi period (1662–1722), late
17th–early 18th century
Porcelain with blue glaze and incised
decoration (Jingdezhen ware),
Cup: Diam. 2 ½ in. (6.4 cm); saucer:
Diam. 4 in. (10.2 cm)
The Metropolitan Museum of Art,
New York, Edward C. Moore
Collection, Bequest of Edward C.
Moore, 1891 (91.1.423a, b)

Tea caddy
Britain, Staffordshire, 1740–50
Salt-glazed stoneware,
3 ¾ × 1 ¾ × 2 ¾ in. (9.5 × 4.4 × 7 cm)
The Metropolitan Museum of Art,
New York, Gift of Carleton Macy,
1934 (34.165.67)

Dish
Bristol, England, 18th century
Tin-glazed earthenware,
1 ⅞ × 13 ½ in. (4.8 × 34.3 cm)
The Metropolitan Museum of Art,
New York, Purchase, Anita M. Linzee
Bequest, 1936 (36.140.2)

Design attributed to Cornelis Pronk
(Dutch, 1691–1759)
Dish
Chinese, made for the European
market
ca. 1736–38
Hard-paste porcelain, Diam. 6 ⅛ in.
(15.6 cm)
The Metropolitan Museum of Art,
New York, Purchase by subscription,
1879 (79.2.878)

After a design by Cornelis Pronk
(Dutch, 1691–1759)
Dish
ca. 1735
Hard-paste porcelain, 1 × 6 ¹¹⁄₁₆ in.
(2.5 × 17 cm)
The Metropolitan Museum of Art,
New York, Helena Woolworth McCann
Collection, Purchase, Winfield
Foundation Gift, 1960 (60.150.1)

Decoration after Nicolas Lancret
(French, 1690–1743)
Plate with scene from Les Oies de
Frère Philippe
ca. 1745
Porcelain, ⅞ × 9 × 9 in.
(2.2 × 22.9 × 22.9 cm)
The Metropolitan Museum of Art,
New York, Purchase, Friends of
European Sculpture and Decorative
Arts Gifts, 2016 (2016.114)

Style of Adam Friedrich von
Löwenfinck (German, 1714–1754)
Probably decorated by the itinerant
enameler Johann Philip Dannhofer
(1712–1790)
Plate
ca. 1741–44
Tin-glazed earthenware, H. ¹³⁄₁₆ in.
(2.1 cm), Diam. 9 ⅝ in. (24.4 cm)
The Metropolitan Museum of Art,
New York, Gift of R. Thornton Wilson,
in memory of Florence Ellsworth
Wilson, 1954 (54.147.43)

Chelsea porcelain manufactory
(British, 1744–1784)
Plate decorated with Japanese
Kakiemon-inspired scene with
twisted dragon
ca. 1752 (probably Raised Anchor
period)
Soft-paste porcelain, irregular
Diam. 1 ½ × 9 in. (3.8 × 22.9 cm)
The Metropolitan Museum of Art,
New York, Purchase, Larry and Ann
Burns Gift, in honor of Austin B.
Chinn, 2018 (2018.378)

Worcester factory
(British, 1751–2008)
Jug
ca. 1753
Soft-paste porcelain, H. 3 in.
cup: 1 ⅞ × 2 ⅞ in. (4.8 × 7.3 cm);
saucer: 1 × 4 ⅞ in. (2.5 × 12.4 cm).
(7.6 cm)
The Metropolitan Museum of Art,
New York, Gift of Mrs. Constance D.
Stieglitz, in memory of her husband,
Marcel H. Stieglitz, 1964 (64.142.9)

Worcester factory
(British, 1751–2008)
Cup and saucer
ca. 1753
Soft-paste porcelain, with famille-
verte enamel decoration, 1 ¾ × 2 ¾ in.
(4.4 × 7 cm), Diam. 4 ¼ in. (10.8 cm)
The Metropolitan Museum of Art,
New York, Gift of Mrs. Constance D.
Stieglitz, in memory of her husband,
Marcel H. Stieglitz, 1964
(64.142.78, .79)

Side chair (one of a pair)
British, 1755–60
Mahogany, tent stitch embroidery on
canvas, 39 × 23 ¾ × 18 in.
(99.1 × 60.3 × 45.7 cm)
The Metropolitan Museum of Art,
New York, Gift of Irwin Untermyer,
1964 (64.101.982)

Martin Carlin
(French, ca. 1730–1785)
Combined work, writing, and reading
table and music stand
ca. 1775–80
Veneered on oak with ebony,
tulipwood, and black and gold
Japanese lacquer; mounts chased and
gilded bronze
H. closed: 30 ½ × 15 ¾ × 12 ⅜ in.
(77.5 × 40 × 31.4 cm)
The Metropolitan Museum of Art,
New York, Bequest of Mrs. Charles
Wrightsman, 2019 (2019.283.4)

Lorgnette fan with scene of figures
in a courtyard garden
Chinese, made for the European market
mid-18th century
Paper, ivory, silk, 11 ½ × 20 in.
(29.2 × 50.8 cm)
The Metropolitan Museum of Art,
New York, Bequest of Mary Strong
Shattuck, 1935 (35.80.27)

Meissen porcelain manufactory
(German, 1710–present)
Pair of boxes in the shape of a fan
ca. 1728–30
Hard-paste porcelain,
¾ × 4 ¹⁄₁₆ × 2 ⁹⁄₁₆ in.
(1.9 × 10.3 × 6.5 cm)
The Metropolitan Museum of Art,
New York, The Lesley and Emma
Sheafer Collection, Bequest of
Emma A. Sheafer, 1973
(1974.356.493a, b)

Meissen porcelain manufactory
(German, 1710–present)
Decoration attributed to the
Aufenwerth Workshop
Teapot with cover
ca. 1719–30
Hard-paste porcelain decorated in
polychrome enamels, gold; metal
chain with mounts,
6 ¹⁄₁₆ × 6 ⁷⁄₈ × 3 ⁷⁄₈ in.
(15.4 × 17.5 × 9.8 cm)
The Metropolitan Museum of Art,
New York, Gift of Irwin Untermyer,
1970 (1970.277.5a, b)

Minton factory
(British, 1793–present)
Teapot in the form of a man
ca. 1874
Bone china, 4 ⁷⁄₈ × 7 ³⁄₁₆ × 3 ⁹⁄₁₆ in.
(12.4 × 18.3 × 9 cm)
The Metropolitan Museum of Art,
New York, Gift of Helene Fortunoff
and Robert Grossman, 2017
(2018.62.53a, b)

Bernard Lens II (British, 1659–1725)
Empress of China
before 1725
Mezzotint on moderately thick,
moderately textured, cream laid
paper, sheet: 5 ⁹⁄₁₆ × 4 ¹⁄₁₆ in.
(14.1 × 10.3 cm), plate: 5 ³⁄₁₆ × 3 ¹³⁄₁₆ in.
(13.2 × 9.7 cm), image: 4 ⁵⁄₁₆ × 3 ⁹⁄₁₆ in.
(11 × 9 cm)
Yale Center for British Art, Paul Mellon
Fund, New Haven (B1970.3.1029)

Derby Porcelain manufactory
(British, 1751–1785)
Mother and child group
ca. 1750–55
Soft-paste porcelain,
H. 8 ¹³⁄₁₆ in. (22.4 cm)
The Metropolitan Museum of Art,
New York, Gift of R. Thornton Wilson,
in memory of Florence Ellsworth
Wilson, 1950 (51.1.3)

Saint-Cloud factory
(French, mid-1690s–1766)
Actress (one of a pair)
ca. 1730–40
Soft-paste porcelain decorated in
polychrome enamels, gold,
8 ¹⁄₁₆ × 6 ⁵⁄₈ × 5 ¼ in.
(20.5 × 16.8 × 13.3 cm)
The Metropolitan Museum of Art,
New York, Gift of R. Thornton Wilson,
in memory of Florence Ellsworth
Wilson, 1954 (54.147.11)

Musicians
Chinese, made for the European market
late 18th century
Watercolor on paper,
17 × 14 × ½ in.
(43.2 × 35.6 × 1.3 cm)
The Metropolitan Museum of Art,
New York, Gift of Lawrence
Creshkoff, 1990 (1990.289.21)

Bow porcelain manufactory
(British, 1747–1776)
Air
ca. 1748
Soft-paste porcelain, 7 ¾ × 6 in.
(19.7 × 15.2 cm)
The Metropolitan Museum of Art,
New York, Gift of Irwin Untermyer,
1964 (64.101.688)

James Cox (British, ca. 1723–1800),
purveyor
After a design by Antoine Watteau
(French, 1684–1721)
After a design by François Boucher
(French, 1703–1770)
Jewel cabinet with watch
ca. 1765–70
Case: agate, mounted in gilded
copper and gilded brass and set with
painted enamel on copper plaques,
and fruitwood; Dial: white enamel,
13 ½ × 9 ¾ × 7 ½ in.
(34.3 × 24.8 × 19.1 cm)
The Metropolitan Museum of Art,
New York, Gift of Irwin Untermyer.
1964 (64.101.829)

Mennecy factory
(French, act. 1750–1771)
Asia
ca. 1755–60
Soft-paste porcelain,
H. 5 in. (12.7 cm)
The Metropolitan Museum of Art,
New York, Gift of Estate of James
Hazen Hyde, 1959 (59.208.2)

Greek A factory (Dutch, 1658–1722)
Lidded vase with the head of a
Chinese woman
ca. 1765
Tin glazed earthenware, H. 16 ¹⁵⁄₁₆ in.
(43 cm), Diam. 6 ¼ in. (16 cm)
Rijksmuseum, Amsterdam
(BK-NM-12400-400)

Vienna manufactory (Austrian,
1718–present)
Factory director Claudius Innocentius
du Paquier period (1718–44)
Sweetmeat dish
ca. 1730
Hard-paste porcelain,
3 ³⁄₈ × 9 ¹¹⁄₁₆ × 4 ³⁄₈ in.
(8.6 × 24.6 × 11.1 cm)
The Metropolitan Museum of Art,
New York, Gift of Thornton Wilson, in
memory of Florence Ellsworth
Wilson, 1950 (50.211.5)

Plate
Sèvres manufactory
(French, 1740-present)
Jean-Pierre Fumez (French, act.
1777–1804), decorator
1791
Hard-paste porcelain with enamel
and platinum, Diam. 9 ⁵⁄₈ in. (24.4 cm)
The Metropolitan Museum of Art,
New York, Gift of Lewis Einstein,
1962 (62.165.16)

Platter
Chinese, made for the American
market
19th century
Hard-paste porcelain,
13 ¼ × 16 ⅛ in. (33.7 × 41 cm)
The Metropolitan Museum of Art,
New York, Helena Woolworth McCann
Collection, Gift of Winfield Foundation,
1951 (51.86.335)

Studio portrait: woman standing in profile holding umbrella, Hong Kong
ca. 1868
Albumen silver print with applied color, image: 3 ½ × 2 ⅒ in.
(8.9 × 5.4 cm), mount: 4 ⅛ × 2 ½ in. (10.6 × 6.2 cm)
The Metropolitan Museum of Art, New York, The Horace W. Goldsmith Foundation Fund, through Joyce and Robert Menschel, 2017 (2017.69.6)

Lai Afong (Chinese, 1838–1890)
Woman with exposed bound feet
1860s
Albumen silver print, without frame: 6 × 3 ¾ in. (15.2 × 9.5 cm)
Loewentheil China Photography Collection

Souvenir albums of the imperial family
possibly 1930s
Photos in cloth-bound album, 40 × 6 ½ in. (101.6 × 16.5 cm)
Loewentheil China Photography Collection

Old Hall Porcelain Works
(British, 1861–1902)
Design attributed to Christopher Dresser (British, 1834–1904)
Vase with coiled dragon
ca. 1884–90
Earthenware with gilding, 14 ½ × 8 ⁹⁄₁₆ × 8 ½ in.
(36.8 × 21.7 × 21.6 cm)
The Metropolitan Museum of Art, New York, Gift of Helene Fortunoff and Robert Grossman, 2017 (2018.62.166)

Worcester factory
(British, 1751–2008)
James Hadley (British, 19th century), modeler
Octagonal vase with scenes of the story of the silkworm
ca. 1873
Bone china ("ivory porcelain") with enamel decoration and gilding, 10 ½ × 9 ¾ × 3 ⅝ in.
(26.7 × 24.8 × 9.2 cm)
The Metropolitan Museum of Art, New York, Gift of Helene Fortunoff and Robert Grossman, 2017 (2018.62.97)

Christopher Dresser (British, 1834–1904), designer
Minton factory (British, 1793–present)
Pair of moon flasks with cloisonné decoration
Bone china, 10 ⅜ × 8 ¼ × 4 ³⁄₁₆ in.
(26.4 × 21 × 10.6 cm);
10 ⅛ × 7 ¹⁵⁄₁₆ × 4 in.
(25.7 × 20.2 × 10.2 cm)
The Metropolitan Museum of Art, New York, Gift of Florence and Herbert Irving, 2016 (2016.178.2.2)

Yeesookyung (South Korean, b. 1963)
Translated Vase_2022 TVCSHW 1
2022
Ceramic shards from Capodimonte, Haeju, Hwanghae-do, and white ceramic shards, epoxy, 24K gold leaf, 39 ³⁄₁₆ × 16 ¹⁵⁄₁₆ × 21 ⅝ in.
(99.5 × 55 × 43 cm)
Collection of the artist

Yeesookyung (South Korean, b. 1963)
Translated Vase_2019 TVCW 1
2019
Discarded ceramic shards from Italy and Korea, epoxy, 24K gold leaf, 42 ⅛ × 33 ⁷⁄₁₆ × 27 ¹⁵⁄₁₆ in.
(107 × 85 × 71 cm)
Collection of the artist

Yeesookyung (South Korean, b. 1963)
Translated Vase_2023 TVB 1
2023
Black glazed ceramic and earthenware shards from Hoeryung, North Korea, epoxy, 24K gold leaf, 61 ⁷⁄₁₆ × 57 ¹⁄₁₆ × 56 ⁵⁄₁₆ in.
(156 × 145 × 143 cm)
Collection of the artist

Yeesookyung (South Korean, b. 1963)
Translated Vase_2024 TVGW 1
2024
Celadon fragments from Gangjin, South Jeolla Province, South Korea, and ceramic shards from Mungyeong and Icheon, South Korea, epoxy, 24K gold leaf, 62 ³⁄₁₆ × 50 ⅜ × 50 ⁹⁄₁₆ in.
(158 × 128 × 128.5 cm)
Collection of the artist

INDEX

PHOTOGRAPHY CREDITS

This catalogue is published in conjunction with *Monstrous Beauty: A Feminist Revision of Chinoiserie*, on view at The Metropolitan Museum of Art, New York, from March 25 through August 17, 2025.

The exhibition is made possible by the William Randolph Hearst Foundation and Mellon Foundation.

Additional support is provided by Kohler Co., the E. Rhodes and Leona B. Carpenter Foundation, Karen and Samuel Choi, The International Council of The Metropolitan Museum of Art, the Edward John & Patricia Rosenwald Foundation, and Mimi O. Kim.

This publication is made possible by the Diane W. and James E. Burke Fund.

Additional support is provided by Salle Yoo and Jeffrey Gray and the Doris Duke Fund for Publications.

Published by The Metropolitan Museum of Art, New York

Mark Polizzotti, Publisher and Editor in Chief

Peter Antony, Associate Publisher for Production

Michael Sittenfeld, Associate Publisher for Editorial

Edited by Elizabeth L. Block

Production and color separations by Christopher Zichello

Designed by McCall Associates

Bibliographic editing by Julia Oswald

Image acquisitions and permissions by Josephine Rodriguez

Photographs of works in The Met collection are by Peter Zeray, Oi-Cheong Lee, Anna-Marie Kellen, and Mark Morosse, Imaging Department, The Metropolitan Museum of Art, unless otherwise noted.

Additional photography credits appear on page 255.

Typeset in Ambiguity Radical and Requiem

Printed on Magno Matte 130 gsm

Printed and bound by Ofset Yapimevi, Istanbul

All papers meet FSC standards for paper from responsible sources.

Jacket illustration: Woman with a pipe, ca. 1760–80 (detail, pl. 74)

Pages 2–3: William Hogarth. *A Harlot's Progress*, 1732 (detail, pl. 49)

The Metropolitan Museum of Art
1000 Fifth Avenue
New York, New York 10028
metmuseum.org

Distributed by
Yale University Press, New Haven and London
yalebooks.com/art
yalebooks.co.uk

Authorized Representative in the EU:
Easy Access System Europe, Mustamäe tee 50, 10621 Tallinn, Estonia,
gpsr.requests@easproject.com

Cataloguing-in-Publication Data is available from the Library of Congress.

ISBN 978-1-58839-792-8